MADELEINE E.
Gabriel Blackwell

Outpost19 | San Francisco
outpost19.com

Blackwell, Gabriel
 Madeleine E./ Gabriel Blackwell
 ISBN 9781937402945 (pbk)

Library of Congress Control Number: 2015919182

OUTPOST19

MADELEINE E.

Prelude

...

The Rooftops

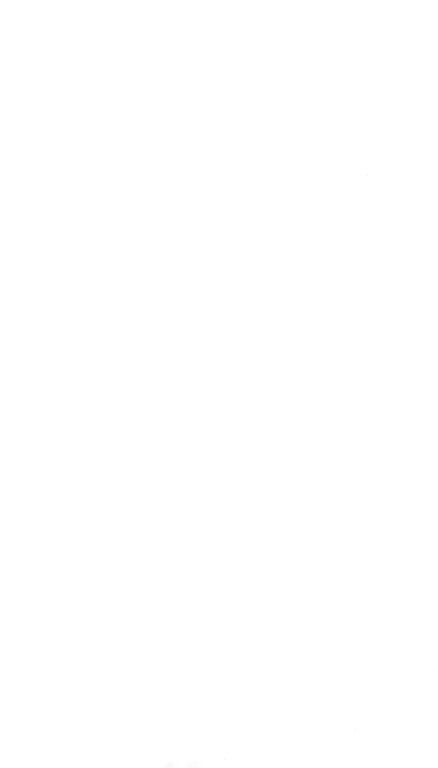

We have only a short time to please the living, all eternity to please the dead.
(Sophocles, *Antigone*)

…

God has given you one face and you make yourselves another.
(Shakespeare, *Hamlet*)

…

[EXT. San Francisco Roof Tops (DUSK)]

…

We open already in pursuit of something ineffable: the outline of a man Jimmy Stewart is chasing. We briefly see this man's face in soft focus and shadowed, but, because we are not ready for it (how could we be? we have no context; we could ask "Will this be a main character?" but our next question would then be "In what?") and because we never see it again, it might as well never have been shown. Can you remember what he looked like? Even after watching *Vertigo* fifty-plus times, I have no mental picture of him. Why is Stewart chasing this man? We will never know.

…

In Philip K. Dick's novel *A Scanner Darkly*, "Fred" (a pseudonym), an undercover police officer whose identity is kept disguised by something called a "scramble suit," investigates *himself*, the person inside the "scramble suit," Bob Arctor, a drug addict living with two other users, one of whom has informed on Arctor, precipitating Arctor's investigation of himself. To make matters worse, Arctor has been given an adulterated form of the drug Substance D, "Slow Death," which is causing his

3

brain's hemispheres to operate independently of each other, so that, as his investigation of himself progresses, he begins to see himself as someone else: "Bob Arctor," suspect, as opposed to Bob Arctor, self. It is at this point in the book that the informant's identity is revealed, to Arctor and to us, but, though things appear to be coming to a head, Dick chooses to then turn Arctor into a vegetable, incapable of even the most rudimentary investigation, and has the book follow him into this new passive state. The ensuing chapters are pastoral, as placid as the preceding fantasy was paranoid. It is an unusual choice, to say the least. Reading it, I felt sure each of the last twenty pages would bring a return to the frantic suspicion of the first two hundred, instilling in the reader, me, some sense of wholeness, of closure. Instead, I got banal scenes in a rehab center and on a farm, scenes that could have come from any of a thousand other novels, I felt, just not this one. And though in those scenes we find out what Arctor was supposed to find out, it is, for these last pages, as though we are reading some other book entirely, as though we have escaped from one narrative into another.

I was reminded of the end of Evelyn Waugh's *A Handful of Dust*, in which Waugh's protagonist, Tony Last, in the middle of a nasty divorce in England—which story we have been following for two hundred pages—decides to go on an expedition to Brazil for which he has no real background. Such a turn of events would seem strange enough in the context of the story we've been following, but things get even stranger when Tony's guide disappears, stranding him in the jungle. Tony nearly dies from disease and starvation, but is rescued by a man known as "Mr. Todd" who keeps Tony alive on the condition that Tony read Dickens aloud to him. The chapter had originally been a short story of Waugh's, "The Man Who Loved Dickens," and it is hard not to see its metamorphosis into the denouement of *A Handful of Dust*—a domestic drama if ever there was one, and as far away from an adventure tale as a book could be—as an utterly bizarre, grotesque deformation of the *deus ex machina*.

That term, *deus ex machina*, comes from Horace's *Ars Poetica*, where Horace uses it as a criticism of the manner in which many Greek dramas were resolved. It may refer to an actual machine (*machina*) called a *mekhane*, used to lower actors onto the stage or allow them to fly above it. The terrified actor, partially blinded by his *prosopon* and strung up above a stage (made of stone, it should be remembered), attached to a system of pulleys and beams creaking from overuse, awaiting his one appearance on stage, destined to provide the play with the only sense of resolution or closure possible. He will need to get his feet under him and keep his *chiton* out of his own way if he is to have any hope of appearing godlike, not splitting his lip, shattering his kneecap, or losing yet another tooth. He opens his eyes: his own thin, frail ankles, the sock just barely clinging to his toes, straining to slip off and float slowly to the stage, the stage below, other actors crossing below him, trained not to notice this weight suspended above their heads—he must have hung there and wondered how it could possibly go well.

. . .

Some children born with damage to one of the brain's hemispheres show few or even no developmental difficulties; hemispherectomies (the removal of one of the brain's hemispheres) are almost exclusively performed on children because children have a much higher degree of something called "neuroplasticity" than do adults. Because of this neuroplasticity, the missing hemisphere's usual functions can be accomplished by the remaining hemisphere. Difficulties seem to arise much more often later in life, when a hemisphere that has already been assigned certain functions is damaged. Cases where one of an adult's hemispheres is damaged have led to anosognosia (the inability to recognize one's own disabilities), aphasia (word-memory loss), and prosopagnosia (face blindness), as well as a host of other disorders. Whatever faculty has been disturbed

by the damage cannot be replicated in the other hemisphere, or else can only be tortuously, circuitously replicated there. Again, though, damage to the same area of the brain, provided it occurs early enough in life, may not have any effect at all. One can only miss what one has already experienced.

…

A Scanner Darkly's "scramble suit" projects a seemingly infinite number of different facial features in front of the wearer's face, one at a time but constantly changing, in randomized combinations. Though the intention is to hide the identity of the person inside the suit, the effect must also be extraordinarily unnerving—anyone who has seen *Late Night with Conan O'Brien*'s "If They Mated" will know just how disturbing facial features from different people brought together in the same face can be. Imagine it: always changing, always throwing up new combinations. How could you even talk to such a thing? Because these facial features have been taken from living (and once-living) human beings, their number cannot be infinite. Mathematically, it is a certainty: the "scramble suit," if allowed to go on operating long enough, will eventually betray its wearer. At some point in time, all of his/her features will be displayed, together. Perhaps the real intention isn't to hide the wearer's face at all—even though it would only be displayed for an instant, surely that would be enough time to cement the suspicions of anyone who knew the person inside the suit. Perhaps the real intention is to make that area of the body so hideous, so inhuman, that no one would ever think to look at it long enough to notice such a thing.

…

To a mind accustomed either to a predominantly psychological literary form, like the modern novel, or to a classical style of

regular and logical narrative development, the sequence of scenes in a play by Shakespeare is likely to appear capricious and arbitrary. Like the relations between the various episodes within an individual scene, the relations between scenes are often determined by other than narrative concerns, and we will have no difficulty following the logic of a Shakespearean play if we keep this in mind.

(Mark Rose, *Shakespearean Design*)

. . .

I renewed my driver's license just before my thirty-fifth birthday. I had originally received the license seven years earlier, when I moved to Oregon. I was in considerably better shape then, and clean-shaven. The person taking my picture had allowed me to keep my glasses on. Now, with a beard and a face showing the extra pounds of seven years of bad habits, I was asked to remove my glasses. The man behind the digital camera took my picture, and, just as I was about to leave, he asked me to please sit back down so that he could take another. I did so. He still looked concerned. Joking, I asked him, "What's the matter? Am I blurry today?" He said no, but the computer, comparing this new picture of me to the one taken seven years earlier, did not believe that I was me. My identity could not be confirmed. It would need further corroboration. He called for a supervisor. Who was I? What name should go on the license, if I was not me anymore? Could it still be considered a "renewal," if they determined that I was some other me?

. . .

Wallace Shawn, in *My Dinner with Andre*, says, "Heidegger said that if you were to experience your own being to the full you'd be experiencing the decay of that being toward death as part of your own experience."

…

The same day I watched the documentary *The Bridge* for a second time, this message showed up in several places on Facebook:

> PLEASE BE CAREFUL! . . . [sic]
>
> Some hackers have found something new. They take your profile picture and your name and create a new FB account. Then they ask your friends to add them. Your friends think it is you, so they accept. From that moment on they can say and post whatever they want under your name.
>
> Please DON'T ACCEPT a second friendship request from me, I have only ONE ACCOUNT.

I was watching *The Bridge* again because I had forgotten I had ever watched it to begin with. *The Bridge* is a documentary filmed over the span of a single year, about several people who committed or attempted to commit suicide by jumping off the Golden Gate Bridge; from the moment (0:03:07) when the white-haired man in the red cap climbs over the railing and the camera loses him halfway down, I couldn't help but watch, even after realizing I was rewatching it. It reminded me of the footage of September 11th, of men and women falling from the towers, of the dread I felt that morning, watching it. News outlets were later shamed, persuaded that to show such a thing was in bad taste. It was erased from their histories, left out of their retrospectives and their memorial programs. But it is what I remembered best about that morning. I remembered that I had actually had to sit down when I first saw people falling. I was standing in front of the television after listening to the message on my answering machine telling me to turn on the

television. On the screen, between news crawls telling me what I was seeing, there was smoke pouring out of one of the towers and the ash of a human being flitting through the air. I could not stand to see what I was seeing, so I sat.

I believe now that the dread I felt watching the news that morning, or, later, *The Bridge*, came from imagining myself in the place of the people I watched. I have a fear of heights, but this was much more than that—what I felt wasn't, after all, mere fear, but dread, the feeling people describe as a "sinking" feeling, an experience, at least in the word's archaic form, of awe or reverence. Not a matter of fight or flight, but of being completely and utterly helpless, unable to so much as move, as though one has lost all will.

What distinguished these experiences from fear, I think, had to do with a question they raised for me: What goes through one's head on the way down? If I search my memory for anything approaching the feeling of falling, I can think of two or three jumps or falls from very modest heights. In these memories, I recall a complete erasure of myself from the world until well after the moment of impact, when my self seems to return, from where I do not know. Does one lose consciousness the moment one steps off into air? I've only ever jumped from a single story, maybe two, maybe just slightly higher than two. Most recently, on the island of Kauai, from the top of Kipu Falls, perhaps twenty or twenty-five feet above the pool below. What if the fall were longer? What if there was not only the moment of erasure I had felt but also a moment of impact, of being brought back to oneself, *before* the final, physical impact, a realization in midair that one has entered a situation from which one cannot hope to escape, that everything that follows has been entirely removed from consciousness because no conscious thought can alter it? What does one think about then? Isn't that awe? I am reminded of the scene in *Raiders of the Lost Ark* when the ark is opened—the opening sequence of the movie was filmed at Kipu Falls. Indiana Jones's rival, Dr. René Belloq,

and the Nazis for whom he has acquired the ark look down into the opening. Something there catches one of the Nazis' eyes. The look on his face just before the skin melts off is the look I associate with awe: expectant, terrified, mindless. The only way to save oneself, as Jones somehow knows, is to close one's eyes to this awe-ful force, to obliterate oneself before it.

Trying to find the exact height of the falls for this book, I learned that, over a five-year period (including the year that I was there), five people had died making the same jump I had, and, as a result of those deaths, access to the falls has now been closed off. I can remember nothing about my own jump now, just the rush of water up my swimsuit and my nostrils as I sank, unbelievably fast, into the pool. I thought that I would never stop sinking, that I wouldn't be able to make it back to the surface before I needed a breath.

. . .

People will do anything, no matter how absurd, in order to avoid facing their own souls. They will practice Indian yoga and all its exercises, observe a strict regimen of diet, learn the literature of the whole world—all because they cannot get on with themselves and have not the slightest faith that anything useful could ever come out of their own souls. Thus the soul has gradually been turned into a Nazareth from which nothing good can come.
(Carl Jung, *Psychology and Alchemy*)

. . .

Rock-climber Mike Pont, interviewed by Garrett Soden for Soden's book *Falling*: "When you take a big fall . . . everything gets really quiet, and very crisp and clear in your mind. You're falling at whatever rate a human body falls, but it feels a lot slower. . . . I can picture it precisely, what it feels like." But he

10

does not say what he pictures, what it feels like.

. . .

The critic Robin Wood writes: "We do not see, and are never told, how [Stewart] got down from the gutter: there seems no possible way he *could* have got down. The effect is of having him, throughout the film, metaphorically suspended over a great abyss." Perhaps. But who is Madeleine Elster, a mystery even in Stewart's fantasy (which, in Wood's metaphorical formulation, is the rest of the film), to this man, Scottie Ferguson, on the verge of death? Will I, too, dream of a complete stranger when I pass, forgetting my life and all the people in it in order to construct a final escape out of the search for a figment of the imagination?

. . .

"I hope we will too."
"What?"
"Meet again sometime."
"We have."
(00:56:38)

. . .

Is this film, Alfred Hitchcock's *Vertigo*, ostensibly the story of a woman who dies three times, actually the story of a man who dies just once?

. . .

According to the clambering hypothesis, primates developed consciousness as a reaction to their weight relative to their environment. For a bonobo or a proboscis monkey, it doesn't much matter how sturdy the branch is it is hanging from or

reaching towards—the monkey is so light, most branches will support it, and so no calculation needs to be made. But for the larger primates, like orangutans, that same action, hanging from a branch or swinging to another branch, is greatly complicated by their body weight. Each move in the canopy is accompanied by a complex internal set of calculations. "Does it look like it will hold?" is a meaningless question because it does not include one crucial element: "me." "Does it look like it will hold *me*?" Falling out of a tree to one's death is a high price to pay for being ignorant of one's self. But if we do not know ourselves, we cannot know the consequences of our actions, cannot even have consequences or actions that are ours.

. . .

Falling is an "orientational metaphor," signifying a lack of control. Thus, to "fall down on the job" means to fail to do something one ought to have done. "Fail" and "fall" share a common origin, the Sanskrit *phálati*, which means "it bursts." "It bursts"?

. . .

Perhaps the greatest contradiction in our lives, the hardest to handle, is the knowledge "There was a time when I was not alive, and there will come a time when I am not alive." On one level, when you "step out of yourself" and see yourself as "just another human being," it makes complete sense. But on another level, perhaps a deeper level, personal nonexistence makes no sense at all. All that we know is embedded inside our minds, and for all that to be absent from the universe is not comprehensible. This is a basic undeniable problem of life. . . . When you try to imagine your own nonexistence, you have to try to jump out of yourself, by mapping yourself onto someone else. You fool yourself into believing that you can import an outsider's view of

yourself into you [and] though you may imagine that you have jumped out of yourself, you never can actually do so.
(Doug Hofstadter, *Godel, Escher, Bach*)

...

To portray your life in order would be absurd: I remember you at random. My brain resurrects you through stochastic details, like picking marbles out of a bag.
(Edouard Levé, *Suicide*)

...

"The reality is that we seldom define things by essence; more often, we give lists of properties. And this is why all the lists that define something through a nonfinite series of properties, even though apparently vertiginous, seem to be closer to the way in which, in everyday life . . . we define and recognize things. A representation by accumulation or series of properties presupposes not a dictionary, but a kind of encyclopedia—one which is never finished, and which the members of a given culture know and master, according to their competence, only in part." That is what Umberto Eco says, in his *Confessions of a Young Novelist.*

In *Flaubert, Joyce, Beckett: The Stoic Comedians*, Hugh Kenner writes that the Encyclopedia is an invention that "takes all that we know apart into little pieces, and then arranges those pieces so that they can be found one at a time. It is produced by a feat of organizing, not a feat of understanding." Thus Eco's "representation by accumulation" is a "feat of organizing, not a feat of understanding," which would seem a kind of diminution. Kenner makes his claim in the context of describing Flaubert's achievements as a novelist: Flaubert recognized in the novel a closed system and perfected it by considering every bit in light of all of the others. Both the novel and the Encyclopedia are,

after all, artifacts; they are controllable, artificial, and finite.

Kenner's capitalized Encyclopedia is historical—compiled by Denis Diderot, it existed at a particular point in time, was printed and had boundaries (endpapers, boards, a binding). The process that he describes, however, is ongoing and unfinished. The production of an encyclopedia understood as an atomization of knowledge is a potentially infinite process; considered point by point, the acquiring of knowledge is simply a variation on one of Zeno's paradoxes—each concept is really a collection of concepts, each of which can be explained as a collection of concepts, each of which can be explained as yet another collection of concepts, and so on. A book is an organization, finite; the process of composing a book is an attempt at understanding, infinite.

. . .

Nonlinear. Discontinuous. Collage-like. An assemblage.
Self evident enough to scarcely need Writer's say-so.

Obstinately cross-referential and of cryptic interconnective syntax.
Here perhaps less than self-evident to the less than attentive.
(David Markson, *This Is Not a Novel*)

. . .

Anyone whose goal is 'something higher' must expect someday to suffer vertigo. What is vertigo—fear of falling? No, vertigo is something other than fear of falling. It is the voice of the emptiness below us which tempts and lures us; it is the desire to fall, against which, terrified, we defend ourselves.
(Milan Kundera, *The Unbearable Lightness of Being*)

. . .

It is a cliché: "My whole life flashed in front of my eyes," we say. The dead will never be able to tell us what happened in the moment of death, so we, the living, can speak only of the near-death experience. Still, the cliché seems questionable: What "eyes"? If it is just a "flash," how does it register, and how much of it registers? Whether we register it or not, how much of our lives can pass in a "flash"? Is the flash actually the experience of relief, like the feeling of first scratching an itch, relief that we have reached the point where we can finally describe our life as whole, complete, finished?

Our experience of time is plastic, that much we do know. We have all felt it change: a few seconds seem to take hours to pass; hours pass in what feels like seconds. That, too, is a cliché. The cliché of the moment of death or near-death has its complement in this strange, subjective pliability of time. Scottie's fall from the rooftop may have taken just a little over two hours, the movie's running time, that instant for him (and for us) like entering a wormhole somehow, and at the end, at the bottom, just before the moment of impact, we have a view from a great height, looking down but not seeing. Why not? Can anyone really anticipate what the journey will be like or how long it may seem to take? A fall of seven or eight stories may as well seem like two hours, two years. It therefore seems just possible—doesn't it?—that we are all already in that moment of passing, that our lives flash before our eyes because the lives we are living only *seem* to pass at the speed we have accustomed ourselves to, that we are all living in a kind of freefall, that our experience of life is really only an experience of the moment of death, that we are all already on the point of dying, and that this is why we pass out of existence in an instant. One moment alive, the next, not. A thread is cut. It is not only Scottie hanging from that gutter. We are there, too.

...

Although, properly speaking, we open the film with a stranger, a woman who will never again appear in it, neither Midge nor Madeleine nor Judy, a woman who is not credited (though appearing underneath the credits) and who seems to have nothing to do with what follows.

…

Saul Bass, on the (beginning of the) title sequence: "Here's a woman made into what a man wants her to be. She is put together piece by piece and I tried to suggest something of this as the fragmentation of the mind of Judy."

…

The ultimate abyss is not a physical abyss but the abyss of the death of another person. It's what philosophers describe as the "night of the world." Like when you see another person, into his or her eyes, you see the abyss. That's the true spiral which is drawing us inward.
(Slavoj Zizek, *The Pervert's Guide to Cinema* (film))

…

Bass's shot of the eye from which the spiral ascends during the title sequence mirrors or mimics a shot (or, really (appropriately), *two* shots) in Maya Deren's "Meshes of the Afternoon," of a woman's eye at an identical distance from the camera. Given that "Meshes" was filmed in 1943 (*Vertigo* was released in 1958), there is no reason not to think that Bass knew of and was perhaps even quoting from Deren's film, in which a woman is first doubled, then trebled, and, by the end, either commits suicide or is murdered by the man she lives with.

…

I discovered this quotation while watching "Meshes of the Afternoon" on YouTube; below the video itself was the usual embarrassing thread of commentary from the site's "users" but also this quote, from Deren: "The task of cinema or any other art form is not to translate hidden messages of the unconscious soul into art but to experiment with the effects contemporary technical devices have on nerves, minds, or souls."

…

The disturbing figure in "Meshes of the Afternoon," the black-cloaked, mirror-faced figure that the woman (Deren) chases three times, is not nearly so disturbing as the woman (again, Deren) herself, appearing in one particularly jarring scene with mirror-ball eyes bulging out of her sockets. But isn't that a nun's habit the mirror-faced figure is wearing? Bass, it seems to me, may not have been the only one quoting Deren in *Vertigo*.

…

We say the eye is the window of the soul, but what if there is no soul behind the eye, what if the eye is a crack through which we can perceive just the abyss of a netherworld?
(Zizek, *The Pervert's Guide to Cinema*)

…

Psychologists distinguish between remembering something—which is to recall a piece of information along with contextual details, such as where, when and how one learned it—and knowing something, which is feeling that something is true without remembering how one learned the information.
(Ferris Jabr, "The Reading Brain in the Digital Age")

…

People suffering nervous breakdowns often do a lot of research, to find explanations for what they are undergoing. The research, of course, fails.
(Philip K. Dick, *VALIS*)

...

When told the script for what would become 1940's *Foreign Correspondent* wasn't "logical," Hitchcock is supposed to have replied: "I'm not interested in logic, I'm interested in effect. If the audience ever thinks about logic, it's on their way home after the show, and by that time, you see, they've paid for their tickets."

...

Chaos is merely order waiting to be deciphered.
(Jose Saramago, *The Double*)

...

At the end of a television show about a photo of an unidentified man falling from the World Trade Center's north tower on September 11th, the mother of the man the filmmakers have identified as the man in the photo says, "I hope we're not trying to figure out who he is, and more trying to figure out who we are, through watching that."

...

I had been given a job at a small college about fifty miles south of Portland as a visiting Assistant Professor of Creative Writing, a seemingly prestigious but actually precarious position, and one I had won through what I had to feel was a kind of mistaken identity. I had published a book called *Critique of Pure Reason*,

a collection of essays and fictions that never attracted even a single review; the hiring committee, tasked with full teaching loads and their own research, had no doubt hired me on the strength of its title and a few laudatory words from one of my future colleagues, a kind man who had not read the book either.

The appointment was for three years, but, because I'd begun in the spring rather than the fall, and because the college issued contracts on an annual basis, I was told, it was theoretically renewable for up to three and a half years. Instead, the college reversed direction and declined to renew my contract after just two and a half years. (Could it be that they'd found me out? Read the book?) Though I was never notified of the fact, it became clear that I would be out of a job at the beginning of the summer, and that whatever else I would be doing that fall I would not be returning to the college. I was, as a result, finding it difficult to focus on the book I was supposed to be working on, a study of the film *Vertigo*. Because of the nature of the academic year, though (I would have had the next three months off in any case, and would be paid as though I were working), I felt the burden of this new uncertainty as a rearrangement or duplication of my seasons rather than a milestone or a capstone or even just a disappointment: my summer had, in an instant, had another summer tacked on to its end, had suddenly become a sentence without a period. Looking for a job in that moment seemed somehow like eating a second lunch today because you had been told that, a week from now, you would have to miss lunch.

I had planned to make some progress on the book with my summer (despite not having a strong sense of what that would mean other than reading whatever came to hand and taking notes), but I now found I could not, no matter how much time I devoted to it. My anxiety about the thing, I think, stemmed from feeling no quickening, no critical mass or momentum as the project entered its own summer. When I came upon something that seemed worth copying out into my notes, I did

so. But days—whole weeks, even—would pass without adding a single word to the manuscript. Once I had begun, I thought, I could finish, but I could not begin. I had no idea what was in the notes I was taking, and though I added these notes to the end of the document, I found my narrative stuck before the beginning of the film proper, in a sequence that, if the story had never become a film and been left a novel, would never have existed at all—it did not need to because it was not part of the narrative's present action, and because all of the information it communicates is neatly summarized in the scene immediately following it, in Midge's apartment.

This short introduction or prologue seems to stand outside of the *Vertigo* of most people's memories: Who remembers the chase on the rooftops, really, or even the title sequence? Saul Bass's *Vertigo* was not Saul Bass's *North by Northwest*, and Bernhard Herrmann's *Vertigo*, while undoubtedly memorable, was still not Bernhard Herrmann's *Psycho*. People who remember at all remember a spiral—the one from the poster—or a warbling melody—repeated throughout—not the close-ups of the woman's face or the careful ebb and crescendo of that opening theme. For most people, not even the moment when Scottie hangs from the gutter is part of their memory of the movie—it begins instead in Midge's apartment, with its vague echoes of the more famous set of Jeff's Village apartment in *Rear Window* (Jimmy Stewart's presence, perhaps, and the fact that both of his characters are convalescent; that looming window and the world visible through it; the desexualized female). And just before the moment that scene opened, my book seemed to have closed. I could not manage to press on.

Though conscious I would be out of a job—was already out of a job—I was not careful with my money and could not stay at home with my notes. While my wife was at work, I took the bus to Powell's and bought books I would not read, just for something to do. I went to the café around the corner from our apartment for coffee rather than making it myself. I went to

the movies, even when there was nothing I particularly wanted to see. I took long drives out to the coast and back. I went to Pittock Mansion and the reservoir at Mount Tabor. I had no place to be and no reason to be any place.

…

Hitchcock: "We must bear in mind that, fundamentally, there's no such thing as color; in fact, there's no such thing as a face, because until the light hits it, it is nonexistent. After all, one of the first things I learned in the School of Art was that there is no such thing as a line; there's only the light and the shade."

…

Writers who worked on *Vertigo*:
Pierre Boileau (original story)
Thomas Narcejac (original story)
Norman Denny (Hitchcock's English translator of *D'Entre les Morts*)
Alfred Hitchcock (throughout pre-production, production)
Alma Hitchcock (throughout pre-production, production)
Maxwell Anderson (first treatment, June-July, 1956)
Angus MacPhail (second treatment/"structural layout" Aug.-Sept., 1956)
Alec Coppel (continuity ("numbered paragraphs with no dialogue"), fall, 1956)
Sam Taylor (script, 1956-1957)

…

Hitchcock, at the German film studio Ufa in 1924 to film *The Blackguard*, visited the set of F. W. Murnau's *Der letzte Mann*, where Murnau had a real train car set up in front of some small wooden cars, and then another real train car far off in the background, with extras getting out of it. "What you see on

the set does not matter. All that matters is what you see on the screen," Murnau is supposed to have said. Back on the set of *The Blackguard*, Hitchcock put dwarves in the background of a crowd scene, to give it a sense of perspective.

. . .

In battle, in forest, at the precipice in the mountains,
On the dark great sea, in the midst of javelins and arrows,
In sleep, in confusion, in the depths of shame,
The good deeds a man has done before defend him.
(*Bhagavad-Gita*)

. . .

Because my own life lacked structure, I looked for it in *Vertigo*. Being a film about doubles, one expects *Vertigo* to have two parts, more or less equal if not exactly identical, but, as I watched it and rewatched it, I started to think that the movie's shape was more complex.

The double is synonymous with the uncanny: Freud's example of his idea of the *unheimlich* is a man catching his reflection in a mirror and believing it to be someone else. Clearly, I thought, *Vertigo* has an uncanny aspect—the half of the film before Madeleine's "death" meets the half after Madeleine's death in Scottie's mid-film delusion/vision/dream as the self meets its perceived double in a mirror.

But now I saw this aspect in a different light, expressed in the film's two *divisions*, not in the film's two *parts*. In fact, I came to believe that the film had three parts. The first: before the police officer's death, very brief. The second: from the scene in Midge's apartment to the inquest and Scottie's confinement. And the last: from Scottie's release from the hospital to Judy's death. *Three* parts—the self meeting its double in the mirror, the double, and the mirror itself, an element that needed to be

considered, I thought. The mirror is where the self loses its integrity—one looks into the mirror and sees one's self, but this self is experienced as Other (for instance, one does not look *out of* its eyes but instead *into* them).

One detail in particular convinced me of this structure: the corset that Scottie complains of in the first scene in Midge's apartment. I had always ignored it before. It's small talk, as almost nothing else is in *Vertigo*—*Vertigo* is a relatively quiet film, and when its characters speak, they speak in double entendres. Even after I started to think about it, I couldn't assign it any particular significance, I merely suspected it hid some greater meaning. A corset seemed like a triviality, a minor therapy for a fall that had killed another man. So went my thinking—either Scottie had been rescued from the rooftop or he hadn't. Black or white. This or that. If he had, there was no division there, no break in the timeline; we go from the gutter to Midge's apartment with no significant jump forward in time. If he hadn't been rescued, Wood was right: the whole film takes place in that last moment before he falls to his death. But now I began to think that the corset seemed to argue for another possibility, a botched or difficult rescue and a lengthy rehabilitation following it.

We later learn that a year passes between Madeleine's death and Scottie's discovery of Judy. Might there not have been a similar period between the death of the officer and this scene in Midge's apartment? Long days and weeks spent in traction, full-body casts and physical therapies, restricted movement and unending pain, all of it happening off-screen in the blink of an eye? Something about the dissolve between scenes had always convinced me that barely any time had passed, but now I reconsidered. Why assume a short recovery or no recovery at all? It does seem, given the dialogue between Scottie and Midge, that Scottie's position (his lack thereof, I mean; his unemployment, his "wandering") is a new thing, a recent thing, but one can't be certain of that—it may only be new to Midge. One assumes that Scottie and Midge are close friends, but this need not be

true—when, after Madeleine's death and one final appearance in the sanitarium, Midge disappears entirely from the film, Scottie seems more or less unaffected by her absence. Perhaps it is that Scottie's retirement has given him the time to reconnect with old friends he hasn't seen since college (which, given his evident age, was quite some time ago). Perhaps Scottie and Midge ran into each other because of the corset. Midge does the illustrations for some sort of apparel company—maybe she works for the place Scottie bought his corset from. Maybe they met in the lobby or at the entrance, *Midge, is that you? How have you been? Come up to my place tomorrow, Johnny-O, we'll have a drink and talk about the gay old Bohemian days.* The only clues to just how much time has passed off-screen are buried deep within the dialogue.

If there are three parts, it is the film's two divisions that are its structural doubles. One is the beginning of Scottie's acrophobia, the other is (supposedly) the end of it. This gives us, separate from the two parts dealing with Madeleine/Judy, a third part, the very first scene, before the acrophobia and before Madeleine. More interestingly, if we take that scene, the scene designated in the script as the "San Francisco Roof Tops" scene, as its own part, the other two parts are more balanced; they no longer seem quite so lopsided in favor of the first "half" of the film (which is longer by twenty-five minutes than the second half), because there is no first half or second half, only first part, second part, third part. These three parts are by no means equal, but the two that had seemed curiously unequal—the only two parts of the movie, as I had previously thought—seem to be much closer to equal than before.

...

Accustom the public to divining the whole of which they are given only a part. Make people diviners. Make them desire it. (Robert Bresson, *Notes on the Cinematographer*)

…

The hidden harmony is better than the visible.
(Heraclitus, *Fragments*)

…

In the book, *D'Entre les Morts*, there are only two parts. Quite literally: There is Part One, made up of six chapters, and Part Two, also made up of six chapters. The first part is about 90 pages, whereas the second part is only about 75 pages. What is it about the second part of this story that we all seem to want to avoid?

…

The spirals in Saul Bass's title sequence, clearly meant to evoke the eye of the woman from whom they first appear to swirl out of, also quite clearly resemble a vagina.

…

How did people erase themselves like this? he wondered.
(Adam Ross, *Mr. Peanut*)

…

Francois Truffaut: *Vertigo* is taken from the Boileau-Narcejac novel *D'Entre les Morts*, which was especially written so that you might do a screen version of it.
Alfred Hitchcock: No, it wasn't. The novel was out before we acquired the rights to the property.
FT: Just the same, that book was especially written for you. . . . As a matter of fact, Boileau and Narcejac did four or five novels on that theory. When they found out that you had been

interested in acquiring the rights to *Diabolique*, they went to work and wrote *D'Entre les Morts*, which Paramount bought for you.
(Francois Truffaut, *Hitchcock*)

...

Throughout their partnership, [Boileau and Narcejac] produced novels that were puzzles requiring close attention, each combining startling twists of plot with characters at their wit's end, grasping at any opportunity to find meaning.
(Auiler, *Vertigo*)

...

Hitchcock: "[Music] makes it possible to express the unspoken. For instance, two people may be saying one thing and thinking something very different. Their looks match their words, not their thoughts. They may be talking politely and quietly, but there may be a storm coming. You cannot express the mood of the situation by word and photograph. But I think you could get at the underlying idea with the right background music."

...

It could be said of me that in this book I have only made up a bunch of other men's flowers, providing of my own only the string that ties them together.
(Michel de Montaigne, *Essais*)

...

An old thing becomes new if you detach it from what usually surrounds it.
(Bresson, *Notes*)

...

Research was Hitchcock's detective work. . . . He relished the process of 'putting himself through it' in preproduction, scouting out real-life settings and real-life counterparts for the characters. He compiled notes and sketches and photographs partly for authenticity . . . but also as a springboard for his imagination. He always tinkered with the reality.
(Patrick McGilligan, *Alfred Hitchcock*)

. . .

Are the cameras shooting the footage for *The Bridge* sited at Old Fort Point? The very spot Madeleine chooses to jump into the Bay from?

. . .

At the beginning, I think of endings.
(Kate Zambreno, *Heroines*)

. . .

The only true purpose of a good list is to convey the idea of infinity and the vertigo of the *etcetera*.
(Umberto Eco, *Confessions of a Young Novelist*)

. . .

How should we understand Saul Bass's spiral descending into the *woman's* eye at the end of the title sequence? A hint of who will suffer—not Scottie—from the vertigo of the title? Or is it more surprising that, instead of descending into the woman's eye, it doesn't emanate out from it (as it does at the beginning of the sequence)?

...

Not the work I shall produce, but the real Me I shall achieve, that is the consideration.
(D. H. Lawrence)

...

There are people who like to complete all the reading, all the research, and then, when they have read everything that there is to read, when they have attained complete mastery of the material, *then* and only then do they sit down to write it up. Not me. Once I know enough about a subject to begin writing about it I lose interest in it immediately.
(Geoff Dyer, *Out of Sheer Rage*)

...

At the urging of my agent, I had been looking for a "more personal" response to Alfred Hitchcock's *Vertigo* for many months when, in September of 2012, *Sight & Sound*'s decennial poll named it the best film of all time, forty votes ahead of *Citizen Kane*, which had held that title for fifty years. Suddenly, there were a hundred pitches for books about *Vertigo*, two hundred, more. I was relieved. As I say, I had been looking for an approach already for some time and finding that nearly every frame of the film had been pumped full of meaning and carefully explained by its critics again and again. What could I have added? Now, I could instead give up, remain silent.

I had been perfectly content to watch the film over and over, to read books about the film's production, books of film theory and literary theory that mentioned it, biographies of Hitchcock, Novak, and Stewart—I had always been more of a reader than a writer. I copied out little snippets of interesting text, more notes than I ever would have read over, all without producing a

single word of my own. In the margins, I wrote comments like this one, my lame attempts at the "personal" response my agent seemed to want but which never came together as a single story. I wondered, in an email to my agent (perhaps as a way of avoiding going through all of these notes and making something whole out of them, I emailed him, telling him I couldn't get through all of my notes, couldn't make something whole out of them) if this collection of quotes from other books and my marginal notes might not be a more convincing and ultimately more worthwhile book than the book they were intended to produce; it wouldn't really be a personal response to the film, but I didn't see that as a drawback. It would be a kind of critic's notebook, an assemblage, a commonplace book, but also an homage and an acknowledgement. My agent replied that editors would be unmoved. He told me to get back to work.

He also told me I was being naïve. The only reason he had taken the book on was that it was sold already. It was a variable that was not a variable at all, a thing that could be counted upon. There would be people like me who would buy it, and there would be many people like me—just think of everyone who had seen *Vertigo*. I had only to "tell my part of the story," like varnishing a chair from Ikea and telling people I had made it. As a result of the poll, though, other writers—more enterprising than I was and less bothered by the idea of "value"—were now picking up the subject. There would be ten new books on the film by the end of the year. The moment, he told me, would very soon pass, and every day I delayed, the book was less and less likely to garner any serious attention—by which he meant "sell well." It would not make it to the shelves; it would begin and end in a bargain bin somewhere. This did not boost my confidence in what I was doing. I had already been wondering what I had to contribute to the study of *Vertigo*, and now I felt sure the answer was nothing.

. . .

Madeleine E.

This is a book about a man and his girlfriend, who live together. She has taken a week off work, but doesn't tell anyone why. She is going to have an abortion. She will need the rest of the week to recover. She would have taken more time off work, but she needs to work because the man is unemployed, and she supports them both, and she doesn't make much to begin with. The man sits in the waiting room of the clinic with the girlfriend's mother. The man feels as though something has caught up with him. He can't imagine how things can get any worse, but he also can't imagine that things will get better. He will always feel this wretched, he thinks. Nothing good will ever happen again. We do not learn what the mother or the girlfriend are thinking or feeling, but, really, what could be more difficult for either one than to find themselves in this situation?

As soon as the nurses have left her alone to rest, the girlfriend gets up from the operating table. She leaves the room she has had the procedure in and goes across the hall to where she left her clothes. She dresses and walks out into the waiting room. Alright, she says, let's go. It has all been so quick, the nurses haven't even noticed she's not in the operating room anymore. The man and the mother don't know the girlfriend isn't supposed to be up and moving. The girlfriend faints on her way to the elevators, even while being held up by the man and her mother, and she sits on the floor next to the elevator for half an hour before she can finally make it downstairs and into the car. The man feels guilty about the whole thing. Not what happened after, but what happened before. Even though it was a decision they both made, he feels responsible. He even feels guilty about feeling responsible; it's self-centered, he thinks. The last thing he would ever do is address the subject head-on. He avoids talking about it and tries to avoid even thinking about it. Forever after, the man can't imagine the child that might have been, but he never forgets that it doesn't exist. They never speak

about it.

The man and his girlfriend had arguments before the abortion. After, they never argue. Not that they never disagree, but they don't argue. Instead, both of them go silent. In part, this is because each feels like they have inflicted some injury on the other, something irreparable. They are careful not to make things worse. Not only was there the procedure and all the guilt surrounding it, but also there is the man's accident, or what they call his accident. Two months after the abortion, things got so bad between them, the girlfriend left. She was gone for almost a month. Though he told no one, the man attempted suicide while she was gone. One day, he was supposed to meet up with an old friend, but he didn't show up. The old friend called the girlfriend to see if she knew where he was. The girlfriend was the one who discovered him. He suffered permanent brain damage as a result of not getting enough blood to his brain for several hours. Now, he is a step slower than he used to be. He gets frustrated much more easily than he did before, but he doesn't forget what he has done, and he tries not to take it out on the girlfriend. The girlfriend feels so bad she moves back in with him.

There are a few blank pages. We come back to these characters, but we can't be sure where in time we are. Something has changed. The man and his girlfriend are walking in the park with a little girl. We learn that the girl is not theirs. It is the little girl's fourth birthday, and she's having a party in the park next to their apartment, so, when she has to go to the bathroom, they take her back to their apartment. She is the girlfriend's friend's daughter. The girlfriend and the girl's mother are not as close as they used to be—jobs and motherhood got in the way. They don't dislike each other, there was no big fight, they just never see each other anymore. When they were younger, still in high school, people said they looked alike. They were often asked if they were sisters—not twins, but sisters. While they are in the apartment, the little girl noticed a picture of the girlfriend, age five, stuck to the refrigerator with a magnet in the shape of a

horse. The girlfriend took it down. See, she says to the little girl, See how much we look alike? The little girl nods: she looks more like the girlfriend than her own mother. Later, when they leave the party, the girlfriend starts crying. The man is confused, but he holds her, and then, in silence, they both get ready for bed. Later, much, much later, when he has no reason to remember this, he does remember it, and he figures it out.

. . .

I watched the film until the film itself became a kind of blindness. (G.C. Waldrep, "D.W. Griffith at Gettsyburg")

. . .

As reported by Michael Wilding, Hitchcock said, "The secret of suspense . . . is never to begin a scene at the beginning and never let it go on to the end."

. . .

The first version of the script, written by Maxwell Anderson, was called *Darkling, I Listen*. In it, Scottie's acrophobia first manifests itself during a sequence on the Golden Gate Bridge. At the end, Judy jumps from the Bridge. If, once retitled and rewritten, she had fallen from the gutter?

Part One

...

Madeleine E.

Coming out of the forest onto a slope of scree during a hike with my wife, the trailhead—and our car in the gravel turnoff next to it—was directly in front of us, but far, far below. The trail had gone steadily uphill, looping past a lake and winding through trees so thick there were no plants growing under the canopy, just pine needles, dirt, and a few rocks. Because the lake was in a valley on the other side of the mountain we had been climbing, it seemed like we had not climbed up the mountain at all, only pivoted around it. But then the terrain grew steeper a mile and a half in and started to switchback, finally opening out onto this slope, cutting back through the forest, and then alternating between the forest and the rocky slope on the way up to the summit. Each time we came back to the rocks we were higher up, but, to have traveled so far along the trail—each switchback perhaps a quarter of a mile—we still did not seem to have gone very far up the mountain. Looking out and down, I felt that strange sensation of having to guard myself from something I knew I would never do: not to jump, not with any thought of falling, just a strange pull to go to the edge and then pass beyond it, into the air, to run forward into space. My fear of heights, I thought, was a recognition of this impulse in myself, my curious fascination with edges. When I looked out from the edge, I felt as though my feet were being pulled into what I was looking at, as though the ground were falling away beneath me, as though the edge was getting closer and closer even though I was not moving towards it. Something in me was drawn to the horizon.

It occurred to me then that the care we normally exercise in space necessarily involves the curvature of another dimension: time. The default way down is also the fastest. Gravity obeys parsimony. My wife and I could arrive at our car in an instant,

accelerating to terminal velocity at 9.81 meters per second per second, but it would take us hours to reach the car by trail. In looking down from a great height, I was in fact looking into the future, undergoing a kind of time travel. Is the fear of heights also a fear of the future, of knowing what is to come before it has come? A fear of inevitability? In order to stave things off, I crawled through space like someone on his way to an execution.

We generally experience travel along the horizon as a reprieve from aging. "Go West, young man!" Horace Greeley had said, as if to move out along the sun's path was to slow or even stop what that transit signifies. Such travel, in my experience, always seems interminable, like a day that never ends. One looks out of the car window or the train window and sees the landscape and the landscape never changes or else seems to be continually refreshed, replicated like a cheaply-made cartoon's background, the bush one has just passed seeming like the bush one passed the minute before, the ranks of telephone poles maddeningly regular, the fields, even the hills no more than ghosts of those one has already seen. But vertical travel—a fall—takes place so quickly and so definitively we can hardly remember the experience. Once, we were there. Now, we are here. There is only a feeling in the pit of our stomach to mark the stretch between; there is almost no sense of time passing. We travel through space but we fall through time.

…

Love is so short, forgetting is so long.
(Pablo Neruda, "Tonight I can write")

…

The famous "vertigo effect" of *Vertigo* was accomplished by simultaneously tracking back (moving the camera away from the subject) and zooming in. "When Joan Fontaine fainted at the

inquest in *Rebecca*," Hitchcock recalled, "I wanted to show how she felt that everything was moving far away from her before she toppled over. I always remember one night at the Chelsea Arts Ball at Albert Hall in London when I got terribly drunk and I had the sensation that everything was going far away from me. I tried to get that into *Rebecca*, but they couldn't do it. The viewpoint must be fixed, you see, while the perspective is changed as it stretches lengthwise. I thought about the problem for fifteen years. By the time we got to *Vertigo*, we solved it by using the dolly and zoom simultaneously." François Truffaut writes, "The reason why so many brilliant or very talented men have failed in their attempts at directing is that only a mind in which the analytic and the synthetic are simultaneously at work can make its way out of the maze of snares inherent in the fragmentation of the shooting, the cutting, and the montage of a film. To a director, the greatest danger of all is that in the course of making his film he may lose control of it." Viewpoint and perspective; dolly and zoom; the analytic and the synthetic; the detail and the whole. Truffaut limited his claim to directors and film, but it seems to me that one could easily say the same thing about writers, artists, and craftsmen and their labors. Or about husbands and marriages.

...

Robin Wood says (and then reaffirms in his "Endnotes for Earlier Editions") that when Scottie looks down from the stepstool in Midge's apartment, he sees the same alleyway into which the policeman has fallen to his death. Does Scottie hang from Midge's gutter in the prologue, then, or perhaps from across the way? Does he, in fact, hang just outside Midge's window? (Does this give us a clue as to how he might have gotten down?) Spatially, this seems impossible. And watching it myself, I really can't see the similarity Wood must have seen, unless perhaps we are now meant to be on the opposite side of that alley in

Midge's apartment. It isn't merely that the light has changed (it has, from late dusk—almost evening but not quite, the light tinted blue, indicating that the sun has not yet completely set (or that the filmmaker is shooting day for night)—to the bright light of noon or shortly before, as though the movie was told in real time rather than the accelerated time it seems to be occupying), but also that there are several fire escapes in Midge's alleyway that I don't see at the beginning of the film. There, the buildings fall straight downward without interruption—as does the policeman. The angle at which the camera is set, too, is different, though this might go towards proving Wood's point rather than refuting it, if the camera's angle is meant to cover up the similarity. And look at Midge's near-panoramic view; for Scottie's leap (the policeman's leap, the pursued man's leap) from one building to another to have been at all feasible, this window ought to be facing a wall. What can Wood possibly mean, then? That Scottie *believes* this to be the same alley? That he *perceives* it as the same alley?

For all of the difficulties presented in taking such a statement literally, Wood's reader is never given any reason to doubt that it is meant to be taken literally. And, if only as a thought experiment, it is more interesting to take Wood at his word: This is the same alley. The policeman has fallen from the roof of Midge's building. Scottie has hung from its gutter. The tragedy (perhaps also the rescue) takes place right outside, and, when Scottie looks down from the stepstool, he sees what he sees when looking down from the gutter. He is revisiting the scene of a crime. Because doesn't that then retroactively put Midge in Scottie's (future) position (at Mission San Juan Bautista) with regards to the policeman/Madeleine? Unaware of what is happening above, she hears a cry and looks out her window just in time to see a body falling past. Was that . . . ? Can that possibly have been . . . ? We can imagine her then rushing to the window, looking down to the alley just as Scottie will later (that is, now, in this scene) look down from the very place she is

standing, from the slightly-higher vantage of her stepstool, just as Scottie will (later still) look down from the tower window to the tiles of the roof of the Mission San Juan Bautista. Below, in place of Madeleine Elster's body, the policeman's. In place of Judy Barton running up the stairs to the top of the tower, the pursued man crossing the rooftops. In place of Gavin Elster tossing his wife's body from the tower, Scottie reaching out to the policeman and watching him go over. The policeman become Madeleine. Midge become Scottie. Scottie become Elster. Has Midge tried to make someone over, too, or fallen in love with the wrong person? Undoubtedly, she has. Is the policeman, like Judy's Madeleine, a fake? Who has actually fallen? What would be Scottie's motive in getting rid of the policeman, or in seeming to get rid of him? Who or what is actually being sacrificed?

…

We become unpleasant to ourselves the moment we gain / some distance / from what we were.
(Martha Ronk, *Vertigo*)

…

Not that I did this often, but on those occasions when I wanted to see if anyone was selling a used copy of *Critique of Pure Reason*, the book I had spent my early thirties writing (intending to, I guess, inflate my ego if the price had climbed from $1.59 to $1.95; or, if the price had gone down instead, to feel sorry for myself, having passed into obscurity without ever really having climbed up out of it), that book was always the only thing listed under my name and was always alone on "Amazon's Gabriel Blackwell Page." But now the elevator on the right side of the browser's window had shrunk to half its usual size and there was at least one more listing below the one for *Critique*. I scrolled down, expecting to find a copy of a journal I had appeared in

but instead found two more entries, books, complete with listing pages of their own. The first was called *Shadow Man* and the second was called *The Natural Dissolution of Fleeting-Improvised-Men*. Both were out of print and unavailable. Neither had so much as a single review on the site, but, when I searched elsewhere, I found that they had attracted a very modest amount of attention when first published—as much, it seemed, for their manner of treating their subjects as for their dubious literary qualities. Google came up with seven reviews, all in obscure magazines; one of them mentioned *Critique of Pure Reason*. And the bio on the listing page for *The Natural Dissolution of Fleeting-Improvised-Men*, with its uncanny resemblance to my own bio, raised even more questions: Who could have done this? And why "Gabriel Blackwell"? Why pick on me, I thought? Who was I? Why had this happened to me?

…

Is Midge, then, Wood's "great abyss"?

…

There is half a woman's head (blonde) hanging on Midge's wall, next to the window but facing away from it, the same direction Carlotta faces in the portrait. In the crossfade at 00:38:00, Madeleine, in profile, faces the opposite direction.

…

When we see a face, it's basically always the half of it. A subject is a partial something—a face, something we see—behind it, there is a void, a nothingness. And of course we spontaneously tend to fill in that nothingness with our fantasies, about the wealth of human personality and so on and so on. To see what is lacking in reality, to see it as that—there, you see subjectivity.

To confront subjectivity means to confront femininity. Woman is the subject; masculinity is a fake. Masculinity is an escape from the most radical, nightmarish dimension of subjectivity.
(Zizek, *The Pervert's Guide to Cinema* (film))

…

This forgetting or not noticing is an authentic and integral part of watching any film—this book is an account of watchings, rememberings, misrememberings, and forgettings; it is not the record of a dissection.
(Geoff Dyer, *Zona*)

…

The writing of novels, I think, is so beside the point, isn't it? One writes novels to write the author of the novel.
(Michael Martone, *Four for a Quarter*)

…

A book is the writer's secret life, the dark twin of a man: you can't reconcile them.
(William Faulkner, *Mosquitoes*)

…

Look in the mirror. That's you and not you, after all, because the person in your mind *isn't* the person in the world. And if you don't know this already, you will.
(Ross, *Mr. Peanut*)

…

Even when we attempt to be natural, we are often imitating

what we regard as natural, which often amounts to what art has taught us to regard as nature.
(Wendy Doniger, *The Woman Who Pretended to Be Who She Was*)

…

The only things that one can use in fiction are the things that one has ceased to use in fact.
(Oscar Wilde, *The Picture of Dorian Gray*)

…

The view from Midge's window is of Russian Hill; later in the film, after the scene in the Argosy Bookshop, Scottie drops Midge off at her apartment at the corner of Union and Montgomery, on Telegraph Hill. In the opening sequence, Coit Tower (which is on Telegraph Hill) can clearly be seen in the background as the three men leap from rooftop to rooftop. Later, in the scene following Madeleine's suicide attempt at Fort Point, we see the view from Scottie's apartment, facing Telegraph Hill, with a similar view of Coit Tower. Thus, contrary to Wood's assertion, if at the beginning of the film Scottie is hanging from the gutter of any building that will subsequently play a part in *Vertigo*, it would seem that, rather than Midge's apartment, it is his own.

…

And how is it that Scottie is a man of "independent means"? Police aren't typically so well paid. Elster, too, in the scene in his office—"As long as I have to work at it"—is a man of independent means, though perhaps only formerly. Or is what he says true? Does he really have to work at it? Clearly, neither of these men are without a past.

…

A rich man, a powerful man.
(00:34:27)

…

Let me take care of you, Judy.
(01:44:05)

…

Scottie is not only corseted in Midge's apartment, he also carries a cane (though he doesn't use it there, except to gesture with). Anyone seeing him on the street that day would have seen a man with a cane, a man with a rigid posture and a (slightly) different figure; the following day, when the corset comes off, however, his posture will change and so will his figure. He will no longer carry a cane. It is as though in this scene in Midge's apartment—and apparently throughout his (first) recovery—he is in disguise. But he is disguised as himself. In this, he prefigures Judy's Madeleine (and perhaps Judy's Judy): a person with an uncanny resemblance to another person (who is, in reality, that person), but with a different carriage and bearing, and with a distinguishing feature others will be sure to notice (for Scottie, the cane; for Judy, the blonde hair). One can imagine another one of Scottie's "college chums" running into him at Ernie's and telling him, "You know, you look just like a man I once knew. Good old Scottie Ferguson. Wonder whatever happened to him."

…

"Gabriel Blackwell is the author of *Shadow Man*. He lives in Portland, Oregon, where he is at work on his next book, *Madeleine E.*, a study of Alfred Hitchcock's *Vertigo*."

43

. . .

If one painted more forgeries than one's own paintings, wouldn't the forgeries become more natural, more real, more genuine to oneself, even, than one's own painting? Wouldn't the effort finally go out of it and the work become second nature?
(Patricia Highsmith, *Ripley Under Ground*)

. . .

Succeeding the painting the plagiarist no longer bears with him passions, humors, feelings, impressions, but rather this immense encyclopedia from which he draws.
(Sherrie Levine)

. . .

My readers, who may at first be apt to consider Quotation as downright pedantry, will be surprised when I assure them that next to the simple imitation of sounds and gestures, Quotation is the most natural and most frequent habitude of human nature.
(James Boswell, "The Hypochondriack")

. . .

As Pablo once remarked, when you make a thing, it is so complicated making it that it is bound to be ugly, but those that do it after you they don't have to worry about making it and they can make it pretty, and so everybody can like it when the others make it.
(Gertrude Stein, *The Autobiography of Alice B. Toklas*)

. . .

How else can one write but of those things which one doesn't

know, or knows badly? It is precisely there that we imagine having something to say. We write only at the frontiers of our knowledge, at the border which separates our knowledge from our ignorance and transforms the one into the other. Only in this manner are we resolved to write. To satisfy ignorance is to put off writing until tomorrow—or rather, to make it impossible.
(Gilles Deleuze, *Difference and Repetition*)

…

There was a duplication of myself involved, perhaps even a triplication.

There was I who was writing. There was I whom I could remember. And there was I of whom I wrote, the protagonist of the story.

The difference between factual truth and imaginative truth was constantly on my mind.

Memory was still fundamental, and I had daily reminders of its fallibility. I learnt, for instance, that memory itself did not present a narrative. Important events were remembered in a sequence ordered by the subconscious, and it was a constant effort to reassemble them into my story.
(Christopher Priest, *The Affirmation*)

…

Person, ME *person* and earlier *personne*, derives from OF *persone* (late MF-F *personne*): L *persona* orig a mask (Gr *prosopon*), as worn in the Ancient Classical theatre, hence the role attributed to this mask, hence a character, a personage, hence a person . . .
(Eric Partridge, *Origins*)

…

[INT: Elster's Office (DAY)]

...

Tom Helmore, the English actor who plays Gavin Elster in *Vertigo*, had been in two previous Hitchcock movies, 1927's *The Ring* and 1936's *Secret Agent*. He appears in the credits for neither one.

...

Rewatching the sequence in which Scottie visits Elster in his office, I am struck by Elster's apparent unease; he seems, in his stiff-armed posture and impatient swiveling in the chair, like a child in his father's office, placed there out of the way and told not to move, not to touch anything. What does it mean? There is already something awkward and exceptional in Helmore's performance: his (British) accent, which stands out in this scene between a (American) man and his old college chum (also, one would have supposed, an American). The effect is to make one suspicious of Elster from his introduction—has he ever even been in this office that he says is his? Is he in fact or has he ever been a friend of Scottie's? Is he even Gavin Elster? And on the other side of the desk and in contrast to the man across from him, in contrast also to the awkward pose that he himself has affected in Midge's apartment at the beginning of the previous scene (which, even in the timeline of the movie, immediately precedes this scene in Elster's office (where, then, is Scottie's cane?)), Scottie seems perfectly at ease. It is Scottie's milieu, it seems, if not his office. Already, even before he has begun to control the characters around him, he is in control (even while he is out of control in attempting to control them). And Elster is not in control, or wants to appear so.

...

The West presented many opportunities to become what is commonly called a self-made man, a man of wealth, but it offered more profoundly an opportunity to make oneself up, as a fiction, a character, a hero, unburdened by the past. "Oh, what was your name in the States?" went one California song. "Was it Thompson, or Johnson, or Bates? Did you murder your wife and fly for your life? Say, what was your name in the States?" In those days, San Francisco was the capital not only of California but of the West, and the West was for Yankees a place without a past, both a gritty terrain of bare earth and long rivers and a fiction of masculinity and possibilities. . . . For those who came from the East, the West was a place without a past, and amnesia felt like freedom.

(Rebecca Solnit, *River of Shadows*)

. . .

There is something else to note in the office scene: Helmore was apparently much shorter than Stewart, and the fact that there are no wide shots or full shots showing both actors standing up, the very careful staging of two-shots, and the frequent use of medium shots (and the camera's avoidance of any angle or framing that would show the two actors' feet together), are all attempts to hide the disparity in height. The low-angle medium shots of Helmore, made necessary by Helmore's height, place the camera—and thus the viewer—in a subservient, even awed position. This gives the viewer the illusion that Helmore is in control of the scene; he looms over the much-taller, seated Stewart, and he returns to the side-area with the long table several times, presumably because its floor was raised and he could be made to look taller simply by standing on it. Stewart is quickly ushered over to the chair and remains sitting for most of the scene while Helmore walks around, leaving only the shots with Stewart and Helmore near the door to be contended with. These are made to work through imaginative framing.

Or perhaps through set-dressing: I'm left wondering whether Helmore was, in those shots, standing on a block, or on a raised mark, or if Stewart was standing slightly underneath the set in a cutout.

Regardless of how it was achieved, these tricks (tricks common in Hollywood, where most actors are quite short and appearance is all-important) make it seem as though the two actors occupy two different sets—the camera looks up at Helmore, but straight on at Stewart; Helmore stands on the stairs or in the raised portion of the set; Stewart sits, or stands in a cutout a foot lower than the rest of the set. Helmore is on stage, and Stewart is in the orchestra, or even in the audience. For Helmore, as for any actor playing to an audience, Stewart would be at best a ghost, a wager worthy of Pascal. In the scene, in the movie, Stewart does not rise to the level of even a prop in Helmore's play—Scottie's suggestions and reservations, remember, are all cast aside without consideration—but he is nonetheless the reason the performance is given. This is the position Stewart's character will play for the remainder of the first half of the film: He exists not as an actor but as a witness.

…

Was it a ghost?
(00:52:47)

…

Especially note the two-shot of Helmore and Stewart just after Helmore has delivered his line, "Someone dead." The camera cuts to Stewart and his perplexed, even angry reaction, then pans back to fit Helmore into the frame. It is obvious that Helmore, who has just descended the stairs (it looks like two risers from the way he moves), has still not come to rest flat, on the same plane as Stewart, even though he is leaning against the

desk Stewart is sitting in front of. Were there two sets? or two levels to this one set?

...

Helmore's previous film was 1957's *Designing Woman.*

...

Robert Boyle, set designer for *Vertigo,* subsequently helped Hitchcock recreate Elster's office in Hitchcock's home. Hitchcock, of course, so famous for his profile that he made it part of his signature, was, in addition to being quite stout, also quite short. One wonders how much time Hitch spent in that raised portion, looking down on his visitors, how comfortable he was in the chair behind his desk.

...

Do you believe that someone out of the past, someone dead, can enter and take possession of a living being?
(00:13:44)

...

So there was no "I" anymore. . . . It was strange to have no self—to be like a little boy left alone in a big house, who knew that now he could do anything he wanted to do, but found that there was nothing that he wanted to do.
(F. Scott Fitzgerald, "Pasting It Together")

...

My agent wrote that he hated my title, *Vertigo Vertigo Vertigo.* He made some reference to *Beetlejuice.* Anything else, he pleaded.

Anything.

It wasn't his style to make suggestions—he pointed out problems. I was the writer. It was my job to fix them. Sometimes, though, I didn't fix them. A week or two earlier, I had clicked through all of his comments, deleting every one, and then sent the draft back unchanged. I wanted to pretend that he wouldn't notice, that he would write back saying what I'd sent was great, but I knew he would notice. He did. It was ten days before he replied. He said he had been busy—something family-related. He didn't comment on the draft I'd sent. I thought it seemed passive-aggressive of him. He must have thought I was being passive-aggressive to send it in the first place. I'm sure we were both right.

I sent him a link to the Amazon page I had found. "This is bad news," was my subject line. He was confused; I had written another book I had never mentioned? I explained the whole thing to him. He thought it was me, playing a joke on him. I couldn't convince him otherwise. I can hardly blame him—the coincidence of it did seem unbelievable: How had this other man come to write on the same film I had? Not that *Vertigo* hadn't already had plenty written about it over the years, but *at this precise moment in time*? Two books by two men with the same name, on the same subject? Had that *ever* happened? Just the fact that we were two men with the same name writing at the same moment seemed extraordinary; that we were writing about the same thing—that was too much. I proposed *Madeleine E.* as the title. This was *actually* a joke. He liked it. "Much better than VVV," he wrote. "Not sure why you had to go through all that trouble just to tell me your new title." He still thought I was joking. My girlfriend heard me cursing in the next room. I had to stop work and go for a walk.

On my walk, after I had calmed myself down, I decided that he was right: it *was* a joke, just not mine. I mean, it would be so easy to list a book on Amazon, to offer a used copy (already sold, naturally) of something no one would ever order anyway.

(Still, though, the question lingered: why me?) How could I have been so easily fooled? Shouldn't that book have shown up in a previous search if it had been released, as its Amazon page stated, years before? Wouldn't one of my friends, the cashier at Safeway, my mother—*my agent*—have mentioned that there was another Gabriel Blackwell out there, also a writer? The whole thing had to be a hoax. It couldn't possibly be true.

But, after two days spent working through the notes I had deleted, two days in which I did actual writing, two days in which I left my desk at eleven feeling no guilt for not being at it, two days which then concluded with the twin miracles of two full nights' sleep, I put the book aside again. I had just typed *Madeleine E.* on the title page, I don't even know why. To placate my agent, just as the other edits had been made to placate him. I imagined the other Gabriel Blackwell, doing the same thing. I had never worried about the originality of my work before but suddenly I felt as though I was trespassing in my own manuscript. And still that nagging question: Why, out of all of the obscure writers one could choose to prank, why choose me?

…

When I like people immensely, I never tell their names to any one. It is like surrendering a part of them. I have grown to love secrecy. It seems to be the one thing that can make modern life mysterious or marvelous to us. The commonest thing is delightful if one only hides it. When I leave town now I never tell my people where I am going. If I did, I would lose all my pleasure.
(Wilde, *Dorian Gray*)

…

In his essay, "Family Romances," Freud says, "There are all too many occasions when a child is slighted, or at least feels that he

51

has been slighted, that he does not have the whole of his parents' love, and when above all he regrets having to share it with brothers and sisters. The feeling that his affection is not fully reciprocated then finds expression in the idea, often consciously recollected from early childhood, that he is a stepchild or an adopted child." *Vertigo* seems to illustrate an allied mechanism: Madeleine, split in her affections between her husband and Scottie, is revealed to have adopted her persona from a long-dead ancestor, and then subsequently revealed to have adopted that adopting persona from another already-dead woman, the real Madeleine Elster. But whose fantasy is it, really? Is it Scottie's? He would have reason to want to believe that Madeleine isn't Madeleine—as Madeleine, she is a married woman, unavailable to him; as Judy, she is Judy, single, "playing a role" as a wife, and thus available.

Or is it Elster's fantasy? Had Madeleine strayed? Was that the reason for her murder? The affections he once had all to himself had been adulterated, and he found himself wishing his wife was not his wife, was anyone else, so he made her into anyone else?

Or is it Judy's fantasy? Her employer, Elster, finished with her when her role as a woman playing the role of another woman has served its purpose, no longer her husband (he never was), no longer her employer, no longer serving any purpose to her, and she without a role, first adopted and now cast aside?

Or is it our fantasy?

...

Imagine Judy Barton during the period she is supposed to be playing Madeleine, how careful she must have been, how careful she must have been required to have been. She cannot be seen by any of Elster's friends or her relationship with Elster will be revealed ("Gavin, you scamp! How long have you been keeping this one from us?"). And she cannot be seen by Scottie, perhaps a much easier task (there is only one of Scottie), but one that is

easier said than done because, after all, she is being followed by Scottie. We can assume that this period is relatively short, but it is longer than a day or two, and life goes on, doesn't it? She must eat, sleep, wash up. Where? Judy cannot be seen at Elster's house (except outside of it), because she is not his wife—presumably, at least the staff and her neighbors will know what the real Madeleine Elster looks like—but neither can she be seen at her own apartment. If Scottie caught her there, he would know she was not Madeleine Elster. Where can she go when she is not being Madeleine Elster? Is it possible that, because she had no opportunity not to be Madeleine, she was Madeleine during those days or weeks, 24 hours a day (meaning, in effect, she *was* Madeleine)? Or did she simply disappear when no one is looking, somehow cease to exist?

…

A person may identify himself with another and so become unsure of his true self; or he may substitute the other's self for his own. The self may thus be duplicated, divided, and interchanged.
(Sigmund Freud, "The Uncanny")

…

For our second anniversary, my wife's sister bought us a baby name book. It was supposed to be a joke. I read part of the introduction—stupid writing that tried too hard to seem "fun"—and then I turned to my name, to find out what it "meant." There was never any thought of using the book to name a baby. My name was listed under the heading "Unusual Names." Of course I knew about the angel (though I didn't know that angels were neither male nor female, but (possibly) both; there are gendered versions of my name, Gabriel/Gabrielle, but maybe they aren't necessary?). There was also this encouraging sentence: "There

is no reason to think that unusual or unattractive names are associated with deficits in academic or social functioning." This came under a subheading, "Unusual names make for unusual people?" The idea seemed to be that, in naming your child, you were helping to create them. Like my name itself, the idea is biblical. Adam, naming the animals. God, creating light.

I had never thought much about my name before; I mean, thought about what it really was. My parents had named me "Gabriel Blackwell" and put that name on my birth certificate, but I hadn't really been born with that name, had I? It was not "mine" in the same way as my hair is mine or my hands are mine. It was just a name. (Do I really need to quote Shakespeare?) If I were to change my name, I wouldn't become someone else. My memories wouldn't change. If I renamed myself "O.J. Simpson," I would not *be* O.J. Simpson. Or I would be, but in name only. I would simply be another O.J. Simpson. If, when I went to renew my license, I discovered that my parents or the state had misspelled my name on my birth certificate, nothing about my life would change except for the name on my driver's license. But, the flipside of all of this was that my being "Gabriel Blackwell" was not really different from Jimmy Stewart being Scottie Ferguson. My name, I mean, was not a unique marker of my existence, not in the same way my body was—my body was me. My name wasn't. When someone met me in person, they came to know me; when someone heard a story about me, I became a fiction.

No matter how badly a novice butchers the words of Shakespeare, she will still be Ophelia for whatever time she spends on stage. No matter how badly I act out "Gabriel Blackwell," I cannot be any less Gabriel Blackwell.

…

The gothic horror and romantic terror of the Doppelgänger is the horror and the terror of a Siamesed bond: a life contravening

yours, but its fate your fate.
(Hillel Schwartz, *The Culture of the Copy*)

…

But love and hate, he thought now, good and evil, lived side by side in the human heart, and not merely in differing proportions in one man and the next, but all good and all evil. One had merely to look for a little of either to find it all, and one had merely to scratch the surface. All things had opposites close by, every decision a reason against it, every animal an animal that destroys it. . . . Nothing could be without its opposite that was bound up with it. . . . Each was what the other had not chosen to be, the cast-off self, what he thought he hated but perhaps in reality loved . . . there was that duality permeating nature. . . . Two people in each person. There's also a person exactly the opposite of you, like the unseen part of you, somewhere in the world, and he waits in ambush.
(Patricia Highsmith, *Strangers on a Train*)

…

"One shouldn't live alone."
"Some people prefer it."
"It's wrong."
(00:50:30)

…

Chronology is not the same as causality.
(Jan Kjaerstad, *The Seducer*)

…

Let the cause follow the effect, not accompany it or precede it.
(Bresson, *Notes*)

…

In *Vertigo* one learns as much about Alfred Hitchcock from the complex dualities of the Kim Novak character as from the tormented, doomed lover played by [Jimmy] Stewart.
(Donald Spoto, *The Dark Side of Genius: The Life of Alfred Hitchcock*)

…

Two facts are obvious: everybody knows Alfred Hitchcock, and nobody knows him.
(John Russell Taylor, *Hitch: The Life and Times of Alfred Hitchcock*)

…

Einstein seems to have said that if one went to the trouble (not to mention the expense) of devising an infinitely powerful telescope, a telescope that could also somehow penetrate any celestial body it met, and then trained its sights straight out along the horizon, one would see the back of one's own head. However, he later admitted that such an enterprise would be ridiculous; after all, the barber routinely offers us this view for free.

…

Searching for "Gabriel Blackwell" using Google returns ~10,000 results—the quotation marks are important, since, without them, you get pages where both those words appear but not in that order, i.e., pages with a Blackwell somewhere and a Gabriel somewhere else. It seems significant that, in order to get Google's algorithm to register that you mean what you say, you have to put what you say in quotes, which is the opposite of what happens when you put a word or words in quotes in print.

The exact number of results depends on the day. I noticed a probably imperceptible-to-anyone-but-me fluctuation of around one hundred results, +/-, like some distant star winking in the sky; still, over 10,000 iterations of me. I couldn't think about them as I always had before. They no longer seemed so benign. Now, each one was a direct competitor, even the ones that were obviously me.

. . .

If two identical people meet, it's only natural that they should want to know everything about each other, and the name is always the first thing we ask, because we imagine that this is the door through which one enters.
(Saramago, *The Double*)

. . .

For Catholics, christening, a baptism, is meant to cleanse the child of original sin. The child must be given a name (i.e., "christened") before the baptism, as that name is then used in the ceremony. The original sin is exorcised during the baptism—the child is born into a type of possession and, if it dies before this ceremony, it cannot be admitted into Heaven but will instead spend eternity in Purgatory. Without a name, there is no baptism. Without a baptism, there is no salvation. On the other hand, in sailing lore, to name a boat once she is already afloat is very bad luck, and there are many superstitions regarding the renaming of boats.

. . .

Hitchcock: "For me to take someone else's script and merely photograph it in my own way simply isn't enough. For better or for worse, I must do the whole thing myself. And yet, in a way,

one has to be terribly careful that one doesn't run out of story ideas. Like any artist who paints or writes, I suppose I'm limited to a certain field. Not that I'm comparing myself to him, but old Rouault was content with judges, clowns, a few women, and Christ on the Cross. That constituted his life's work. Cézanne was content with a few still lifes and a few scenes in the forest. But how long can a filmmaker go on painting the same picture?"

. . .

Hitchcock said: "What I've tried to put in my films [is] what Edgar Allan Poe put in his novels: a completely unbelievable story told to the readers with such a spellbinding logic that you get the impression that the same thing could happen to you tomorrow. And that's the key thing if you want the reader or viewer to substitute himself for the hero—since people are, after all, interested only in themselves or in stories which could happen to them."

. . .

Someone who spends his life drawing profiles will end up believing that man has one eye, Braque felt.
(Anne Carson, "Short Talks")

. . .

Another way to think of Plato's cave is as a condition in which people live entirely in representation and interior space, in a universe constructed by humans, ultimately inside the imaginations of those who came before, an operation that suggests nesting Russian dolls and a certain crampedness of the imagination after a few generations.
(Solnit, *River*)

…

Judy's gray suit as worn by Novak was originally designed for a different actress, Vera Miles. A trebling (Miles→Novak→ Judy(→Madeleine; a quadrupling?))? Novak objected to the dress because of the color—Edith Head recalled, "I remember her saying that she would wear any color except gray." Might she also have objected because the suit was not hers?

…

An image must be transformed by contact with other images as is a color by contact with other colors. A blue is not the same blue beside a green, a yellow, a red. No art without transformation. (Bresson, *Notes*)

…

According to the website howmanyofme.com, which uses an algorithm that takes the population according to the 2010 census and the relative popularity of a person's first and last names and determines the probable number of Americans with that name, as of 6/22/2012, there were probably 21 Gabriel Blackwells in the USA. I was able to find a handful of them without much effort at all.

…

Terror lurks not only in the dark shadows or in solitude . . . sometimes we can be most alone, most threatened, furthest beyond help, in the middle of a crowd of normal, friendly people.
(Taylor, *Hitch*)

…

What we need to know—what Scottie needs to know but doesn't investigate—is not what we think we need to know: who Madeleine Elster was. Madeleine Elster is the film's MacGuffin.

If Judy Barton sees her [staged] rescue—Scottie's dive into the Bay—as a [real] gesture of devotion, then when she wakes in Scottie's apartment, she's already to some degree under his spell. "He kept the child and threw her away," Pop Liebel's line about the man who kept Carlotta, has already been twinned to Elster's real story: Elster will throw Judy away once his plot is accomplished, and she has already realized this by the time she meets Scottie. Scottie, though, doesn't throw her away, won't, and it is this that she falls in love with. This explains her actions in the second half of the film, her acquiescence to Scottie's increasingly disturbing demands—she can't help herself any more than Scottie can. But one thing, the most important thing, will yet be left unexplained: why does she jump from the mission's tower? What is she afraid of, held so tightly by Scottie, her tormentor and her protector? Whatever causes her conscience to jump at shadows is also the clue to her identity before Elster and his plot. What we need to know in the end isn't who Madeleine Elster was, but who Judy Barton has been.

…

An incomplete double reading list:
"The Student of Prague," H. H. Ewers.
"William Wilson," Edgar Allan Poe.
The Devil's Elixirs and "The Doubles," ETA Hoffmann.
"The Double," Fyodor Dostoyevsky.
"Love and Mr. Lewisham," H. G. Wells
The Picture of Dorian Gray, Oscar Wilde.
"At the End of the Passage," Rudyard Kipling.
"The Horla" and "Peter and John," Guy de Maupassant.
"Borges and I," Jorge Luis Borges.
Despair, Vladimir Nabokov.

Do Androids Dream of Electric Sheep, Philip K. Dick.
"The Secret-Sharer," Joseph Conrad.
Invisible Man, Ralph Ellison.
"Goodbye, My Brother," John Cheever.
The Double, Jose Saramago.
"The Strange Case of Dr. Jekyll and Mr. Hyde," Robert Louis Stevenson.
The Invention of Morel, Adolfo Bioy Casares.
The Dark Half, Stephen King.
Twelfth Night, William Shakespeare.
The Affirmation, Christopher Priest.

...

There is the Gabriel Blackwell in South Carolina who was jailed for domestic abuse. His wife, so far as I can tell, was the victim. I don't know what her name is; they don't release those details sometimes. He seemed, in any case, already too infamous to pull such a prank.

...

There is the Gabriel Blackwell in Trinidad, a professional cricketer. The only information on that Blackwell was written in an arcane code I could not break, in match scores and the miscellaneous statistics of a sport I had never so much as pretended to understand. This, as much as his Trinidadian nativity, eliminated him from my serious consideration.

...

There were three Midwestern Gabriel Blackwells—a chef, a student, and an intern at a political office. Their abandoned social media profiles, their inscrutable pictures, and the brief mentions of them on obscure "professional" blogs gave each one the weight of a fragrance. If it were any one of them, I felt

sure I would never know. They all seemed similarly likely to be fictions or fakes.

. . .

And there was still this other Gabriel Blackwell, a man who, according to the reviews, had written two books about himself, two books that seemed also to be copies of other author's books, a man who had now disappeared. He had released his last book two years ago. *Madeleine E.* had been "in progress" then. Was it still in progress now?

. . .

Twenty-three hundred people go missing in America every single day. During the time it took you to read that sentence, another person has gone missing. At any given moment, the odds of any one of those estimated twenty-one American Gabriel Blackwells going missing are a little less than one in a billion. If you have a more common name, the chances that you will go missing in the next hour are much higher.

. . .

In art, to reduce is to perfect. Your disappearance bestowed a negative beauty on you.
(Levé, *Suicide*)

. . .

Changing your name is no guarantee that a sudden accident won't befall you.

. . .

I felt like I had no choice. I had to find him. I had to know if it was real. What else could I do? It would always be another reason not to write the book. Did he exist? Was he someone I already knew?

. . .

There is the same thrill of one-way glass . . . as in hearing the sound of your voice recorded. Or catching sight of yourself in the background of a photograph. Or passing yourself in an electronics storefront—a peep of a view as your image walks toward you. For you are always a secret to yourself. . . . But there are glimpses and hints and clues.
(Ross, *Mr. Peanut*)

. . .

Man is not truly one, but truly two. I say two because the state of my own knowledge does not pass beyond that point. Others will follow; others will outstrip me on the same lines: and I hazard the guess that man will be ultimately known for a mere polity of multifarious incongruous and independent denizens.
(Robert Louis Stevenson, *The Strange Case of Dr. Jekyll and Mr. Hyde*)

. . .

If Heraclitus is right, then every new sentence introduces a new character. The Gregor Samsa who awakens to find himself changed into a monstrous vermin is not the same Gregor Samsa who lifts his head to see his vaulted brown belly—that Gregor Samsa is already and will always have been a monstrous vermin. In literature, the period gives us a way to say that something has changed, a moment has passed. In life, what are the periods?

…

Each of us is several, is many, is a profusion of selves. So that the self who disdains his surroundings is not the same as the self who suffers or takes joy in them. In the vast colony of our being there are many species of people who think and feel in different ways.
(Fernando Pessoa, *The Book of Disquiet*)

…

[INT: Ernie's Restaurant (NIGHT)]

…

Hitchcock: "Miss Novak arrived on the set with all sorts of preconceived notions that I couldn't possibly go along with. You know, I don't like to argue with a performer on the set; there's no reason to bring the electricians in on our troubles. I went to Kim Novak's dressing room and told her about the dresses and hairdos that I had been planning for several months. I also explained that the story was of less importance to me than the over-all visual impact on the screen, once the picture is completed."

…

On the other hand, *Vertigo* was undoubtedly a film in which the leading lady was cast as a substitute for the one Hitchcock had in mind initially. The actress we see on the screen is a substitute, and the change enhances the appeal of the movie, since this substitution is the main theme of the picture: A man who is still in love with a woman he believes to be dead attempts to recreate the image of the dead woman when he meets up with a girl who is her look-alike. . . . Seated next to Grace Kelly, and viewing the

scene in which James Stewart urges Kim Novak to put her hair up in a bun, I realized that *Vertigo* was even more intriguing in light of the fact that the director had compelled a substitute to imitate the actress he had initially chosen for the role.
(Truffaut, *Hitchcock*)

...

Just as his admiration for Grace Kelly had been a part of Stewart's decision to make *Rear Window*, here again the actress who would become his costar seemed to be crucial: Stewart—indeed, like Hitchcock himself—did seem to have become more interested in the picture when, at the last moment, the original female lead stepped down.
(Auiler, *Vertigo*)

...

Men don't want Midge. They don't even want Judy—an honest-to-goodness girl from Salina, Kansas. They don't even quite want Madeleine, for all her vulnerability. Nor do they want Carlotta—it's "Madeleine" who wants to be Carlotta, the tragic heroine of her own obsessive story. Men want the space *between* Madeleine and Carlotta; between reality and illusion lies the dream. The imagination set free. They can slip out of their names and into the maze of desire.
(Judith Kitchen, *Only the Dance*)

...

Marlene Dietrich, preoccupied with appearances to the extent that she demanded a full-length mirror be hung next to the camera so she could check her look under each lighting scheme, said, "It is a woman's job to sense the hungers in men and to satisfy them without, at the same time, giving so much of

herself that men become bored with her. It is the same with acting. Each man or woman should be able to find in the actress the thing he or she most desires and still be left with the promise that they will find something new and exciting every time they see her again."

…

Often things begin as a fake, inauthentic, artificial. But you get caught into your own game and that is the true tragedy of *Vertigo*. . . . Appearances win over reality.
(Zizek, *The Perverts Guide to Cinema*)

…

Vertigo was released on May 9, 1958. It earned back its costs, but only barely. Reviewers compared it unfavorably to other Hitchcock movies. Universal Pictures took note: While other Hitchcocks made the rounds on the revival circuit, *Vertigo* collected dust in a film vault. Robin Wood wrote his chapter on *Vertigo* from memory. By the time the film was restored and rereleased, the negative's colors had faded so much that the restoration was compared to Ted Turner's "colorization" of classic black and white movies. (The U.S. law instituting the National Film Registry was the National Film Preservation Act of 1988, prompted by—among other things—Turner's purchase of the MGM archives (which would have included *North by Northwest*, already in color) and his systematic "colorization" of those films.) Even after the critical turnaround and the rerelease's better showing at the box office, Universal still seems cool to the movie. There are several versions of *Vertigo* available on DVD and VHS, but only one on Bluray. At the time of this writing, the Bluray is available only as part of a 15-disc boxed set, "Alfred Hitchcock: The Masterpiece Collection." It would seem insulting to summarize *The Birds*, *Psycho*, or *Rear Window*—

who doesn't know what happens in those movies? But with *Vertigo*, one never knows when it will disappear again, or what will be lost.

…

Scottie Ferguson is a detective for the San Francisco Police Department. I have the distinct feeling that he is the Chief of Detectives, if there is such a thing, but I don't think it's ever really said whether he has any sort of supervisory role in the department; he may just be a detective. We do hear, from his friend Midge, that he once had ambitions to become Chief of Police, but we never find out at what rank he retired. While chasing a fugitive across the rooftops of downtown San Francisco, Scottie doesn't make a jump from one building to another, inadvertently causing the officer who stops to help him to fall to his death. As a result, Scottie develops acrophobia and a debilitating vertigo. He suffers some physical injury too, but we never learn the extent or even the nature of that injury. Worried that he'll never again be able to perform the functions of his job, Scottie quits the force and enters an uneasy retirement. A man named Gavin Elster calls him to ask if they can meet.

This Elster is a college friend of Scottie's (who nonetheless can't remember Elster). Bored, not especially curious but having nothing better to do, Scottie goes to see Elster, who tells him that his wife, Madeleine, has been wandering during the day, perhaps quite far from the city. Not only that, but she seems not to realize that she has been wandering—she can't recall where she has been or what she has been doing. Elster wants to know that she's safe, he tells Scottie, perhaps also that she is not cheating on him (though Elster says it isn't *that* that he's worried about). Scottie declines. He changes his mind when he sees Madeleine.

Madeleine's wandering seems to have a kind of routine. Her stops all have something to do with a mysterious woman

from the "gay old Bohemian days of gay old San Francisco," a woman named Carlotta Valdes, the mistress of a married man who "kept [their] child and threw her away." Carlotta, driven insane by the double loss of lover and child, wanders the streets looking for her lost son or daughter until finally she turns up dead, a suicide. Madeleine, Carlotta's great-granddaughter, is now at the age Carlotta had reached when she killed herself, Elster tells Scottie, and he is worried that now Madeleine will kill herself too.

And he is right to be worried. Madeleine attempts suicide, throwing herself into the Bay from Fort Point, at the foot of the Golden Gate Bridge. Scottie saves her and the two begin an affair. The affair is short-lived. Scottie takes Madeleine to the Mission at San Juan Bautista to confront her with his ideas about Carlotta. Frightened by his sudden passion, she runs from him, up the bell tower above the mission chapel, where Scottie is unable to follow because of his acrophobia. He stops halfway up the stairs, and she disappears into the belfry above. He hears a scream. He sees her body plummet past the window he has reached. He sees her body on the tiles of the roof below.

The loss of Madeleine is too much. Scottie becomes unhinged. After the inquest, he is committed to an asylum for a period. When he is released, he seems to see Madeleine everywhere. He begins dating a woman he thinks looks like Madeleine, a woman named Judy Barton, who turns out to have been hired by Elster to "play" Madeleine. Scottie, though, doesn't know this (or does he?). He forces Judy to dress like Madeleine. He forces her to dye her hair, and to wear it the way that Madeleine did. It is obvious Judy has feelings for Scottie, but Scottie is oblivious, obsessed by his memories. Judy is a kind of wax figure to him, a doll to be played with. He realizes his mistake only when he has taken this cruel treatment too far: she is the woman he wants her to be, inasmuch as she is the woman he held when he thought he was holding Madeleine, but she has never been the woman he thought he'd fallen in love with,

"Madeleine Elster," a woman he must now understand he has never even really met. He takes her back to San Juan Bautista, and, this time, he is able to climb the tower to the top. He accuses her of infidelity—to him, to herself—and she doesn't deny it. Judy, surprised by a nun coming to check on the couple and disturbed by Scottie's behavior, falls to her death.

The end.

…

Above all, do not attempt to be exhaustive.
 Sam Taylor says Laurent Binet says Roland Barthes says.

…

The only artists I have ever known who are personally delightful are bad artists. Good artists exist simply in what they make, and consequently are perfectly uninteresting in what they are. A great poet, a really great poet, is the most unpoetical of all creatures. But inferior poets are absolutely fascinating. The worse their rhymes are, the more picturesque they look. The mere fact of having published a book of second-rate sonnets makes a man quite irresistible. He lives the poetry he cannot write. The others write the poetry they dare not realize.
(Wilde, *Gray*)

…

My agent worried about the books on *Vertigo* that had already been written, the ten or so books that were due to be published before the end of the year. I worried about one book, *Madeleine E.*, still unpublished and, I thought, probably unfinished. Since my agent didn't believe in *Madeleine E.* he didn't worry about it, but if it was finished and found a publisher, the news would come as a betrayal to him. It didn't even matter if that happened

before my book came out or after. It would look like lost revenue.

My worries ran deeper: What would it mean if this other book not only seemed to others but actually *was* the realization of what I had, as yet, only just begun, the culmination of my work, rather than merely its opposite or its complement? What if I were straining to create something not only already in existence, but something that, when finished, would be a copy of something that existed already? A copy of a copy of *Vertigo*, a film several decades old, having already inspired several copies?

…

Chris Marker's *La Jetée*
Paul Verhoeven's *Basic Instinct*
Lloyd Kaufman's *Sugar Cookies*
Mel Brooks's *High Anxiety*
Brian DePalma's *Obsession*
countless reused shots, homages of plot and composition and music, countless uses of the "Vertigo effect"

…

While Hitchcock maintains that he is not concerned with plausibility, the truth is that he is rarely implausible. What he does, in effect, is to hinge the plot around a striking coincidence, which provides him with the master situation. His treatment from then on consists in feeding a maximum of tension and plausibility into the drama, pulling the strings ever tighter as he builds up toward a paroxysm. Then he suddenly lets go, allowing the story to unwind swiftly.
(Truffaut, *Hitchcock*)

…

Hitchcock: "All that matters, all that exists for the audience,

is what is on the screen. It doesn't matter if the set extends no more than six inches beyond what the camera records—it could as well be six miles for all the effect it would have on the audience. The whole art is knowing what matters in each shot, what the point you are selling is."

...

Though *High Anxiety* takes its plot from *Spellbound* rather than *Vertigo*, and is intended as a satire of Hitchockian tropes in general, rather than specifically those found in *Vertigo*, the poster art, the title sequence, and the protagonist's phobia all come from *Vertigo*. I don't think the pairing of these two movies is sloppy or accidental—*Spellbound* involves someone appearing to fall to their death who has actually been murdered prior to that fall, someone pretending to be someone else for the sake of the murderer, and a man so paralyzed by his fear that he is unable to prevent (or so he thinks) the murder in the first place. In *Spellbound*, however, a dream resolves things. The murderer is punished. In *Vertigo*, there is no resolution and Elster gets away.

...

Hitchcock's great need (exhibited throughout his life as well as in his death) to insist on and exert authorial control may be related to the fact that his films are always in danger of being subverted by females whose power is both fascinating and seemingly limitless.
(Tania Modleski, *The Women Who Knew Too Much: Hitchcock and Feminist Theory*)

...

Judging by my Facebook feed—full of writers—most authors try to average between one thousand and two thousand words

71

a day. Even if you're hunting and pecking, typing a thousand words only takes about an hour and a half: ten words a minute for one hundred minutes, one thousand words. I did this arithmetic to make myself feel less alone. My writing time was usually spent not writing, which is not to say I spent it doing math: I Googled my name to see if anything new came up; I went for a walk; I rode my bike to the movies; I couldn't decide on a movie, so I rode my bike home from the movies; I went to Powell's and didn't buy anything; I walked around next to the river; I read; I tried to watch a movie at home. Once, I had been one of those writers who could turn out two thousand words a day and then head off to my day job. Now, I wrote an email, maybe. My routine had been permanently disturbed.

To make matters worse, my wife's routine remained the same. She left the house at nine or ten, either to go to work or to school, and was back at six or eight, depending on the day. By that time I was just starting to write—I mean actually typing into the manuscript—and I pretended to resent the intrusion. I should have been relieved.

One day, having hurriedly wasted my morning, I shut my laptop and went for a walk in a direction I didn't usually take. Most days I walked north, through Irvington up to Alberta, or west, toward the river, but that day I went east, toward Broadway and the café where I had once worked. I crossed Broadway at 16th, jogging across after the DON'T WALK sign had come on, even though I had no reason to be in a hurry. The driver of a bus pulling away from its stop honked, and I turned and saw my wife behind one of the bus's windows, not where she was supposed to be. I couldn't have been mistaken: Beneath the watery, shimmering reflection of the *BROADWAY FLORAL* sign was her face, her hair, her glasses, even what I was sure was the shirt she had been wearing when she left the house that morning. But she had left hours earlier, with the car, to go to work and then, after work, she was going to a friend's birthday party. Why would she be on a bus? She was nowhere near her

work. She was nowhere near her friend's. Had she come home and left again since I left for my walk? When I got home, neither she nor the car seemed to have been there. Besides, the bus had been headed downtown, in the wrong direction for her work or the party.

Another day I saw her in the corner of the frame of a video on the *Oregonian*'s website, a video of a protest taking place downtown, near Pioneer Square. I watched the video again, and then I watched it again. I was sure it was her. Standing next to her was a man whose face was obscured by another person standing in front of him. This man was clearly holding onto her arm. She was supposed to be in class at the time of the protest. I didn't know what to think. If I asked her about it, she would get defensive, whether or not anything had happened. I decided I would let her bring it up.

She came home late that night, having gone to a bar with a friend and then stayed later than she expected in order to sober up a little. That's what she told me, anyway. I was already half asleep when she lay down beside me but I could tell she had just taken a shower. Not knowing what I was saying, I asked her why she had taken a shower, but, in my half-awake state, I must not have spoken clearly. She didn't understand me, or she claimed not to understand me, and said so, turning to face away from me. Now I was fully awake. I repeated my question. She told me she had been around smokers at the bar and didn't want the pillow to smell like cigarettes. She fell asleep then, but despite the fact that I had been on the verge of drifting off just moments before, I laid awake for what seemed like hours and woke up to find I had fallen asleep after all. I knew I would do no work that day. I thought about following her instead.

…

[Laura] Mulvey considers two options open to the male for warding off castration anxiety: in the course of the film the

man gains control over the woman both by subjecting her to the power of the look and by investigating and demystifying her in the narrative.

(Modleski, *Women*)

. . .

Men's fascination with [the] eternal feminine is nothing but fascination with their own double, and the feeling of uncanniness, *Unheimlichkeit*, that men experience is the same as what one feels in the face of any double, any ghost, in the face of the abrupt reappearance of what one thought had been overcome or lost forever.

(Sarah Kofman, *The Enigma of Woman*)

. . .

Latent structure is master of obvious structure.

(Heraclitus, *Fragments*)

. . .

[Scottie's desire] is a desire to merge with a woman who in some sense doesn't exist—a desire, then, that points to self-annihilation.

(Modleski, *Women*)

. . .

Writing about Ben Hecht's *Notorious* script, Bill Krohn says, "Hecht believed that what men love in women is their own 'lost femaleness,' and he portrayed in Dev's behavior the same mechanism of disavowal that he analyzed in his 1944 study of anti-Semitism, *A Guide for the Bedeviled*. Dev fights the allure of Alicia's femaleness like the anti-Semite who, in Hecht's words,

'wrestles with the jew as an ape might assault his own unlovely image in the mirror,' and Alicia pays the price."
(Bill Krohn, *Hitchcock at Work*)

...

Kim Novak's career was modeled on that of Jayne Mansfield's, a career created out of thin air by Harry Cohn. In other words, Novak's was a career modeled after a career invented by a man who set out to make a woman into a woman other men will find appealing.

...

When Scottie Ferguson in *Vertigo* begins investigating the mysterious Madeleine Elster, the first point of view shot shows him as a mirror image of the woman, and the rest of the film traces the vicissitudes of Scottie's attempts to reassert a masculinity lost when he failed in his performance of the law.
(Modleski, *Women*)

...

In Sophie Fiennes's film, *The Pervert's Guide to Cinema*, the philosopher Slavoj Zizek explains Scottie's motivations in the second half of the film with a maxim I have never before heard: "The only good woman is a dead one." It is, frankly, difficult to listen to, even given Zizek's context: explaining what he calls the "male libinal economy." I am not much swayed by his jargon, here or elsewhere in the film, and his insistence on likening film to shit (he explains the moments before a film begins are like looking into a toilet bowl and waiting for what has been flushed down to come back up) is risible and more than a little ridiculous, but many of his insights into *Vertigo* and the other films he discusses are interesting.

Putting aside the rather ugly implications of (even the existence of) such a maxim, and keeping in mind Modleski's contentions, Zizek's comment puts me in mind of one of the earliest examples of the double in American literature, Edgar Allan Poe's "William Wilson," in which the titular Wilson is haunted by a man exactly like him who turns up whenever Wilson attempts to cheat, deceive, or otherwise act immorally. At the end of the story, Wilson confronts his double and stabs him repeatedly, but then thinks he perceives a mirror in front of him where he thought the other Wilson had stood. In it, his reflection is bloodied and pale as though dying.

Madeleine is a woman who doesn't exist, a phantasm. When Scottie asks who he thinks his wife is impersonating, Elster answers, "someone dead." Elster is not only referring to Carlotta Valdes—he is also referring to Judy's acting out of Madeleine, his wife who he has already murdered, i.e., "someone dead." Judy as Madeleine as Carlotta is a woman playing a ghost acting out a ghost. Anything of substance in what Scottie sees in such an apparition is thus bound to be a reflection; the woman in front of him is trying her best to appear immaterial. When we look through glass at the silver backing of a mirror, what we see is neither glass nor silver. We see ourselves. Scottie looks through Madeleine at Judy and sees neither Madeleine nor Judy. He sees his double, and, because all doubles and doppelgangers exist ultimately to reveal to us our failings, he destroys it for what it reveals in him. That, in doing so, he leaves nothing intact is the tragedy of *Vertigo*. He cannot recognize in Judy what is Judy's because he is so determinedly looking for what is Scottie's.

...

Robin Wood writes, "Throughout the first part [of *Vertigo*], Hitchcock uses the technical apparatus of point-of-view shooting/editing systematically to enforce identification with the male viewpoint. The very first sequence after the credits

employs this more emphatically than any other Hitchcock opening: thereafter, we see through Scottie's eyes and we are prevented from seeing virtually everything that is beyond his consciousness." (Wood, HFR, 363) And yet, take another look at one of the more famous "subjective" sequences in the film—the scene at Ernie's where Scottie first sees "Madeleine."

When Kim Novak enters the bar area, we get a close-up from what we believe must be Scottie's point of view. Indeed, Scottie's subsequent fascination with "Madeleine" seems to hinge on our belief in just that—that this is the moment in which Scottie is bewitched. In a shot that is in the trailer but was cut from the final film early in the editing process, Novak looks directly into the camera, a technical no-no (breaking the fourth wall) but a very clear signal to the audience as to how to read this set-up. But then we cut away back to Scottie, in a medium shot that reveals he is looking at "Madeleine" only out of the corner of his eyes, using the very limits of his peripheral vision. The POV shot, then, could not possibly reflect what Scottie sees in those moments—"Madeleine" occupies the center of its frame. She is not occluded at all, as she would be if she were occupying a peripheral space. Instead, the shot must represent the view of someone sitting next to Scottie, turned fully towards Novak in that instant. But there is no such person at the bar. We look, with the camera, and there is only a couple turned away from the room, towards the bar, engrossed in a private conversation we cannot hear. In all subsequent so-called "subjective" shots, we will find that the camera occupies a space other camera angles reveal is absent of observers, too. It is thus a ghost who looks over Scottie's shoulder, seeing the things that he ought to have seen—seeing things as he *might* see them with reflection but not as he sees them in the moment. We, the audience, see *only* what is "beyond his consciousness." It is precisely the fact that he is blind to this part of himself, this self beside his self, that leads him to the Mission, to the Tower, to the inquest, and back through them all.

...

[The first shot of Madeleine, at Ernie's] is not (cannot possibly be) a point-of-view shot, yet it has the effect of linking us intimately to the movement of Scottie's consciousness. The camera movement is unlike anything in the film up to that point, introducing a completely new tone, the grace and tenderness underlined by Bernard Herrmann's music. Madeleine is presented in terms of the 'work of art' (which is precisely what she is): her movement through the doorway suggests a portrait coming to life, or a gliding statue; when she pauses, turns her head into profile, the suggestion is of a 'cameo' or silhouette, an image that will recur throughout the film. As 'work of art' Madeleine is at once totally accessible (a painting is completely passive, offering itself to the gaze) and totally *in*accessible (you can't make love to a picture).
(Robin Wood, *Hitchcock's Films Revisited*)

...

How does a writer go so far inside her character that she comes face to face with her mirrored self?
(Judith Kitchen, *Distance & Direction*)

...

My girlfriend and I had once worked at the same non-profit. I was a grant writer there, but I hated the job and couldn't wait to leave. A month before I quit, one of our coworkers told me someone in the office had a crush on me. It was common for people there to sleep together—something about the stress and the subsistence wages—but I had never been that type of person. Because I had been overweight most of my life, I found it difficult to believe anyone could find me attractive and so, to avoid embarrassment, I rarely asked anyone out. But the

coworker's comments gave me courage. I thought for sure it was one of the four administrative assistants, the only people there who had taken an interest in my writing. Two of them were married, so I guessed it must be one of the other two. I asked her out. The whole thing was so long ago I can't remember what we did on the date, but I do remember that when we'd gone back to her place and were sitting on her couch, she asked me why I'd asked her out. I remembered she'd looked genuinely curious. I gave her an answer that seemed appropriate—it was complimentary but vague, since I didn't really know her that well—but I remember thinking I had guessed wrong. There was no second date.

A week later, I put in my notice. Things weren't awkward between the woman and I, if anything, she was friendlier than ever, but it was clear that she felt no attraction to me, and vice versa. When I told her I was leaving, she congratulated me—no one wanted to work there; everyone was biding their time—and said, "Oh, she's going to be so sad." She told me who it was who had the crush on me. She didn't know that I'd asked her out because I'd thought it was she. It was a surprise, then, for both of us.

It was a relatively small office, so I thought it would be better to wait until after my last day to approach this woman, the one who actually had the crush on me—to tell the truth, I was probably just scared—but if I wasn't working there anymore, it would be that much more difficult to approach her. I was going out of town, and, being a coward, I figured the best way to do it would be to send her an email asking her out, using as my excuse for not doing it in person the fact that I was out of town and didn't have her phone number. Later, on our second date, she told me it was lucky I'd emailed her at work and not at her private email address, because, just before I'd written that email, someone had hacked her account and she'd been locked out ever since. I didn't know her private email address at the time, so there was never any question I would use it, but I didn't say

79

anything. I let her tell the story.

Whoever had hacked her account had sent emails to people in her address book—she found out when her brother forwarded one to her at work—telling them she wanted to meet them at such-and-such a place at such-and-such a time. The email said only that it was very important they be on time. The addresses were all far away, so no one she knew had actually gone to one of these meetings (she hoped *no one* had, and worried it was some kidnapping thing, even though she told me it was probably really a scam and this was just the first step), but one of her bosses had asked her if she was OK, and another person in the office had given her funny looks, and she had wondered why she couldn't log in to her email. Then her brother forwarded her the email and she found out what had happened. In the end, she abandoned the hacked email address and set up a new one, and never really thought about it unless someone mentioned sending an email to her there.

. . .

Though the too-obvious parallels between Kim Novak and Judy Barton, between Elster/Scottie and Alfred Hitchcock are attested to again and again in analyses of *Vertigo*, the facts cannot be escaped or disguised: Hitchcock was saddled with an actress he did not want (the role was written for Vera Miles, who became pregnant just before the film went into pre-production) who was unwilling to accede to what he wanted from her (the oft-repeated anecdote about her telling Edith Head she would wear anything so long as it wasn't gray and wasn't a suit).

. . .

It is as if [in the first scene between Scottie and Midge], the film is humorously suggesting that femininity in our culture is largely a male construct, a male "design," and that this femininity is in

fact a matter of external trappings, of roles and masquerade, without essence. This is an idea that the film will subsequently evoke with horror. For if woman, who is posited as she whom man must know and possess in order to guarantee his truth and his identity, does not exist, then in some important sense he does not exist either, but rather is faced with the possibility of his own nothingness. . . . In this respect, it is possible to see the film's great theme of romantic love as something of a ruse, a red herring . . . the source of the man's fascination with the woman is her own fascination with death, with the gaping abyss, which she hallucinates as her open grave and which is imaged continually in the film in its many arch-shaped forms of church, museum, cemeteries, mission.
(Modleski, *Women*)

…

Hitchcock's mature films poignantly explore the nature of absence and of loss. In *The Man Who Knew Too Much*, it is the loss of family security abroad; in *The Wrong Man*, the loss of innocence and family unity at home; in the trilogy *Vertigo—North by Northwest—Psycho*, the loss of identity itself, for there is no living person at the center of these three great works. Madeleine Elster, George Kaplan, and Mrs. Bates are the ultimate MacGuffins.
(Donald Spoto, *Spellbound by Beauty: Alfred Hitchcock and His Leading Ladies*)

…

The book, now, was not something I worked on. It was, instead, an excuse, a reason not to do other things. I read. I thought about how I would write the book. I couldn't write other things because I was writing the book, but I wasn't writing the book, so I wasn't writing anything. I told my wife I was working on the

book. I told myself I was working on the book. I thought about the bus. I thought about the video clip. I watched the video clip again. I wondered what it meant. I wondered if I could follow my wife without her finding out about it. I thought about what that would mean.

…

Why does my memory insist that the story of Anselmo, Camilla, and Lothario in *Don Quixote* is other than what it is? I remember it as the story of a man (Anselmo, though I didn't know his name or any of the others until I reread the book) who convinces his friend (Lothario) to dress up as him (Anselmo) in order to seduce his wife (Anselmo's wife, Camilla), making Anselmo a cuckold, having been cuckolded by himself. But that makes no sense. How would that work? A woman can't cheat on her husband with a man she believes to be her husband, can she? What would that prove to the husband? Was I thinking of another story entirely? Or, as seems likely, was I conflating one or more other stories with this one?

For a very long time, I thought that Anselmo's story was in *The Decameron* or maybe *The Canterbury Tales* but I couldn't find it in either. I had read all three books around the same time, twelve or thirteen years before (I had also read *Manuscript Found at Saragossa* and a few collections of folk tales and fairy tales at the time, making the whole thing even more difficult), but I never considered that the tale I was looking for could be in *Don Quixote*. Where the *Tales* and their clear influence, *The Decameron*, are mostly about the stories themselves, their frames receding, the *Quixote* is very much about its frame, about Don Quixote, even while it is really a compendium like the other two. Somehow, Cervantes focused his readers on the man of the title despite (because of) the profusion of characters and subplots. Is it as simple as madness, a stereotyped and rudimentary but still distinct characterization? Or is there something in Cervantes's

choice of tales that focuses us?

...

[Jimmy] Stewart became in a way what Hitchcock considered *himself* to be: a theorist of murder (*Rope*); a chair-bound voyeur drawn to and fearful of love (*Rear Window*); a protective but manipulative husband and father (*The Man Who Knew Too Much*); and the passionately haunted pursuer of an impossible, duplicitous ideal (*Vertigo*).
(Spoto, *Spellbound*)

...

Anselmo convinces Lothario to try to seduce Camilla, his wife. Lothario refuses at first, but Anselmo is relentless. Eventually, Lothario agrees, but Camilla refuses his advances. Lothario reports back to Anselmo. Anselmo is not satisfied. He doesn't believe Lothario. Anselmo leaves town, and arranges for Lothario to stay with his wife. Lothario can't help but fall for Camilla, and Camilla gives in to Lothario's advances, too. After an anticlimactic detour via a maid and her lover, Camilla and Lothario run off together and Anselmo finds out that Camilla was faithful to begin with, but, through his own actions, is not anymore. Anselmo dies out of grief. "Lothario" is now used to describe (this is according to *Webster's New World College Dictionary*) "a seducer of women; rake." This seems unfair to Cervantes's character—Lothario resists Anselmo's plan, and, though he does fall in love with Camilla and does seduce her, it is all unwillingly. His seduction, such as it is, isn't his. Instead, he carries out his friend's orders. It is really Anselmo's seduction of Lothario that we witness; Lothario and Camilla have much smaller parts to play. Apparently, a later adaptation of this story, a play by Nicholas Rowe called *The Fair Penitent*, is the more likely source of the eponym, but it's interesting to think about what it

might mean if it is Cervantes's tale behind it. Why should such a man be so reviled?

…

Vertigo is or could be considered a variation on Anselmo's story, particularly a variation in which it is not curiosity or perversity driving Anselmo, but revenge. But who, in such a version of *Vertigo*, would be Anselmo? Elster seems the obvious choice, but I'm not so sure it would be Elster. Couldn't it instead be Scottie? (Or Madeleine, from beyond the grave?) Is this the source of my confusion about the tale's storyline? If Anselmo had asked Lothario not only to attempt to seduce his wife, but to do so as himself, as Anselmo?

…

[EXT. Brocklebank Apartments (DAY)]

…

Many cultures tell stories about people who pretend to be other people pretending to be them, thus in effect masquerading as themselves, impersonating themselves, pretending to be precisely what they are. This . . . tells us that many people must put on masks to discover who they are under the covert masks they usually wear, so that the overt mask reveals rather than conceals the truth, reveals the self beneath the self; and it tells us that, although such masquerades cannot change people into other people, they may change them into others among their many selves.
(Doniger, *The Woman*)

…

Hitchcock: "I don't want to film a 'slice of life' because people can get that at home, in the street, or even in front of the movie theater. They don't have to pay money to see a slice of life. And I avoid out-and-out fantasy because people should be able to identify with the characters. Making a film means, first of all, to tell a story. That story can be an improbable one, but it should never be banal. It must be dramatic and human. What is drama, after all, but life with the dull bits cut out."

…

Truffaut to Hitchcock: "Almost all of your films center on an interchangeable killing, with one character who has committed the crime and another who might just as well have been guilty of it."
(Truffaut, *Hitchcock*)

…

[INT. Scottie's Car (DAY)]

…

From Hitchcock's December 4, 1956 letter to Maxwell Anderson, inviting him to do a second script of *D'Entre les Morts*:

"Before I go on to tell you what has been done, I think I should admit to you that after all this time it might have been better for me to have followed your original suggestion to have completed the structural layout even as far as a temporary script before you did the dialogue. I can only apologize for putting you to 'double trouble.' (Wouldn't this be a good title for this picture?) . . .

"First of all, I should make it clear that the structure has been organized on the basis of telling two stories. First, the 'front' story, which is the one that the audience is looking at and

second the big story which, in other words, is the conspiracy and which is only revealed to the audience in the final scene."

…

The movie does play like two movies, though not the interlocking or complementary ones Hitchcock describes in his letter to Anderson. Instead: as one ~eighty minute feature that ends with the faked death of Madeleine (the discovery of her *real* corpse) and the inquest at San Juan Bautista, and one oddly-proportioned (a little less than an hour) shorter film that follows Scottie's confinement in the hospital. The interim between these two narratives is like that between two movies in a theater: the lights go down, flash, then come back up; there is music, but, apart from that, almost no sound; and the rest of the film more or less ignores this period in its characters' lives—we get details of Scottie's earlier hospital stay from Midge in the "first" film, but Midge disappears before the "second" film begins and there is no one to take her place. This second film is what most critics focus on, the story of Scottie remaking Judy into Madeleine and the discovery of Hitchcock's "conspiracy," but it takes up very little screen time, comparatively speaking.

…

From Hitchcock's notes:

A. The necklace from the portrait definitely connects Judy with the past. Therefore I haven't created another Madeleine, Judy is Madeleine!
B. If I were to confront her now, she would deny everything, because I have already seen her identification as Judy.
C. If Judy is Madeleine, who was the woman who fell from the tower, dressed the same as Madeleine, with the same color hair?
D. Judy could not have been Elster's wife at the time because

Elster's wife's maiden name was Valdes.

E. Elster's wife had money therefore she must have been the dead woman—murdered for her money.

F. Why was I brought into this thing? Madeleine pretended to have suicidal tendencies. I was fooled by her throwing herself into the water. I was fooled by the Carlotta Valdes nonsense. But why me? Because I was to be a witness of the suicide—a witness who could not climb to the top of the tower.

...

It is no longer a question of imitation, nor duplication, nor even parody. It is a question of substituting the signs of the real for the real, that is to say of an operation of deterring every real process via its operational double, a programmatic, metastable, perfectly descriptive machine that offers all the signs of the real and short-circuits all its vicissitudes.
(Jean Baudrillard, *Simulacra and Simulation*)

...

Again, though, there may be three parts to the movie, not two. Not just before the staged death and after, but before Scottie's acrophobia, during it, and after his "cure"; what Scottie believes is happening (the "front" story), what is really happening (what "the audience is looking at"), and something that cannot be defined (" ") but which must have something to do with Scottie's life before his accident. Or with Judy's.

...

People need to feel that they have been thwarted by *circumstances* from pursuing the life which, had they led it, they would not have wanted; whereas the life they really want is precisely a compound of all those thwarting circumstances. It is a very elaborate,

extremely simple procedure, arranging this web of self-deceit: contriving to convince yourself that you were prevented from doing what you wanted. Most people don't want what they want: people want to be prevented, restricted.
(Dyer, *Rage*)

…

The actress took the limitations of her costume as a source of character development: "I can use that feeling when I play Judy. Judy is trapped into portraying Madeleine, and she doesn't want to. She wants to be loved as Judy. But she always has to go along with what someone else wants in order to get the love she wants. So I used that feeling of wearing someone else's shoes that didn't feel right, that made me feel out of place. The same thing with Madeleine's gray suit, which made me stand so straight and erect the way Edith Head built it. I hated that silly suit, to tell you the truth, but it helped me to be uncomfortable as Madeleine."
(Auiler, *Vertigo*)

…

It is an odd thing, but everyone who disappears is said to be seen at San Francisco. It must be a delightful city, and possess all the attractions of the next world.
(Wilde, *Gray*)

…

According to Hitchcock's biographer Patrick McGilligan, the sequence of Scottie following Madeleine was originally accompanied by a voice-over. It must have been Scottie's narration—who else could it belong to?—but, since he knows nothing about Madeleine or what she's up to in these scenes, and since he must come across as mystified so that we, the audience,

will know that *we* should be mystified, I can't imagine what he would have said. "Well, now, I wonder what she's doing here." Having that voice-over would put the audience in Scottie's head, making the picture that much more subjective, so the fact that it has been cut from the film as it was eventually released must mean that we are not meant to be in his head, that we should be further removed from the events we see onscreen than Scottie is. We are not meant to empathize with him, but still we feel what he feels sympathetically because he is the film's focal point, and because while we cannot understand Madeleine—who, after all, doesn't exist to be understood—we *can* understand Scottie.

…

I can't find any evidence of this voice-over in the script, but in the version posted on dailyscript.com (accessed 7/22/12), there *is* a voice-over—Elster's—in the Ernie's scene. Elster's monologue continues from the office scene to the restaurant: "I don't know what happened that day: where she went, what she saw, what she did. But on that day, the search was ended. She had found what she was looking for, she had come home. And something in the city possessed her."

…

Elster yearns for the past and fears it.

…

It always surprises me when a commentator remarks upon Judy as Elster's mistress. I see no evidence for it in the film.

…

[INT. Flower Shop (DAY)]

…

Does Madeleine seem to be turned away from Scottie because she is shown in a mirror (and so reversed, as in a negative)? Or is she actually facing away from him?

…

I was either bored or I was obsessed. I don't have enough distance from myself to be able to say. I scrolled through hundreds of pages of search results for "Gabriel Blackwell," thinking maybe, eventually, I'd come to the end. There, buried deep in all those virtual mes, were ads for "Background Reports," people promising to continue my search in the real world. How could I resist?

The first service that had me in its database was named "personsmart.com"; all I could see without ordering their report were the cities and states where I had lived, my age, my immediate family members, and any aliases I had used (I hadn't used any, but the listings around mine all had several, a fact I found intriguing). Their information was accurate, but they had my age wrong—they thought I was two years older than I was—and they thought I still lived in New Orleans, even though I had moved away in 2005 and had lived in three places in Portland in the meantime. For $27.95 (discounted 30% with "membership trail" (sic, I think—they had to mean "membership trial," as appropriate as "trail" is)), personsmart.com would send me a report listing my: "age, possible current address, up to 20 year address history, phone numbers, bankruptcies, tax liens & judgments, property ownership, possible relatives, possible roommates, aliases / maiden names, neighbors, marriages and divorces, dea registrants, nationwide criminal check and website ownership." Even though I was curious about the difference in

90

age, I couldn't justify spending thirty dollars to have someone tell me things I already knew. Half of the things they offered to tell me about myself had nothing to do with me anyway.

But when I clicked back to the Google search results page and tried the next link (there were results from "stillman.com" and "america-person-search.com," among many others), I found the same info, the same weird age mistake, and another address, one that did not correspond to any city I had ever lived in, in San Francisco. San Francisco? Surely this was a joke.

. . .

There are . . . times . . . when the performance of a conscious self-imitation, or anti-Method acting, comes in very handy. A person who has undergone a trauma . . . may experience it like a death, so that she feels as if she had become a different person and tries to keep going by pretending to be who she was, trying to behave as she knows she used to behave, until she can remember how it actually feels to be who she is.
(Doniger, *The Woman*)

. . .

Does one ever resemble oneself?
(Villiers de L'Isle Adam, *Tomorrow's Eve*)

. . .

Ecstasy . . . literally means being beside oneself, which means standing slightly apart from one's body and slightly apart from one's mind. From which vantage point one might experience one's body—and perhaps even one's consciousness—as things.
(Maggie Nelson, *The Art of Cruelty*)

. . .

You put on a bishop's robe and miter, he pondered, and walk around in that, and people bow and genuflect and like that, and try to kiss your ring, if not your ass, and pretty soon, you're a bishop. So to speak. What is identity? he asked himself. Where does the act end? Nobody knows.
(Philip K. Dick, *A Scanner Darkly*)

…

In this film in which we have a man (Gavin Elster) playing himself but not himself (since not only is he innocent in his version of himself, but he is also concerned for his wife's health and safety in that version of himself) and a woman (Judy Barton) playing another woman (Madeleine Elster) who is supposed to be playing a third woman (Carlotta Valdes), it seems notable that the only character whose identity can actually be said to have really changed during the film is the one who seems most himself throughout: Scottie Ferguson.

Scottie leaves himself behind at the beginning of the movie when he retires from the police. And he does so without regret—when Elster asks for his help, Scottie tells Elster, "I don't want to get mixed up in that kind of stuff," the kind of stuff that was once his profession, the kind of stuff he used to do every day. When asked by Judy/Madeleine what he does, he says, "Oh, just wander." He has gone from a detective with the ambition to become chief of police in the first frames to a flâneur without any particular interests for most of the middle of the movie. Not only this, but he is suffering from acrophobia, an illness he did not have when the movie began, suffering from it to the degree that he has changed his life completely to accommodate it. And yet, on a surface level, Scottie would seem to be the most stable character in the film—"stable" being relative, given his mental instability and his obsession, provoked by Madeleine's death. He is stable to the degree that that instability and obsession is present more or less throughout the movie, and stable to the degree that

at least his actions are explainable. He is, paradoxically, the least frangible of the film's main characters, the one we, the viewers, can count on to be himself and to remain himself, even though, again, he doesn't remain himself, and may not, when we meet him, even *have* a (fixed) self.

…

Sometimes coincidences take years to arrive and, at others, come running along in Indian file, one after the other.
(Saramago, *The Double*)

…

I was invited to give a reading in San Francisco. It was the only such invitation I'd received since before my book had come out, and, even though the organizers couldn't pay, I felt like I couldn't say no. It was superstition. I told my wife that I thought if I turned this one down, I would never be invited to give a reading again. Besides, the flight to SFO was only an hour and a half, easy: I could fly down in the afternoon, read that night, and then have the following day to myself. My wife had to work and couldn't come with me—with me unemployed, she said, she couldn't afford to take the time off. The tickets weren't expensive, but I was broke. I figured that since I was already going into debt for this trip, I might as well go to stillman.com and request all the information they had on the Gabriel Blackwell who supposedly lived in San Francisco, the Gabriel Blackwell who shared so much information with the Gabriel Blackwell who was me. It's not as though I was expecting anything.

The report was even stranger than I thought it would be—obviously, something had gone very wrong somewhere along the line. According to the report, I (and it was definitely me: "our" past addresses were the exact same, for one thing, and so were the names of every member of our immediate family; I

93

mean, there has to be a limit to coincidence, right?) had moved to the Castro in San Francisco from an address in Portland I'd left almost five years ago, just before my wife and I got engaged and moved in together. There was no record of our present address. And their records had me down as two years older—I still wasn't sure what to make of that. My wife and I bought a car just before I found out I wouldn't be a professor anymore; our credit histories had been checked by finance guy after finance guy—this couldn't be someone posing as me, at least not for the purposes of financial gain. So what, then? I had "his" address and I was on my way to San Francisco.

…

[INT. Mission Dolores (DAY)]

…

When Scottie enters the Mission Dolores, Hitchock's composition puts the two bell-pulls(?) in the background at the center of the shot (the camera also lingers on them, after Scottie leaves the shot). These bell-pulls resemble hanged men, one lower than the other.

…

Carlotta Valdes
Dec. 3, 1831 - March 5, 1857

…

Though Carlotta Valdes is, by all accounts, a suicide, she is buried in the cemetery at the Mission Dolores, a Catholic churchyard. According to the movie, she was interred in 1857. Catholic views on suicide have changed, of course, and suicides *can* now

be buried in consecrated ground as a result of Vatican II (1962-1965), but prior to that council, suicide was considered murder and the deceased treated as a murderer. So, is Gavin Elster lying about Carlotta's cause of death? Is Pop Liebel misremembering it? What was Carlotta's actual fate, if not suicide? What if, in dying through an accident caused by a man obsessed by his image of her, Judy really *is* reliving Carlotta's death? What if, in seeking to avoid our fates, we instead ensure them?

…

In *Basic Instinct*, Catherine Trammell, writing under her pen-name Catherine Woolf, writes the novel *Love Hurts*, describing perfectly the crime that will occur, before that crime actually occurs.

…

The bodies of suicides were not interred in consecrated ground because of concern over their resurrection on Judgment Day.

…

In the past, according to superstitions that functioned with the force of law [and with barbarous inhumanity towards their families] suicides were interred with a stake through the chest to *lay the ghost*.
(Jeffrey Pethybridge, *Striven, the Bright Treatise*)

…

The address I got from stillman.com was on 19th Street, an apartment in one of those old Victorians that made me jealous of people who lived in San Francisco. The house was or had been green with white accents, but, unlike the other neat homes

next to it, the paint was flaking off and there were garbage cans out front, tagged in illegible white letters: "Lost Boys." My hand shook when I reached out to punch in the number of the apartment on the keypad. It took me two tries to get it right, and no one answered. As I was walking back down the stairs, I was surprised by a loud buzzing noise. I could feel the vibration of it in my stomach. It went on just long enough for me to collect myself, climb back up the stairs, and open the door.

To the left of the door were five metal mailboxes with numbers on them. My number was the highest of the five (it was number 10, for some reason, not number 5), so I guessed the apartment I was looking for was on the top floor. The door started buzzing again. I looked up and someone with long, wavy blond hair leaned over the railing of the staircase above me and then immediately disappeared back over the banister. I tried to say "Hello," but all that came out was a wet sound like "hech." I felt too self-conscious to try again. I debated whether I ought to go up the stairs, but then I felt stupid for standing there, on a stranger's staircase, not moving, and I went up.

The stairs were narrow and carpeted, with dark oiled wood banisters and a large oval opening down the center. All the lights I passed were unlit, but there must have been a skylight at the top of the stairs because a weak daylight irradiated everything. There was the muffled sound of hammering that could have come from one of the floors above or from another building entirely; apart from that, the house was silent.

When I reached what I thought had been the place where the person had looked over the railing, there was no one there. At the end of a short corridor next to the next flight of stairs, there was a potted plant and a green door. There would have been no reason to knock. It was not the apartment I was looking for. The numbers kept climbing, but I had not reached number 10, so I kept climbing, too.

The carpeting stopped before the stairs did, on the way up to the fourth floor. I felt distinctly as though I was not supposed

to be where I was. The skylight in the ceiling let in light through a thick film of dust or decayed leaves or pollen or something, just bright enough to see down another unlit hallway with two doors on either end, both open, neither numbered. I didn't know what to do. I went back down a flight to the potted plant and the green door to check the numbers of the apartments. One higher than the other, each lower than the number I was looking for. I went back up to the top, feeling lightheaded from all the climbing. Maybe I was holding my breath. I looked into the back apartment first, but the flooring there had been removed. Clearly, it could not be this one, I thought. I looked into the front apartment, which at least had subflooring down. It was dark, but the windows had no coverings and there was enough light that I could get around without bumping into anything (though I couldn't really see what it was I wasn't bumping into). Many of the walls had been opened and sheetrock had not yet been hung. Some of the wiring had been done, and some of it hung out of the walls or from the ceiling. I had to use my phone as a flashlight in a couple of the rooms. In what had once been and would possibly again become a bathroom, I found some tools that I guessed were used for plumbing. Like the floors in the other rooms, they were covered in a thick layer of dust. I guessed the owners had begun a renovation and then run out of money, or else just given up on their own project. No one could live here, I thought. I walked through each room again, slowly, looking for any clue, but I didn't find one.

…

Carlotta's headstone remained in the Mission Dolores cemetery for several decades, a tourist attraction, until one of the movie's rereleases, when members of families with relatives buried in the churchyard complained—a headstone without a body buried beneath it, on consecrated ground? In 1889, 16th Street was extended through the Mission and some remains had to be

reburied in a mass grave. And in the 1950s, other bodies were disinterred and moved to other cemeteries to make room for new construction. Carlotta's headstone could hardly have been the only marker for an empty grave at Mission Dolores. According to the website, "HowStuffWorks.com," it takes the flesh of a buried body fifty years to fully decompose. By the time of this writing, then, even if a body had been buried under Universal's prop headstone at the time it was erected, there would be no body there now. A skeleton, perhaps, some cloth, but nothing recognizable as the person commemorated by the headstone. What would the Church have done if, removing the headstone, there had been a coffin underneath, a skeleton inside? Look again at the scene of Madeleine (Judy) in the cemetery. Look at how close together the graves are.

No one seems to know what became of the headstone. Is it up in some attic in the Mission? In a disused belfry? In a basement, below the ground?

…

[INT. Art Gallery (AFTERNOON)]

…

PORTRAIT OF CARLOTTA
Artist Unknown
Donated Anonymously

…

The "Portrait of Carlotta" Madeleine visits in the Palace of the Legion of Honor was first painted to resemble Vera Miles, the actress Hitchcock intended to play Madeleine. The painting of Miles-as-Carlotta still exists. When Miles announced she was pregnant and Kim Novak was cast in her place, the painting had

to be redone, somewhat hastily, by the artist John Ferren, who designed the dream sequence later in the film (the first version had been painted by an Italian painter, Manlio Sarra). And the version that appears in *Vertigo* does resemble Kim Novak—look at the nose, the cheekbones, look at the jutting lower lip—not perfectly, but closely. Are we then supposed to understand that Madeleine does in fact resemble Carlotta (is Scottie ever shown a photo of Madeleine, the "real" Madeleine?), and Judy, in turn, resembles Madeleine? Or has Judy been chosen not for her resemblance to Madeleine, which would perhaps be dangerous for Elster, appearing at Ernie's, but for her resemblance to Carlotta, who Madeleine is not, in fact, related to and does not (did not) resemble? Madeleine, then, fated for a different, unique death, while Judy, acting out Madeleine-as-Carlotta, really acts out Judy-as-Carlotta, atavistically, unwittingly, repeating her true ancestor's/historic double's story?

...

You say your being, your vital joy, have been taken from you by a human presence? By the light of a smile, the gaiety of an expression, the softness of a voice? A living woman leads you, by her attractiveness, to your death?

All right! Since this woman is precious to you—I AM GOING TO STEAL HER OWN EXISTENCE AWAY FROM HER!

I'm going to show you . . . I can capture the grace of her gesture, the fullness of her body, the fragrance of her flesh, the resonance of her voice, the turn of her waist, the light of her eyes, the quality of her movements and gestures, the individuality of her glance, all her traits and characteristics, down to the shadow she casts on the ground—her complete identity, in a word.
(Villiers, *Tomorrow's Eve*)

...

When, in his essay "Ev'ry Time We Say Goodbye," John Berger writes, "Painting brings home. The cinema transports elsewhere," he is trying to highlight the movement that defines moving pictures. "Movies," he says, "not because we see things moving, but because a film is a shuttle service between different places and times." "Ours is the century of enforced travel," he writes, "I would go further and say that ours is the century of disappearances. The century of people helplessly seeing others, who were close to them, disappear over the horizon. . . . Perhaps it is not so surprising that this century's own narrative art is the cinema."

Reading all this, it strikes me that, though we may be said to look at a painting, the same cannot be said of a film—we do not look *at* it. We may think of a painting's subject when we look at it, but, in doing so, we are forced also by the experience to consider the texture of the canvas or the wall or the object in front of us, the painted-on surface. We look and see the relief of the oil paint or the wash of the tempera or the flatness of the lacquer. Another way of saying this is one cannot look through a painting as one does a window.

Film is something different. It is projected. What we see is light, not film. The surface onto which a film is projected is customarily ignored; typically, the artist has no say in what her film is projected onto. Film thus better resembles a window than a painting, and better resembles a memory than a window, for no matter how abstract a film gets, it will always be nothing more than a portal into the past: some past person or some past vista or some past event—film invites the viewer to cast himself back into the past, to stand behind the viewfinder and view something happening elsewhere at some other time as though he were present and contemporaneous. It is, in other words, ethereal, evanescent, nonexistent. It is not a thing but a memory.

And yet, most films are not documentaries. They pretend to represent something that never existed *as it seems in the film*, but which nonetheless did, at one time, exist. When we see Scottie

seeing Judy for the first time, we are not seeing Scottie seeing Judy for the first time, but we *are* seeing Jimmy Stewart. We are seeing Kim Novak. Scottie does not exist, but neither does Jimmy Stewart, and even though Kim Novak still exists at the time of this writing, she does not exist as she did at the time of filming. What we are not seeing is a representation of Jimmy Stewart, a representation of Kim Novak. In no way is *Vertigo* a thing on the same order as a painting. We are seeing things as anyone on set would have seen them, just with certain parts of the set cropped out, certain moments in time cut from our memories. It is not impossible that someone on set might have a memory of filming *Vertigo* that includes everything in *Vertigo* and nothing else. Her memory would then be identical to the film. One cannot say the same of a Monet. One cannot say the same even of a Warhol.

…

[INT: McKittrick Hotel Lobby (DAY)]

…

"It does seem silly," or so says Ellen Corby, the actress who plays the unnamed manager of the McKittrick Hotel, in a scene whose importance to the so-called "front" story has always escaped me—the connection to Carlotta is or could be important to Elster's illusory Carlotta/Madeleine storyline, but why should Madeleine go there and then disappear? And why should Corby's character deny that she was there? If she really hasn't been there, then what have we seen? What does any of it mean for Scottie, for Judy? Clearly, Judy can't allow Scottie to catch her there, but why bribe the manager (if that's what's happened) to say that she hasn't been there at all that day? And if she slips in past Corby, how has she slipped out?

…

Corby gives up "Carlotta's" name when Scottie shows her his badge, but won't admit to having seen her that day—yes, I know who she is, but no, you haven't seen her. The effect is of convincing us that Judy-as-Madeleine is Scottie's fantasy rather than Elster's, that he is already following a ghost.

…

Corby's manager betrays no knowledge of the hotel's history— "Carlotta Valdes?" "Yeah, that's it. Sweet name, isn't it. Foreign, but sweet." But not the same name as that of the woman for whom the building was built? Is Corby's manager even real?

…

Walking back to my hotel, I found a used bookstore that specialized in genre fiction. I wouldn't have stopped if it had been just another used bookstore—there were many on Valencia—but the lurid painted covers of the paperbacks in the front window drew me in. There were bookshelves from floor to ceiling and old drugstore paperback racks ringing what had formerly been the original oak bar, complete with brass rail. Drawn up next to the bar was an ALF standup and, next to it, Paul Muni from *Scarface*, but there was no one behind the cash register, or anyone in the shop at all that I could see. The categories the books were organized under were absurdly specific—"Extraterrestrial Vampire Romance"; "Afrofuturism"—but mercifully for me, there was a "San Francisco Noir" section near the front door. The bells on the door had jingled, and I could hear someone walking around in the back—the floorboards creaked—but no one came out. I had to hit the porter's bell on the bar to get the clerk's attention. A young woman opened the door opposite the one I'd heard the creaking coming from. She whispered

something as she came out, I couldn't hear what. She sold me a hardbound omnibus edition of Dashiell Hammett's novels, priced at $10, and then went back into the back room. I took a postcard on my way out.

Because I had a couple of hours to go before my reading, I went back to my hotel room and started to read *The Maltese Falcon*. I had never read it, though I'd seen the movie once, long ago. It was good, and I ended up taking the book with me everywhere; I read it in the Indian buffet where I had a very late dinner; on the bus to the reading that night and on the way back; at Fisherman's Wharf the next day; on the boat to Alcatraz; up at Coit Tower.

There was a bookplate on the inside cover with no name written on the line. I debated whether I ought to write my own name there. Normally, I didn't like to write in books. Some of the calligraphic letters of the "Ex Libris" ended in flourishes that were meant to look like crows or ravens. I wondered: the Falcon had been covered in black enamel, supposedly to hide that it was gold underneath, but underneath the enamel was lead. Gutman hadn't thought to look underneath the lead— he had just left the Falcon to Spade and O'Shaughnessy and walked out. Could it have been more difficult to encase the gold statue in lead than to make a new statue out of lead that was an exact replica of the original, gold statue? Either way, you'd have to go through the same process, wouldn't you? No one had thought to check: What if there was gold underneath that lead? What if they had found what they were looking for after all, but it had been disguised so well they hadn't realized it? What's a better disguise for something valuable than something worthless disguised as something equally worthless?

…

The most devastating line in *The Maltese Falcon* is also the most autobiographical: "He loved his family, he said, as much as he

supposed was usual, but he knew he was leaving them adequately provided for, and his love for them was not of the sort that would make absence painful." Could Hammett's wife really have failed to read what was meant?

...

We are all more or less public figures, it's only the number of spectators that varies.
(Saramago, *The Double*)

...

My wife and I fought once late at night, long after we had fallen asleep. One of us woke the other by accident: I thought she had kicked me awake and she thought I had shaken her awake. If I did, it was because she had kicked me. That's what began it. Though it started with who woke who, it moved on to other things, I can't say what—I wasn't completely awake at the time and now I can't remember—but I do remember that it was very contentious. For the first and only time, my wife (rather than I) left to sleep on the couch, and I became even angrier when I heard her snoring a few minutes later. How could she sleep at a time like this? I fumed, alone, in our bed.

The next day, I rode the MAX downtown to the Central library. This was in the days of Fareless Square, when one could ride the MAX to the library for free. I fell asleep on the train somehow, just for a few moments but long enough to wake completely disoriented. Worried I had already missed my stop, I immediately got off, as it turned out, a stop too soon, at Pioneer Square. I stumbled out of the train, trying to make my way through the crowd of people trying to get on the train. Directly in front of me, even walking toward me through the crowd, was a man who looked exactly like me. I stopped dead in my tracks. It wasn't until a man shoved past me, a man with a bike who had

waited for me to decide what direction I was going in and then lost his patience, that I realized that I was not looking at another man at all, but at my (exceptionally clear) reflection in the full-length glass of the Starbuck's kiosk. Naturally, I put this down to a lack of sleep.

Many months later, I had a similar experience in San Francisco's Union Square, except that I had slept well the night before, and what had been in Pioneer Square just a reflection was, in Union Square, not.

…

[INT. Argosy Bookshop (DUSK)]

…

Scottie and Midge enter Pop Liebel's Argosy Bookshop at dusk, according to the script, and the sun sets while they talk with Liebel. Making the sun seem to set and the light disappear was tricky because the interior of the bookshop is actually a set, on a soundstage somewhere in Los Angeles, and so the San Francisco street scene we see outside of it is not outside of it at all; it is another piece of film, rear-projected onto a screen behind the set. The lighting on the set had to be matched to this other piece of film while the scene was being shot and then gradually dimmed while shooting was going on, all while presenting the actors and the set the way Hitchcock wanted them presented, no simple feat. And if the light on the set at any given moment didn't quite match the light on that piece of film, the whole scene would have to be shot again. If the actors flubbed a line, the scene would have to be shot again, and again, the lighting would have to be matched. If someone on the set coughed, if someone walked in front of the camera, if a truck passed by outside, if the boom mic got in the shot, if any one of a thousand things went wrong, the scene would have to be shot

again, and again the lighting would have to be matched. Shooting on location, especially at that time, presented its own share of difficulties, but this inconsequential effect seems excessive to me—how much simpler to just have the scene take place during the day, when one lighting scheme could be used throughout, or during the night, when, again, a single lighting scheme could have been used, instead of this borderland between the two necessitating such a complicated lighting scheme. This is one of many places in his films where Hitchcock, whether intentionally or not, highlights the artificiality of what he is doing, of what we are watching.

. . .

At 00:33:50, the first shot of the Argosy, Midge and Pop Liebel in the background could easily pass for Kim Novak (note the gray coat, mimicking the gray suit) and Alfred Hitchcock.

. . .

Pop Liebel's Argosy Bookshop is, in reality, the Argonaut Book Shop, located on Sutter Street between Jones and Taylor, four blocks west-northwest of Union Square. The street scene projected onto the screen behind the set is thus very close to the spot where Scottie will follow Judy to after seeing her for the first time, "Sutter Street near Leavenworth," i.e., one block west of the Argonaut. Both the fake Argosy and the real Argonaut specialize in California history; any further west than this spot in the city, the film seems to say, and everything is an invented history, a fakery, a hoax. Or should I be looking at it as one would a negative? Do I have it backward? Is the history invented and the hoax fact?

. . .

Cinema provided [a] lens for seeing truly and for seeing what could not truly have been seen before. Many early films, like those of the quick-change artist and impersonator Leopoldo Fregoli, were devoted to the disrobing of false identities, the unveiling of deceptions.
(Schwartz, *Culture*)

...

Nicholas of Cusa, in "On Informed Ignorance," writes: "The finite mind can therefore not attain to the full truth about things through similarity. For the truth is neither more nor less, but rather indivisible. What is itself not true can no more measure the truth than what is not a circle can measure a circle, whose being is indivisible. Hence reason, which is not the truth, can never grasp the truth so exactly that it could not be grasped infinitely more accurately. Reason stands in the same relation to the truth as the polygon to the circle; the more vertices the polygon has, the more it resembles a circle, yet even when the number of vertices grows infinite, the polygon never becomes equal to a circle, unless it becomes a circle in its true nature. The real nature of what exists, which constitutes its truth, is therefore never entirely attainable."

Lawrence Weschler, in his book of interviews with artist Robert Irwin *Seeing Is Forgetting the Name of the Thing One Sees*, translates Nicholas slightly differently, writing, "Logic, [Nicholas] suggests, knowing, is like an n-sided polygon nested inside a circle. The more sides you add, the more complexities you introduce, the more the polygon approaches the circle which surrounds it. And yet, the farther away it gets as well. For the circle is but a single, seamless line, whereas your polygon seems to be breeding more and more lines, more and more angles, becoming less and less seamless." It is significant that Weschler puts the opposition in terms of logic and faith, rather than reason and truth. We may ask ourselves, what is the nature of

Scottie's faith in Madeleine? What is the status of her truth? We may find, along with Scottie and Nicholas, that reason and logic simply don't apply. We may find instead that we have attempted to measure something using a tool not suited to the task.

. . .

Pop Liebel remembers the name Carlotta Valdes—and her tragic end—but not the name of the "rich powerful man"?

. . .

Whether a daring inventor or a living anachronism, the forger is a master of the déjà vu, producing what the archaeologist or historian is already looking for, artifacts or documents quite familiar and a little strange. The familiarity makes the work meaningful, the strangeness makes it valuable.
(Schwartz, *Culture*)

. . .

If it is as Pop Liebel says it is, Elster's story has what looks like a large hole in it: a powerful, rich man—never given a name— has a child with Carlotta Valdes; being childless, he and his wife take the child as their own. So far so good. We are not told what sex the child is or any other details about it, but we know it will become Madeleine's grandparent. The rich, powerful man who is the child's father is thus Madeleine's great-grandfather, and so his identity should be easy enough to find, though the movie makes no effort to find him. The script even goes to the extent of having Liebel not remember his name so that Elster can, in a subsequent scene, be the one to reveal that Madeleine is related to Valdes. This delay is in fact unnecessary, as we never learn Madeleine's maiden name and have no reason to suspect that Scottie knows it at this point in the movie or would recognize it

if Liebel were to remember it.

Now, unless that rich, powerful man has made a point of informing his child or those close to him that the child, while his, is not his wife's, that child would have no reason to suspect that the woman raising it (the wife of the rich, powerful man, in other words, not its mother) was not its mother. Given all the rich, powerful man has already done to Carlotta, and given the results of all of those actions—Carlotta's suicide—one would be excused if one were to assume that the rich, powerful man would likely have wanted to keep the child's true parentage a secret from everyone, except perhaps his wife, who would be embarrassed if the truth were to come out and so would be likely to have her own reasons for sharing—and keeping—his secret. And if all of that is so, where and when would Madeleine's mother, two generations removed from those events and thus protected by two layers of secrets and fictional history, where would she have learned about Carlotta and her connection to the Valdeses? Who still alive would have known enough to tell her?

…

We can apprehend the sadness in so many works by male copy artists, who battle to make the copier an instrument of total salvation and arrive so often at absence . . . the works seem exhausted by their bodiliness, the artists less proud of the resultant image than of their struggle with the machine to realize it.
(Schwartz, *Culture*)

…

In Boileau and Narcejac's *D'Entre les Morts*, the Elster character tells the Scottie character about the family connections at once, in the novel's equivalent to the office scene. And the ancestor driven mad has not had to give up her child, so the wife of the

Elster analogue in the novel has the madwoman's name as her maiden name. Why did Hitchcock and his screenwriters want to make this situation so much more complicated?

…

The self, as viewed not only by the self but by the person for whom the self is the object of love, begins at one remove from the ideal partner, the "right" one, and approaches that sense of rightness only when a substitute is found for the substitute. (Doniger, *The Woman*)

…

After many years of living in cities, I don't look into people's faces when I pass them on the street. Maybe it's wariness, or some attempt at self-preservation. Later, in my memory, they've been erased. In my mind's eye, the people I passed minutes before are a blur, but the buildings and the streets are there. Does the brain work the way the first cameras did, with an exposure time so long that, unless its subjects remain perfectly still, they turn into smears? How else could you live so close to so many other people?

I can't remember a single other person from that day now, and I'm sure if you'd asked me an hour after it happened, I would have said the same. This man, the man with my face, would have been just another blur if it weren't for the suit he was wearing; I'm sure of it. The suit looked familiar, which is what first caught my eye—he was across the square when I spotted him—but I don't know why it would have seemed familiar, since I couldn't recall ever seeing it before. This man had gray hair—mine could only be said to be graying—and he was thinner than I am, and because he was thinner he also seemed taller, but in all other ways he looked like me. I was terrified.

The moment I saw him, I felt as though someone had caught

me committing some crime. I tried to hide that I had seen him. I tried to keep walking in the direction I had been walking, in the manner I had been walking before, but I was conscious of the effort of seeming normal, and the people around me couldn't possibly have failed to notice it, too. *He* noticed it. As we passed shoulder to shoulder, he looked me full in the face, and, without changing his expression, swung around and started to follow me. I saw his reflection in the windows of the Union Square Macy's. I could trace his shadow up Stockton. Above all else, I did not want to meet him. I did not want to be confronted with him. Does it seem strange that I was frightened of him?

I ran up the street and then further up the hill, until I was crossing over the Stockton Tunnel, thinking I could duck back down the stairs into the Tunnel and give him the slip. But he was already down on Stockton when I got there, looking up at me. The stairs on both sides of the tunnel were closed, with fencing up around the entrances. I looked down at him, trying to think of what to say. "Well? What is it?" I asked. He said nothing.

…

[EXT. Dockside (SUNSET)]

…

And if Scottie follows Madeleine but refuses to help her when she jumps into the Bay? Or if he has another attack of vertigo at just that moment—perhaps, without meaning to, looking up into the net of guywires and girders below the bridge, thinking to himself how precarious any foothold up there would be, how far one would fall if one fell? What then? Would Judy take her role so seriously as to actually drown? How much could Elster have paid her, to make it worth it to risk her own death in playing out another woman's life? How much did a salesgirl's life cost in 1958? What could have been the nature of the payment?

...

Many more people commit suicide by jumping from the Bay side of the Golden Gate Bridge than the Pacific side. There are barriers on the Pacific side, but even before there were, more people jumped from the Bay side. And whether Maxwell Anderson's preliminary script had her jumping from that side or not, Judy jumps from that side.

...

Faked deaths always end in real deaths.

...

Only one is a wanderer. Two together are always going somewhere.
(00:57:37)

...

If there is a dark power which treacherously attaches a thread to our heart to drag us along a perilous and ruinous path that we would not otherwise have trod; if there is such a power, it must form inside us, from part of us, must be identical with ourselves; only in this way can we believe in it and give it the opportunity it needs if it is to accomplish its secret work.
(E. T. A. Hoffmann, "The Sandman")

...

The characters in [stories of self-imitation] circle back on themselves in a ring with a twist in it—the twist of self-deception or the deception of others, of ambivalence or ambiguity, or of the paradox of married sexual love.
(Doniger, *The Woman*)

...

Is "Only one is a wanderer . . ." a line Judy Barton from Salina, Kansas could have come up with? Are any of Madeleine's lines? She only really seems to be "acting" starting at 01:16:00, just before entering the tower.

...

In a story called "Web Mind #3," computer scientist Rudy Rucker writes, "To some extent, an author's collected works comprise an attempt to model his or her mind." Those writings are like a "personal encyclopedia," he says; they need structure as much as they need preservation. He thus invented the "lifebox," a device that "uses hypertext links to hook together everything you tell it." No writing required. "The lifebox is almost like a simulation of you," Rucker says, in that "your eventual audience can interact with your stories, interrupting and asking questions." He isn't only talking about the traces we leave after we die. He's repositioning immortality as a question of organization and technology. It's a technophile's version of the Turing test—if an interaction with you can be so perfectly simulated that there is no difference between interacting with you and interacting with the lifebox, is the you the lifebox simulates actually simulated, or is it, instead, another you?

While researching an article for *The Atlantic*, Alexis Madrigal discovered that telemarketing centers have begun using soundboards—recorded speech activated by the press of a button—in place of human response. Rather than answer the person on the other end of the line, the call-center worker selects the appropriate snippet of sound from a computer menu and then the computer responds to the caller. Even though nearly all such call-center workers were simply repeating a script to begin with, there were problems: some workers had weird or unpleasant voices, some had strong accents, and some couldn't

control their emotions. Humans are human. They have good days and bad days. Even at their best, they might not be as good as the best representatives. The solution? Record the best representatives and then have those recordings available to every worker, at the touch of a button. While Madrigal seems to join in the software's programmers' enthusiasm for this technology, he ends his article with the thought "When we look around our world at the technologies we have, it's hard to imagine the series of steps that got us to where we are."

Madrigal began investigating this technology, he tells us, because of an article in *Time*, "Meet the Robot Telemarketer Who Denies She's a Robot." The "robot" of the headline is named Samantha West. This Samantha West called *Time*'s reporter offering health insurance. When the reporter asked if he was speaking to a robot, Samantha West "replied enthusiastically that she was real, with a charming laugh," but when asked "What vegetable is found in tomato soup?" she claimed not to understand the question. (Fair enough—the tomato is a fruit.) When asked what day of the week it was the day before, she complained of a bad signal. Other reporters called Samantha West. Each time, her answers, both on-script and off-, were exactly the same. It seemed clear she was a robot.

Reading about these reporters grilling Samantha West, I couldn't help but think of Philip K. Dick's *Do Androids Dream of Electric Sheep* and his Voigt-Kampff machine. There, because cyborg technology is so advanced, the questions are trickier, based on emotion, something Dick presumed could not be programmed. And maybe he's right. Even if it could come up with slight variations on the same answer—as we all inevitably do when asked the same question—wouldn't Rucker's lifebox always have the same attitude, the same tone?

If Dick is right and the thing that puts us off about these "robot" or "cyborg" telemarketers is their lack of emotion (Madrigal points to this as their main benefit, since both callers and workers find such calls less stressful), then is emotion what

makes us us, what separates us from the way we talk about—and talk to—each other and ourselves? Where does that leave Judy Barton, answering from a script that is not only not her own but isn't even that of the woman she's been asked to play; not Madeleine's but Carlotta's, and not Carlotta's but Elster's? It is Elster's Carlotta's decision to commit suicide, not Madeleine's, and certainly not Judy's. Judy's emotions are not under her control. "Madeleine's" emotions are under Elster's control. But then what does that make Scottie, drawn in by a woman with the affect of a robot, falling in love with a soundboard? Is he just a dupe, or is it something more sinister than that?

...

In her book *The Future of an Illusion: Film, Feminism, and Psychoanalysis*, Constance Penley writes, "The bachelor machine is typically a closed, self-sufficient system. Its common themes include frictionless, sometimes perpetual motion, an ideal time and the magical possibility of its reversal (the time machine is an exemplary bachelor machine), electrification, voyeurism and masturbatory eroticism, the dream of the mechanical reproduction of art, and artificial birth or reanimation. But no matter how complicated the machine becomes, the control over the sum of its parts rests with a knowing producer who therefore submits to a fantasy of closure, perfectibility, and mastery." The concept of the "bachelor machine" originates with Marcel Duchamp and his *Large Glass*, but, as Penley's quote demonstrates, it has been adopted by theorists, metonymically used to mean a closed system, a machine that admits no input and delivers no output. Isn't Judy's Madeleine then a bachelor machine? To the extent that she can even respond to other people (and it is rare, very rare, that the other person is not Scottie), she must do so *as* Madeleine, i.e., within the system that Elster has created for her. Worse, the role she has been given is a bachelor machine within a bachelor machine—when she is

Madeleine pretending to be Carlotta, she is doubly closed-off. But is she then Elster's bachelor machine, or Scottie's?

…

I'm still available—available Ferguson.
(00:08:33)

…

[INT. Scottie's Apartment (NIGHT)]

…

Hitchcock, displeased with Raymond Chandler and his work on *Strangers on a Train* (Chandler was drinking, frustrated in his marriage, somewhat pretentious, generally unpleasant to be around), did what he could to hide the fact Chandler had worked on it. Chandler, famously, married a woman many years his senior, a woman he seems to have loved and who loved him in return, but who was already middle-aged when they met and had, at best, a waning sexual appetite. Chandler, it was said, was fired from his job as vice-president of Dabney Oil because of his alcoholism, but it was his philandering that embarrassed the company, and it was his philandering that really led to his firing. On the surface, there seem to be similarities between Chandler and Hitchcock. At a deeper level, perhaps there really were. Like finds like, but, like the ends of a magnet, it's opposites that attract and likes that repel. Hitchcock seems to have been basically impotent for the greater part of his time in Hollywood. When, during the run-up to the production of *Topaz*, Universal publicist Orin Borsten, a fan of Chandler's, asked if he could have one of Hitchcock's two signed first editions of *The Big Sleep*, Hitchcock said, "Take them both."

…

Hitchcock had Raymond Burr (as Lars Thorwald, the murderer in *Rear Window*) made up and costumed as David O. Selznick, Hitchcock's first American producer. It was not meant as a compliment.

…

Hitchcock repeatedly cast against type—Jimmy Stewart, in all of his Hitchcock roles, for instance. Robert Walker.

…

Janet Leigh, the only bankable star in *Psycho*, he killed off in the first thirty minutes.

…

Cary Grant, 55, a man so cultured and dapper he never needed a costumer for his debonair roles with Hitchcock, began taking LSD "therapeutically" after filming *North by Northwest*.

…

(Of course, "Cary Grant" was born Archibald Leach, and took part of his adopted name from the character he played in a stage production of William B. Friedlander's *Nikki*, one of his first acting roles.)

…

Hitchcock demanded that his production designers and set dressers refer to research photos, often going to great lengths to make the set mirror reality. For instance, he tells Truffaut that

for *Vertigo* . . . he sent people to San Francisco, where the story is set, to photograph apartments of retired detectives with college degrees, and based the design of the James Stewart character's apartment on the photos.
(Krohn, *Hitchcock at Work*)

. . .

The scene that required the most retakes was scene 151, the scene following Scottie's rescue of Madeleine, when she awakes to find herself in his bed.

. . .

When Judy, still in character as Madeleine, awakes in Scottie's bed, she says, "Where is my child?" a reference to Carlotta's lost son or daughter (in Elster's oddly incestuous formula, a child who would be her grandfather or grandmother). But critic Bill Krohn believes the line may also refer to J.M. Barrie's *Mary Rose*, Hitchcock's never-filmed pet project. In Barrie's play, Mary Rose is a young woman who disappears while on vacation with her husband, only to reappear many years later, the same age as when she disappeared. Her son, very young at the time of her disappearance, has grown up, and to all appearances is now older than his mother. Barrie had written, in an earlier work, "The only ghosts, I believe, who creep into this world are dead young mothers, returned to see how their children fare. . . . What is saddest about these ghosts is that they may not know their child. They expect him to be just as he was when they left him, and they are easily bewildered, and search for him from room to room, and hate the unknown boy he has become. Poor, passionate souls, they may even do him an injury." Is Krohn then, by extension, theorizing that Scottie is Carlotta's lost child? Is the film?

...

Legal department memo to Hitchcock:
"If the present indication is to be approved that Scottie has completely undressed Madeleine and put her to bed, the evidence of embarrassment on her part will have to be played down. Also, on page 60, Scottie's broken line, 'Not at all. I enjoyed—talking to you' should be read without the break and also without any show of embarrassment."

...

I once thought that the emphatic nature of words ensured truth. If I could find the right words, then with the proper will I could by assertion write all that was true. I have since learned that words are only as valid as the mind that chooses them, so that of essence all prose is a form of deception.
(Priest, *The Affirmation*)

...

There is no language without deceit.
(Italo Calvino, *Invisible Cities*)

...

Robin Wood writes, "Midge, driving up to Scottie's apartment, sees Madeleine drive away. That the two women never appear, beyond this, in the same scene brings home to us the incompatibility of the worlds they represent. Midge's reappearance immediately after the beautifully sensitive, tentative groping toward a relationship between Scottie and Madeleine, makes us aware of her exclusion from certain levels of experience and her inadequacy to combat the sort of rivalry Madeleine offers; yet at the same time it makes us aware of her

as representing a healthy normality to set against the element of neurotic sickness in Scottie's attraction to Madeleine."

As with an actor playing two roles in the same production, though, it might also "bring home to us" that one can never be in more than one place at one time. Midge does not appear on camera together with Madeleine, not in this scene, not ever. It is not a case of divided affection but of simple, mathematical efficiency—if Madeleine is there, Midge cannot be, and vice versa. Midge parks just as we hear Madeleine's car start across the street, like an actress ducking behind the curtain for a quick change. Midge and Madeleine are one and the same.

. . .

Self-imitation often results from the doomed attempt to resolve the circular paradox of marital sexual rejection. That is, the husband desires both an erotic encounter and a legitimate child, but not always from the same woman, and to close the circle, his wife must double back to become the person she knows she is, the person he cannot see until she transforms herself there and back again: his erotic partner (and often the mother of his children). Wives triple-cross their double-crossing husbands by substituting for the mistresses who are substituting for the wives, so that the man commits adultery with his own wife, stumbling home in the dark. . . . The wife really is the mistress because fantasy and desire make her so—if for no other reason than because she appears in her erring husband's mind to be so. (Doniger, *The Woman*)

. . .

I called the airline to see if I could change my reservation. I wanted to leave as soon as possible. All I wanted was to be home. The representative asked if I had "elevate gold status." I didn't understand what she was saying—elevate?—but I told her that I

didn't think so so that we could get on with it. She asked for my confirmation number. I gave it to her. There was a flight leaving in two hours. I could just barely make it, maybe. I headed for the BART stop on Market. She asked for my credit card number. I reached into my coat pocket. My wallet was gone. I checked my pants and the pockets of my bag. On the other end of the line, the representative told me I ought to retrace my steps. She asked me if there was anything else she could help me with. I hung up on her. I would not be retracing my steps. If I couldn't get out of San Francisco that night, I would stay in my hotel room until I needed to leave for my flight.

…

At 00:51:25, Madeleine asks Scottie, "Have you ever before?" She means "Have you ever [fallen into San Francisco Bay] before," but, because of the elision, one might as well understand her to be asking "Have you ever [fallen] before?"

…

Hitchcock gets on a bus. He just misses his bus. He takes a drink. He walks past the camera carrying a cello, a violin, a trumpet. He is on a train, in a wheelchair, behind closed doors. He is in a class reunion photo and a weight-loss ad. These blink-and-you-miss-it cameos were a kind of signature for Hitchcock, whose real signature typically included a small caricature of his profile. But one gets the feeling that his most famous interviewer, François Truffaut, an early proponent of the so-called "auteur theory," probably thought such appearances were unnecessary—as the man ultimately responsible for them, regardless of whether his image was projected alongside their characters, Hitchcock was *in* every one of his films. In his *Notes on the Cinematographer*, another one of Truffaut's heroes, Robert Bresson writes, "Hide the ideas, but so that people find them. The most important

will be the most hidden." There is no hiding what Hitchcock is not at liberty to hide: that he has created something in his own image. Unless his image hides something else, something more important.

...

The girl you love? She is not a creature of the earth, she does not live in the world, but in you yourself as the high and pure ideal of your art, which inspires you, which breathes from your works, which is enthroned above the stars. (E. T. A. Hoffmann, "The Doubles")

...

Robert Bresson writes: "Things are made more *visible* not by more light, but by the fresh angle at which I regard them." He writes: "Your genius is not in the counterfeiting of nature . . . but in your way of choosing and coordinating bits taken directly from it by machines." He writes: "Shooting is not making something definitive, it is making preparations." He writes: "Don't show all sides of things. A margin of indefiniteness."

...

Vertigo Vertigo Vertigo
The book begins with a young couple buying their first home. We are not told what year it is, but it seems clear that the book is set in the early 1950s. The husband, a veteran, has come back from some unnamed conflict to a prosperity that seems new to him and an accompanying happiness, or at least contentment. Over the course of this opening chapter, we see he is a hard worker, spending most of his time away from home. When he is home, he wants things a certain way, and his wife, our narrator, tries her best to accommodate him, often going out of her way

to do so. We begin to suspect, with his (now pregnant) wife, that something is off about this behavior, but, like her, we want to assume the best—that he is merely trying to provide for his new family, that he is used to military discipline and expects it in others, that he is under stress in a job he was ill-prepared for. Our narrator, stuck at home, occupies her time listening to the radio and daydreaming of visiting the places her husband has just come home from—really, any departure from the life she is leading now seems like a dream, but she finds herself daydreaming about especially those places he has told her about. He never tells her about the days he shot at others or others shot at him, only about the days after, the days when people were walking around in the streets again, as if for the first time, when everyone was so welcoming and friendly, and though no one had anything, they wanted to share what little they could find with each other and with him. This is a world she wants to experience.

A neighbor, older perhaps by a decade than the young wife, begins to take an interest in the narrator. She invites her over for cards and often invents excuses to visit her at home, excuses that seem transparent to us but seem perfectly reasonable to the narrator. One afternoon, the neighbor has the young wife over for tea, and she introduces her to some of her friends, whom the young wife learns are swingers. Our narrator is embarrassed and even a little intimidated, and she runs back home and promises herself she will never talk to the neighbor again. Every time she sees the neighbor's driveway filled with cars, though, she imagines herself in the neighbor's house, in the arms of a stranger. She tells us it isn't that she wants another man (although we get the sense her husband and she rarely have sex, and that this disappoints her), but that she just wants something new, something different.

It begins to dawn on us that the husband may be gay, and that he is certainly having an affair, and that neither he nor his wife wants to admit either. Our narrator has a child, a baby

123

girl, and we skip ahead thirteen years, presumably because the narrator is busy raising her daughter.

Now the daughter is thirteen and the narrator is older than her neighbor was at the beginning of the novel. That neighbor has apparently moved out in those thirteen years, because when we come back to these characters, they are talking about their new neighbors, a young couple, the husband a veteran just like the narrator's husband, and the wife as straitlaced as our narrator was. But something has changed in our narrator in those thirteen years. She criticizes her husband now, constantly, and she asserts herself. He seems different, too: less rigid and less determined to get his way, maybe even defeated. It is almost as though the two have switched roles. The daughter, though we don't even learn her name and can form no clear picture of her, we know is close to her father and carelessly cruel to her mother, who resents the bond her husband and her daughter have formed. We also know that the husband has a lover, a relationship the narrator tolerates, though as a consequence, she won't let her husband touch her at all. The narrator believes this is why her daughter prefers her husband: because she believes that her mother is withholding affection from him, when it is the narrator who cares enough not to tell her that her father is having an affair with another man, an affair that cost the father his career, such that now the mother has to work because the husband can't.

The job our narrator has taken is at a mannequin factory, where she paints eyes, eyebrows, lips, and nostrils on finished mannequins. The rest of the book is a long description of the wife painting the details of her husband's face—he was and remains an attractive man—onto mannequin after mannequin. The only variations in the narrative are when a mannequin comes out slightly warped, and our narrator has to work harder to make the finished product look right. These slightly-irregular mannequins will be sold to downmarket stores, the kinds of places our narrator now shops because it is all she can afford. In the last scene of the book, she finds herself buying clothes for

her husband even though he does not need them because she has seen them on a mannequin that looks—even if only subtly (she does not mold the heads, after all, only applies the finishing touches, and this was one of the irregulars)—like her husband.

…

[EXT. Redwoods (DAY)]

…

There comes a point in our lives when we are most often and most emphatically ourselves on those days when we like to think we are not ourselves.
(Dyer, *Rage*)

…

Since Carlotta (like Judy) is a brunette, but Judy-as-Madeleine does not change her hair color when she goes into her trance as Carlotta, the woman whom Scottie follows at the start is Judy-as-Madeleine[-as-Carlotta] (brunette-as-blonde[-as-brunette]). Where Gavin hints that Madeleine is the reincarnation of a dead woman, Scottie first sees Judy, after the murder, as the resurrected form of what he (rightly) perceives as another dead woman, Madeleine. And one reason why Judy-as-Madeleine-as-Judy-as-Madeleine does not look quite right is because what Scottie really wants to see is Judy-as-Madeleine-as-Judy-as-Madeleine[-as-Carlotta].
(Doniger, *The Woman*)

…

Scottie: What was there inside that told you to jump?
Madeleine: Please!

Scottie: What?
Madeleine: Please don't ask me please don't ask me.
(01:01:24)

…

A reminder: the word "person" comes to us from the word
"persona," a Latin translation of the Greek "prosopon," the
mask actors wore in Greek theater. *Per* (that through which) *sona*
(the sound [of the actor's voice] comes).

…

Scottie: Where are you now?
Madeleine: Here, with you.
Scottie: Where?
(01:00:47)
…

We are never ourselves merely to ourselves but always in relation
to others, even if only imagined others. Like Bishop Berkeley's
tree in the quad, we exist only when someone sees us. We
become the person we see mirrored in the eyes of others, ideally
someone we love or someone who loves us.
(Doniger, *The Woman*)

…

If you are unwilling to know what you are, your writing is a form
of deceit.
(Ludwig Wittgenstein, *Recollections of Wittgenstein*)

…

Deception often leads to being deceived; the trickster is duped

because his own reflection blurs: "I had a mask that hid my face and I no longer know who I was when I looked at myself in the mirror."
(Pierre Marivaux)

...

Each of us is already a lot of people. . . . And so when, failing to be the other person we hoped to change into, we fall back to our default position, we find a different form of ourselves awaiting us, a different one of our many selves.
(Doniger, *The Woman*)

...

Kim Novak: "Sometimes I feel like I'm two different people. One is an ambitious young actress struggling to acquire an armor of sophistication. But not far beneath the surface is a girl who believes herself unattractive and odd—a misfit who is often lonely and introspective."

...

Thinking about the Maltese Falcon, the actual statuette, I found myself thinking also about the first chess automata.

These automata were cabinets with mannequins inside, mannequins put together and articulated so as to be capable of playing chess with human opponents. Though it was not widely known at the time of their popularity, these automata weren't automatic at all. Instead, human chess masters—famous players—hid in recesses in the cabinets and directed the automata's moves. The automata were nothing more than masks or gloves for these human masters. (The masters were paid for their discomfort—the recesses in the cabinets were usually quite small—though, given the rumored turnover in operators, the

discomfort must have been greater than the pay.)

What we have, then, in the chess automaton, is a human pretending to be an automaton pretending to play chess, i.e., pretending to human intelligence, i.e., pretending to be human (since *cogito ergo sum*). (What really is the difference between these masters pulling levers in a cabinet and modern-day programmers writing software? And yet when we play a game of computer chess, we would never dream of saying that we've just played a human being.) That the automaton's challengers did not suspect they were playing another human being is beside the point. Why do we find things disguised as other things (even when those disguises actually expose their wearers) more appealing than things left undisguised? Is this attraction to artificiality the true legacy of the fruit of the Tree of the Knowledge of Good and Evil? The Maltese Falcon was worth at least two lives—would a gold falcon statue, uncovered by lead, really be worth as much? Once the lacquer has been scraped away or the automaton revealed, it's worthless. But in their disguises, they're both worth fortunes.

. . .

Impostors . . . teach us, by positive precept and negative example, how to believe in ourselves as something other than impostors. (Schwartz, *Culture*)

. . .

The local video store has a sign in its window: WE CAN PUT YOUR MEMORIES ON VIDEOTAPE. But memory isn't memory until it is past tense. It is subjective, filled with internal voice. They might capture the event—but not the memory. To do that, I would have to hold the camera, select the angle of vision. And to hold the camera is to efface the self. To become an impersonal eye. A cold and singular lens. (Judith Kitchen, "Transitional")

...

Robert Musil wrote in his journal, "It is not the case that we reflect on things. Rather things think themselves out within us." And we think things out within things, it seems.

...

At the security checkpoint at SFO, I explained that I had lost my wallet but that my flight was leaving in an hour. A TSA agent led me through a passage made out of temporary walls, the kind office cubicles are made out of, and put me in a very small room with a desk but no chair. He pulled out a cell phone, typed some numbers into it, and handed me the phone. I waited for a moment. I was asked by a recorded voice to type in my social security number. I did so. A moment later, there was a woman on the other end of the line, asking me what my father's mother's maiden name was. I told her. She asked me what hospital I was born in. I told her. She asked me when my wife was born. I told her. She gave me a list of courses and asked which one I had not taken my sophomore year of college. After thinking for a while, I came up with what I think was the right answer. She asked me which way one would turn out of the driveway of the apartment complex I lived in in order to go downtown. I thought: "It depends on whether you want to take an unprotected left turn," but I gave her the geographically correct answer. She gave me a list of names and asked me which was not a name of one of my first cousins. Again, I thought for a while and came up with the right answer. She asked me what color my eyes were, how tall I was, if I had any fillings. I answered everything. But if she had asked me how she could have known whether my answers were correct, I could not have answered. I was profoundly disturbed by the whole experience. Eventually, she asked me to turn the phone over to the TSA agent. I did. He handed my ticket back to me and escorted me back to the steel benches where people were putting their shoes back on. He warned me that if I exited

the secured areas anywhere along my itinerary, I would have to go through the same process again, and the questions asked were never repeated. I could barely speak to say, "Thank you." There was no feeling behind it anyway. It would have been a formality—I really wanted to ask him who it was he had called, how this could be real life. I still wonder what his answer would have been.

…

A British Royal Commission in 1904 warned that "Evidence as to identity based upon personal impressions is, unless supported by other facts, an unsafe basis for the verdict of a jury." (Schwartz, *Culture*)

…

The more real-life echoes a crime story had for Hitchcock, the bigger his pool of references, the greater his enthusiasm. (Patrick McGilligan, *Alfred Hitchcock: A Life in Darkness and Light*)

…

[D]ifference implies the negative, and allows itself to lead to contradiction, only to the extent that its subordination to the identical is maintained. The primacy of identity, however conceived, defines the world of representation. But modern thought is born of the failure of representation, of the loss of identities, and of the discovery of all the forces that act under the representation of the identical. The modern world is one of simulacra. (Deleuze, *Difference and Repetition*)

…

A man known all over the world who had delusions that strangers were staring at him—how in this case could reality be sorted out from fantasy? What was the frame of reference which would distinguish them one from the other?
(Philip K. Dick, *Dr Bloodmoney*)

…

[EXT. Cypress Point or Point Lobos (DAY)]

…

There is a moment in the scene the script designates as taking place at "Cypress Point or Point Lobos" (the location at that point still unchosen; filming eventually took place at Cypress Point) where both music and waves are so loud it is possible to believe there are lines of dialogue we cannot hear, a moment in which, for the first and last time, Madeleine and Scottie share a private moment together.

…

Cypress Point and Point Lobos are on opposite sides of Carmel Bay—Cypress Point to the north, on 17-Mile Drive, and Point Lobos to the south, a nature preserve.

…

As with many of the exteriors in *Vertigo*, the one at Cypress Point was only partly shot on location. The close-ups were done in a studio. For continuity's sake, the same tree the production used on set—a prop—was carted out to Cypress Point for the location shots. And not only the tree is artificial: When Madeleine turns and runs down the slope, she ceases to be Madeleine; that is, she ceases to be Kim Novak playing Judy Barton playing

Madeleine (playing Carlotta). Once her back is turned, she has been replaced by a stunt double, another actress now standing in for Kim Novak playing Judy playing Madeleine playing Carlotta. Perhaps most of all in scenes like this one, Hitchcock's famous bias against Method acting can be seen as charity, a gift to an actress who would have been driven insane trying to inhabit the many layers the script called for. Stewart, in this scene, is (stunt) doubled, too—it is not Scottie running after not-Madeleine.

The one time we see the real Madeleine ("real," though, really in quotes, even when it is not—in this case, what's meant is something like: "the actress Alfred Hitchcock chose to play Madeleine Elster," as opposed to "the actress Alfred Hitchcock chose to play Judy Barton playing Madeleine Elster"), what we see is, almost without a doubt, the double of the woman who, in the film, has been hired to play her, a double standing in for a double, in the process, playing herself; falling past the window, this stunt double called in to double for Kim Novak playing Madeleine is playing Madeleine Elster. We later see her in the letter-writing flashback sequence in the tower, slumped in Gavin Elster's arms. The actress hired to play Madeleine in Hitchcock's *Vertigo* is thus not the same as the actress hired to play Madeleine in Hitchcock's *Vertigo*.

…

Scottie: You know the Chinese say that once you've saved a person's life, you're responsible for it forever, so I'm committed. I have to know.
Madeleine: There's so little that I know. It's as though I'm walking down a long corridor that once was mirrored and fragments of that mirror still hang there. And when I come to the end of that corridor, there's nothing but darkness and I know that when I walk into the darkness, I'll die.
(01:02:23)

...

I would rather have someone tell me about an exhibition than see it with my own eyes.
(Edouard Levé, *Autoportrait*)

...

Before the airport and the airplane, before I lost my wallet, and before I saw the other man, I visited SFMOMA. I had been to the museum once before, but the permanent collection—all of it, two entire floors of the museum—had been blocked off. The elevators didn't stop on those floors. We were only allowed to visit the top floor. There was a special exhibit there, a selection of works from the permanent collection. It almost sounded like a joke. My wife was with me; our tickets were half-price, because of the closure.

This time, alone, I skipped most of the permanent collection. There was a Jay DeFeo retrospective on; I had no desire to see it, but I walked past and was drawn in by her painting, *The Rose*. *The Rose* had its own shallow room within the room, intended to reproduce the effect of the recessed bay window in which DeFeo had composed the painting. To the left of the frame of this room was the painting's identifying placard, which explained that the painting, begun in 1958 and finished in 1966, had had to be moved in 1965, when the rent on DeFeo's Berkeley studio went up. It went to Pasadena, where it was then completed. In Bruce Conner's film *The White Rose* (the title of the painting at that time; it was also called *Deathrose* at one point), we see the studio before the move. It looks like an abandoned building. There are plants but no furniture. It is dark. There is a very low stool, crusted with paint, sitting in front of the painting, dead center. In the black and white of the film, the paint on the stool looks like bird droppings. I stood where the stool would have been, transfixed by the deformations of the thick paint where it

reached for the floor.

After walking through a few other rooms, thinking about *The Rose*, I returned to look at the painting again. I read the placard again, though I had read it less than an hour before. Everything that is is a record of its process, I thought; this description of *The Rose* in front of me had more to do with where it had been composed and when than with what *The Rose* itself was struggling to be. Had the curator lacked imagination, or was it our language that lacked imagination? I looked again at the radiating folds of paint, like rock chipped away by the wind and the rain. Each one recorded the time that had passed while DeFeo worked on *The Rose*. All the placards around me were lists: a title, an artist, a place, and a time. The best the curator could do was log the facts. Facts are a set of coordinates, in space and in time. Causation, motivation, character—all the rest is fiction.

The museum guard's walkie-talkie crackled a fuzzy and cryptic message. He performed a series of stretches. What had DeFeo thought of as she sat on the stool, I wondered, this 2000-pound *Rose* blocking out the light; behind her, her plants dying so that this simulacrum of a plant could live? Eventually, she would come to believe that her heavy use of lead-based paints caused her cancer, and she would attempt to reproduce the physicality, the dimensionality of her earlier works through a kind of *trompe l'oeil* effect. The story she would tell herself about the process of creating *The Rose* was that it caused cancer. The facts were coordinates, had only to do with proximity and time.

I found myself unable to meet the "eye" of the composition. Every time I looked at the center of it, I was shunted off along one of its rays. Even when I stepped back into the outer room, next to the placard, I could not focus there. It took me some time to notice how perfect, how precise, the dimensions of each "petal" were. In part, it was this precision that gave the lie to the painting's title—this did not seem like a rose. It seemed like something artificial. Or, no, it seemed as though artificially

perceived, as when something natural, "imperfect" to the naked eye, is seen under a microscope of great power, revealing the fractals and the fractals of fractals of which it is composed, each geometrically perfect and corresponding to a finite set of numbers, seeming as though computer-generated. What if any of this had gone through DeFeo's mind? Why had she changed the title?

...

After Madeleine describes San Juan Bautista, Scottie, having seen the place in his head, says, "You've given me something to go on, don't you see?" "Something to go on" = someplace to go to. In this way, the trip is entirely engineered, part of Elster's plan. But what if Scottie doesn't recognize the details that Madeleine describes? How could Elster have known that Scottie would know what San Juan Bautista looks like? How much of Scottie's past—in what minute detail—does Elster know?

...

Or: Why is Scottie so insistent Madeleine has been to San Juan Bautista before? She is describing a dream; she says that it takes place in Spain. That Scottie believes the dream he has heard narrated took place at San Juan Bautista is as much Scottie's invention as it is Elster's.

...

There's an answer for everything.
(01:13:55)

...

Two scenes intervene between Cypress Point and San Juan

Bautista: one in Midge's apartment, when Midge reveals her self-portrait-as-"Portrait of Carlotta" to Scottie, and, following it, a scene in Scottie's apartment, "early dawn" the following day, when Madeleine tells him about her dream. One scene attempts to conceal what it in actuality reveals, the other conceals that which it is supposed to reveal; Midge's feelings for Scottie are clearest here, where her gesture is meant to be seen as ironic, and Madeleine's are most calculated in the scene following it, just when she is supposed to be at her most vulnerable. "Supposed to" according to her script, that is, the one written by Elster.

Something else is revealed in these scenes. Where we have been led to believe that Scottie, free, "independent," has, to this point, been doing what he wants when he wants to do it, the true nature of his actions now becomes clear. His life is as scripted as Judy's, except that he retains the illusion he is acting out his own will. When he suggests the two of them visit San Juan Bautista at noon that day, he believes he is doing so because he has found the solution to her problem, because he wants to help her. But he is actually doing so because Elster has fed Judy a description of San Juan Bautista, the place where he wants to dispose of his wife's strangled corpse.

…

How much of *Vertigo* takes place in Elster's head before it takes place on screen? How much of it remains in Elster's head? It isn't Scottie's fantasy we're watching, is it? It's Elster's.

…

I arrived in Portland late at night, at a gate at the end of the terminal. Because it had taken me so long to get through security in San Francisco, I was the last passenger on the plane. I had had to stow my bag above a row of seats far behind me, in the only available space in the overhead bins. Because of this, I had to

wait until all of the other passengers deplaned to retrieve my bag when we landed in Portland. The crew were gone. I could hear the sound of a vacuum from somewhere. I walked down the jetway alone, into a seemingly empty terminal. The gate areas I passed were unmanned and unlit; I could see through the huge windows out onto the empty runways. A luggage tram, appearing as though its operator had vanished into thin air right in the middle of doing his job, was the only interruption in the field's perfect, warped grid of lights. There was a couple I recognized from my flight, standing outside of the bathrooms, the husband looking at his cell phone as though in disbelief, the wife clearly ready to be wherever they were due to be. My heart quickened as I passed through the checkpoint—what if I had to go back for some reason?—but I didn't slow down to check my bag and my pockets to see that I had everything with me. I still hoped to catch the last MAX home. I also hoped there wouldn't be a traffic cop on the train checking tickets. I hadn't yet canceled my credit card or my debit card, though I knew I should have. I held out some stupid hope that my wallet was in my bag somewhere, in the folds of a shirt or in the pocket of a pair of pants.

After I got home and dumped out my bag, I tried to remember if there was anything else in my wallet that needed to be canceled. I wondered if I was supposed to cancel my driver's license. If someone who looked like me got his hands on it, couldn't he then pass as me? What could he do, as me?

…

[INT. Midge's Apartment (NIGHT)]

…

Now we can better understand how one can get emotionally involved with the inhabitants of a fictional possible world as if they were real people. It happens only partly for the same

137

reason we can be moved by a daydream in which a loved one dies. In this latter case, at the end of our reverie we come back to everyday life and realize that we had no cause for worry. But what would happen if one lived in an uninterrupted daydream?

To be completely emotionally involved with the inhabitants of a fictional possible world, we must satisfy two requirements: (1) we must live in the fictional possible world as if in an uninterrupted daydream, and (2) we must behave as if we were one of the characters. . . . Once we begin living in a possible world as if it were our real one, we can be disconcerted by the fact that in the possible world we are not, so to speak, formally registered. The possible world has nothing to do with us; we move within it as if we were the lost bullet of Julian Sorel.
(Eco, *Confessions*)

…

To reveal art and conceal the artist is art's aim.
(Wilde, *Gray*)

…

Borges, writing of Coleridge's "Kubla Khan," a poem written in a dream, notes that the original, historical Kubla Khan conceived of his palace in a dream. Centuries later, an English poet who didn't know the palace he was writing about came out of a dream, dreamt a poem in which a palace is built. Borges writes, "Perhaps an archetype not yet revealed to mankind, an eternal object, is gradually entering the world; its first manifestation, the palace; its second, the poem." The character of Madeleine, an invention of Gavin Elster—a daydream, at least, if not a dream proper—is the second manifestation of an archetype not yet revealed to mankind. Its first manifestation, Carlotta's child, was conceived as though in a dream, with a man not Carlotta's husband, a nightmare in which the child is taken away and

138

raised as if Carlotta does not exist. Borges says that a dream leading first to a palace, and then, centuries later and continents distant, to a poem, is more incredible than all of the levitations, resurrections, and apparitions of the Scripture. But the passage of time and the great distance covered aren't really important, are they? Isn't it incredible enough that a dream can be shared by two men? A *dream*, which we still believe, because of Freud, to be a reflection of the individual, an expression of one particular brain? How can more than one person have the same dream? First Elster, then Scottie, then Judy. Now you and I.

…

After my trip to San Francisco, there was an unexpected new coolness between my wife and I. Because I got home very late, and because she worked the next morning, I didn't see her until the following evening. She didn't ask about the trip. I tried to tell her about what I had seen, but her questions, though seeming perfectly reasonable to me later, at the time struck me as mocking. She didn't believe me, and I had no evidence that what I said was true.

What made matters worse was that I could not leave it alone. I brought the man up several times that week, and her objections were always so rational—and my memories so immaterial—I started to share her doubts. *Could* I have seen what I thought I had seen? I showed her the report from stillman.com. She asked how much I had paid for it. She told me, "You get what you pay for." This was wisdom with which I could not argue, having, after all, found the address listed on the report uninhabited and, theoretically, still under construction. But, all along and despite her infectious suspicions, I was afraid. This man had entered the world like an incursion from my nightmares. I didn't want to see him ever again. I wanted *her* to see him, but *I* couldn't bear to.

…

The highest as the lowest form of criticism is a mode of autobiography.
(Wilde, *Gray*)

. . .

Fabrice comes to visit, and talks to me about the book I'm writing. . . . He fixes on the construction of the chapter about the Night of the Long Knives: this series of phone calls, according to him, evokes both the bureaucratic nature and the mass production of what will be the hallmark of Nazism—murder. I'm flattered but also suspicious, and I decide to make him clarify what he means: "But you know that each telephone call corresponds to an actual case? I could get almost all the names for you, if I wanted to." He is surprised, and responds ingenuously that he'd thought I'd invented this. . . . Everyone finds it normal, fudging reality to make a screenplay more dramatic, or adding coherence to the narrative of a character whose real path probably included too many random ups and downs, insufficiently loaded with significance. It's because of people like that, forever messing with historical truth just to sell their stories, that an old friend, familiar with all these fictional genres and therefore fatally accustomed to these processes of glib falsification, can say to me in innocent surprise: "Oh, really, it's not invented?"
(Laurent Binet, *HHhH*)

. . .

I bring up my trip to San Francisco during dinner. My wife and I sit facing the television; she's on the couch, I'm in my chair. She has been ignoring me all night. When I tried to give her a kiss after she got home, she leaned over to open the oven door. When I tried to give her a hug, she twisted away to clean off a plate. She has checked her cell phone more times than I can count. She has gone into our bedroom to charge it, gone into

our bedroom to get it, partly charged. Now we are sitting down. She is eating, with her iPad in front of her and the tv playing something neither one of us is watching. When I mention the man again, I see that, rather than ignoring me, she has been shaking with anger. She looks up from her plate, straight at the tv. She says we couldn't afford the trip in the first place. She doesn't make enough to support us both much less pay for me to go on vacations without her, and now that I'm home, when I should be looking for work, I'm obsessing over this . . . whatever this is. She is sick of it. When she says this, she looks me right in the eye. She is angry. She is so angry I am scared. Not that she would do anything violent, but I'm scared that I've crossed some line, that we've crossed some line.

What is it about the eye that communicates so much of what we're feeling? What physically, objectively, changes when we think we see emotion in another person's eyes? Does it have to do with the pupil? With the shape of the eye (i.e., with how open or closed it is, whether the top eyelid is more closed than the bottom one or vice versa, what position the eyebrow's in, etc.)? Or do we really somehow see through the eye into the soul? My wife's eyes are focused on my own. Her eyelids aren't closed, but her eyebrows are very, very close to her eyes, nearly folding over her top eyelids. Her pupils seem almost to have disappeared. The rest of her face remains completely still. I am finding it difficult to keep looking. It is uncomfortable. I am self-conscious. If I believe in what I've been saying, I should maintain eye contact. Maybe it's not the eyes that express emotion, I think later, but their reflection in the perceiver's eyes.

...

[INT. Livery Stable (DAY)]

...

How can you tell the main character of a story? By the number of pages devoted to him? I hope it's a little more complicated than that.
(Binet, *HHhH*)

…

To influence a person is to give him one's own soul. He does not think his natural thoughts, or burn with his natural passions. His virtues are not real to him. His sins, if there are such things as sins, are borrowed. He becomes an echo of someone else's music, an actor of a part that has not been written for him. The aim of life is self-development. To realize one's nature perfectly—that is what each of us is here for. People are afraid of themselves, nowadays. They have forgotten the highest of all duties, the duty that one owes to one's self.
(Wilde, *Gray*)

…

I am too much concentrated on myself. My own personality has become a burden to me. I want to escape, go away, to forget.
(Wilde, *Gray*)

…

It's not fair. . . . It wasn't supposed to happen this way. It shouldn't have happened.
(01:15:12)

…

[INT. Church Tower (DAY)]

…

142

The measure of a man's greatness would be in terms of what his work *cost* him.

Wittgenstein once told someone.
(David Markson, *The Last Novel*)

...

The guilty . . . may flee when no one pursues.
(Dick, *Scanner*)

...

I myself, I am not a character in this novel; I am the novel.
(Dick's Author's Note, *Scanner*)

...

Scottie: If I could just find the key, the beginning, and put it together.
Madeleine: To explain it away.
(01:04:23)

...

It's too late, there's something I must do.
(01:14:37)

...

Elster assumes Scottie will not follow Madeleine up the steps. He knows Scottie's medical history. He knows of Scottie's phobia. But what if Scottie follows Madeleine up the steps? As difficult as it would be, it isn't impossible. What if he makes it to the top? In the novel, there is a physical barrier, a locked door. Flavierès (the novel's Scottie) would have to climb out a window

and then around the outside of the tower to get to Madeleine. In the movie, there is only Scottie's fear to stop him.

. . .

There is a scene (is this the right word?) in the game *Legend of Zelda: Majora's Mask* in which the player's avatar is first doubled, then trebled, then quadrupled, playing one, two, three, and then four instruments at once, in four different forms. One of the conceits of the game is that there are masks that not only disguise the player but actually give him a different form altogether, transforming him into a different creature with extrahuman abilities (to breathe underwater, fly in the air, or walk through lava), and here, in this scene, all four forms are in play at the same time. Once the player has completed all four transformations and played the song in its entirety, the reward is, perhaps unsurprisingly, yet another mask, a mask that resembles exactly the original bearer of the mask, a character named Gorman, who gives the player the "Gorman Mask." Putting the mask on, the player becomes Gorman. Why, one wonders, would someone carry a mask that looked exactly like himself? What advantage could that possibly give him? And yet, playing this section of the game, I was reminded that I had once asked for just such a thing from my wife, seeing it advertised by a company in Japan that made masks from photographs. My wife would not buy it for me, because, she told me, it would be frightening, and disturbing. Why would I want such a thing, she asked. It would not look like me, even though (because?) it would be designed to look like me.

. . .

So much of being a writer is, I think, about identity.
(Zambreno, *Heroines*)

144

…

In Adolfo Bioy Casares's *The Invention of Morel*, the scientist Morel says, "Until recently science had been able to satisfy only the senses of sight and hearing, to compensate for spatial and temporal absences." This idea, that recordings can "compensate" for "absences," is one that originated with Thomas Edison, inventor of both the phonograph and the Kinetoscope. Edison designed the phonograph with the idea that it would be a kind of alternative to a live performance. It was not supposed to be a historical record of that performance, it was supposed to be a new performance itself—a phonograph of a trumpet, for instance, would stand in for that trumpet in a concert, the rest of the orchestra playing their parts and the phonograph playing its. But recordings are not compensations for absence. They can't be. They're something else. They are things. To see a recording as a compensation for absence makes the whole project seem noble, in a way: Even when its subjects have gone, the recording persists as though they hadn't. Edison was trying to invent immortality. He intended his phonograph not as a method of archiving or disseminating sound but of producing it; the recording *was* the person whose voice it rendered. The idea is flawed at its core, and Edison eventually abandoned it, but it persisted nonetheless.

Even now, our technologies pretend to speak to us, to act out lives in front of us. In a strange way, it isn't what they do but what they don't that damns them to artificiality. They talk over us; they listen only when not in use. If you call your bank and interrupt the recorded voice, the recording will simply stop, as though the person on the other end had been struck by lightning. A recording can't compensate for a person for the simple reason that we are trained from birth to recognize other people as people by how they respond to us. Our parents scold us or hold us when we complain; our toys lie deathly still no matter how much we scream at them.

People made famous by recordings are thus rendered unreal, people with whom we would never—could never—interact. That is, people become celebrities because they cease to be people. They become famous by being captured (the coinage is no mistake) on film or on vinyl. The people onscreen are not people even when we spot them on the street. Isn't that the function of the entourage, the publicist, the photo op? Once a person has been transmuted by an appearance in recorded media, they can never again truly inhabit the same world their spectators do. They move in a parallel world, the world of objects, the world of things. These technologies make compensations of their *subjects*. They destroy them through making them absences.

And still people try to join in conversation with them. They put themselves onscreen, talk back to people who otherwise can't be talked to. Doesn't this help to explain the popularity of "reality television," of "first-person" camerawork (as in *The Blair Witch Project* or *Cloverfield*), of sites like YouTube (where the bulk of the "original programming" is, not coincidentally, reviews or commentaries on already-existing work), of social media, of memoir, blogs, "selfies"? What if these trends aren't a new kind of narcissism, but, instead, an attempt to remedy the imbalance the previous century created with its new media? The audience attempts to have its voice heard by removing itself from the audience, by making of itself a compensation. Maybe it's doomed to failure, but when has that ever stopped anybody?

And perhaps these failures, the fact that none of these new or rediscovered modes achieve true conversation in any traditional sense of the word—the fact that they are more of the same—perhaps this only reveals that we don't after all crave conversation or dialogue so much as we simply wish to be heard. Maybe we even prefer to be heard in a way that limits what or how others can reply to us; we like to pretend that we are absent; we don't mind that a recording is unaware of our presence, that we can become witnesses without fear of becoming participants, that a recording's subjects, its compensations, have, in the act of

being recorded, reduced themselves in some way, devolved from people to things, that we want to become things ourselves out of some desire to reduce ourselves to ghosts. But why?

...

Morel: "When Madeleine existed for the senses of sight, hearing, taste, smell, and touch, Madeleine herself was actually there." (Adolfo Bioy Casares, *The Invention of Morel*)

...

Adolfo Bioy Casares's *The Invention of Morel* is the story of a man, a fugitive—from what crime or persecution, we are not told, though he does tell us that he was "accused of duplicity" and has been imprisoned—who finds himself marooned on an uninhabited island when his boat breaks up on the reef surrounding it. He has been told to go to this island because no one ever stops there; he will never be found. The island's previous inhabitants were all found dead, adrift on a boat, "skinless, hairless, without nails on their fingers or toes." There is a "museum" on the island, a chapel, and a swimming pool. As the fugitive discovers, there are also people, or what appear to be people, on what appears to be a vacation or holiday of some sort. But it turns out that these people are really recordings made by a man named Morel who has invented a device that projects not just images but (it seems) physical, tactile being—these projections are solid, can speak, smell, their sun gives off heat, their tides wash the shore. The only thing that makes them different from the reality the fugitive would be living in without the projections is that their every action is preordained, is only a repetition of a past action, has been recorded by Morel's invention.

The fugitive becomes obsessed by one of Morel's friends (quite possibly the woman with whom Morel was in love, the

reason for the trip and the inspiration for the invention), a woman named Faustine, but, while he can see her, hear her, even touch her, he cannot do anything to alter her actions. She is implacable in playing out her days on the island in the exact sequence they have already followed—no variation, no alteration is possible. The fugitive can hide in her room but can only enter or exit when the door would have been open during the days Faustine actually spent on the island. He can reach out and touch her, knows her to have a physical dimension, but his caresses are completely ineffective—not even a hair is moved, much less an article of clothing. He could perhaps kiss her, but it would be like kissing a wall. And always, no matter what the fugitive does, she and all of the other islanders go about their unwavering routine.

The obsession is fatal: the fugitive, resigning himself to the fact that he will never be able to speak to Faustine or be heard by her, never even so much as feel her flesh give when he takes her hand; knowing also that Faustine, the Faustine who once walked where he now sees her projection walking, the Faustine who once spurned Morel's advances, the Faustine who debarked upon this island and some days hence left it, no longer exists, has been killed by Morel's terrible invention, records himself, ensuring his own death. He records himself walking beside Faustine's projection. He remarks upon things when Faustine appears to have been listening at the time she was recorded. He listens when Faustine says something. He simulates an existence simultaneous to Faustine's, and, in so doing, makes that existence real for the next person to turn on Morel's invention, for that person will see that Faustine, previously alone on the beach or under the shade of a tree, is now accompanied by a man who seems ever so slightly out of place but who nonetheless acts as though he belongs.

. . .

That Bioy Casares would have written "Madeleine" in the passage quoted above—it must be a coincidence, but suppose it isn't? After all, why should he have written "Madeleine" and not "Faustine"? There is a Dora and a Jane Gray in the narrative— why not write either of their names, instead of this Madeleine, a character who does not appear anywhere else but in that passage? Perhaps Bioy Casares, a Francophile, had derived this Madeleine from the same place that *Vertigo*'s writers had derived it, from Proust. "An exquisite pleasure had invaded my senses, something isolated, detached, with no suggestion of its origin. And at once the vicissitudes of life had become indifferent to me, its disasters innocuous, its brevity illusory—this new sensation having had on me the effect which love has of filling me with a precious essence; or rather this essence was not in me it was me. . . . Whence did it come? What did it mean? How could I seize and apprehend it?" being Proust's famous reaction to the tasting of a madeleine.

...

All of Boileau and Narcejac's characters have been renamed in the film—Flavierès is Scottie, Paul Gévigne is Gavin Elster, Renée Sourange is Judy Barton, Pauline Lagerlac is Carlotta Valdes. There is no Midge, of any name. Only Madeleine's name has remained the same.

...

I decided I would say no more on the subject of my doppelganger. I would not be coerced into seeing a doctor. Though I'd always suspected there was something the matter with me, I believed in what I'd seen, and I didn't want it trivialized or turned into a symptom of an illness. My wife was convinced that I was somehow criticizing her by refusing to see someone (she had always seen a therapist). She stopped speaking to me. If I tried

to talk about anything, even what we would do for dinner, she would ignore me, and if I persisted, she would bring up the doctor and my unwillingness to get better. I slept on the couch. She stayed away as often as possible. Though we lived together, were still married, I might as well have been watching her on a security camera.

…

As any Freudian dreambook would have told Hitchcock, dreaming that you can't go up a flight of stairs is a symbol of impotence.
(Krohn, *Hitchcock at Work*)

…

How does Elster get down from the tower? We know that he does, but it seems impossible. Maybe even more mysterious, how can this have been part of his plan? Scottie, paralyzed with fear, is on the staircase. He cannot move, but, for Elster, there is no other way down. For the plan to work, Scottie must be stuck on the stairs. But the plan will fail if Scottie is stuck on the stairs. The body is on the roof below, dead, obviously from a fall from the tower. Does no one think to go up to the top, to find out what happened, whether she was pushed? They've just seen Scottie go up after this woman who is now dead. They don't suspect Elster—they haven't seen him so they can't suspect him—but they aren't interested in finding out what the man they *have* seen is doing? He hasn't come down. The police arrive. They investigate the body on the roof and the circumstances of its death. There are people all over the grounds, watching, looking. How long does Elster stay in the tower, waiting for a chance to sneak away without anyone seeing him? All the while, down below, the police are trying to get in touch with him, to let him know that his wife has died, apparently a suicide, in a

mission many miles south of the city. Mr. Elster, we regret to inform you. While they phone his home in the city, he waits in the tower, watching the priests and laypeople, the policemen, Scottie. They wait for word from him, wait for the picture of what has happened to come clear. Once he has checked his tie and cleaned under his fingernails for the twentieth time, after he has straightened his shirt and his hair yet again, what else is there left to do? How many times would he have gone to the edge, just to see? How many times would he have thought about jumping?

…

The act of creation implies a separation. Something that remains attached to the creator is only half-created. To create is to let take over something which did not exist before, and is therefore new. And the new is inseparable from pain, for it is alone. (John Berger, "Ape Theatre")

…

The movie *is* doubled. The chase on the rooftops is the chase up the tower.

…

And not only Elster. Scottie, too, would be trapped in the tower. With his acrophobia and his vertigo, how can he possibly get down? In the novel, it's explained: he sits on each riser, going down step by step on his butt. I remember doing almost the same at Teotihuacan, on a trip to Mexico City with my wife, a year or two before we were married. She watched from the ground as I went up the Temple of the Feathered Serpent. Going up was easy enough, steep and awkward but manageable, but coming back down, the steps were so shallow you couldn't see the next step past the end of the one you were on—each step seemed to

151

drop off into nothing. I had not been the only one taking those steps half sitting down. It hadn't even seemed undignified, as though I and the others were paying tribute to the gods the Nahuatls had worshipped there. One crawls in the presence of gods. Hitchcock, though, reveals a lack of humility. He cuts from the tower to the inquest. No crawling. No genuflecting. As at the beginning, we leave Scottie metaphorically suspended or trapped, unable to get down. Can we be sure he does? Is he trapped in a tower in the fantasy he's invented, trapped on the gutter?

…

Would it then make more sense to say that the first part ends before the inquest, with Scottie still in the tower?

…

[INT. Inquest (DAY)]

…

Scottie exits the tower and the chapel moments after Madeleine's fall. No one sees him. (Unless Elster does.) But Scottie is at the inquest, under suspicion. Did he come forward, tell someone, "I was there; I saw"? Why would he, after sneaking away?

…

We are not here to pass judgment on Mr. Ferguson's lack of initiative. He did nothing. The Law has little to say on the subject of things left undone.
(01:20:00)

…

Things left undone.

…

Madeleine: I'm obliged to believe that nothing finishes when we think it does . . . that's what's so terrible.
(Boileau Narcejac, *D'Entre les Morts*)

…

At 01:22:00, Scottie and Elster look down out of the window.

The view can't be less troubling for Scottie than the one from Midge's window at the beginning of the film—even though we don't get a perspective shot here (or the famous "vertigo effect"), it is an echo of that view, a loose end now tied up. Scottie seems at peace, calm. Elster tells him his future plans and Scottie looks out the window, unanswering but also untroubled. He is cured. How else can we interpret this? Though he is surprised at the end of the film when he comes to and then passes the spot where he had to stop before, he has been cured much earlier, by the shock of Madeleine's fall, a shock made reference to by Midge in the very scene this shot refers back to. Scottie has conquered his acrophobia *before* his breakdown, and the breakdown has nothing to do with his acrophobia except incidentally, because it was brought on by Madeleine's fall, which Scottie sees as having been partly caused by his acrophobia, or rather by the limitations brought on by that condition.

…

At some point, I realized that the book I had really been writing was not the book under contract. I would never finish that book. The book I was writing I was writing without putting ink on paper. It was a calcification of my thoughts into the crevices left behind by the authors of the books I was reading at the

153

time. I had begun to think of myself, the self I was creating, as a geological formation, a spire ascending not because I willed it but because something had begun—me—and then persisted through time.

. . .

Increasingly, the process of novelization goes hand in hand with a straitjacketing of the material's expressive potential. One gets so weary watching authors' sensations and thoughts get novelized, set into the concrete of fiction, that perhaps it is best to avoid the novel as a medium of expression.
(Dyer, *Rage*)

. . .

The judge at the inquest says that Mr. Elster could not have anticipated Mr. Ferguson's weakness. During their first meeting, in his office, Elster asked Scottie, "Shouldn't you be sitting down?" There's no way the judge could know that of course, but shouldn't Scottie be suspicious that this is the story Elster is going with?

. . .

How could the two hours of *Vertigo* fit between the rain gutter and the pavement? Although our experiences can't alter time—time is useful as a dimension precisely because, like spatial dimensions, it isn't subjective—scientists believe our circumstances can and do change the way our memories work. Or, more exactly, our circumstances change the speed at which our memories recall, and therefore the amount of things they are able to recall in a given moment. Although time doesn't actually slow down, the amount of things a person is able to think at once increases when he or she has the feeling that time

has slowed down. Maybe we use thoughts as a kind of internal clock: One thought takes one second, two thoughts take two seconds, and so on. We think two things and think two seconds have passed, but, because our memories are working faster, only one second has elapsed, and so it seems that time has slowed.

When I'm home, alone, writing or not writing, I can hear my neighbors in their apartment. Our walls are thin. They interrupt my concentration every now and again. I've learned to live with them and they've learned to live with me, but I'll hear them walking to their door, their noisy, creaky door, and I'll wait for them to open it, maybe without even realizing I'm waiting for it, and they won't open it. I lose my focus. Open the door! Their dog will bark and then suddenly fall silent mid-bark, and somewhere in my mind, I'll wonder what happened and I'll lose the sentence I was working on. There is a laugh, louder than normal, more hysterical, and something on the page eludes me. When did any of it happen? I don't remember. I don't even remember *that* any of it happened—I've made it all up. I forgot it almost at the same moment it happened. Which doesn't mean it didn't happen. My memory, intent on preserving the things I am focused on, the things I've told myself are significant—the book—chooses not to recall everything else.

In a near-death experience, everything is significant. And, as one's memory records everything, and everything, seeming significant, calls up a memory that, the brain thinks, might help to prevent or at least put off death, one's life flashes before one's eyes, or at least as much of one's life as has any potential bearing on one's present circumstances. It is not an elegy or a lamentation or even a memoir, it is an escape plan, a plot the brain hatches or anyway attempts to hatch. Somewhere in Scottie's reflections on Madeleine Elster and Judy Barton is the key to saving his life.

. . .

In life you, the reader may suddenly hear a cry for help; you see

only the window; you then look out and at first see nothing but moving traffic. But *you do not hear the sound natural to these cars and buses*; instead you hear still only the cry that first startled you. At least you find with your eyes the point from which the sound came; there is a crowd, and someone is now lifting the injured man, *who is now quiet.* But, now watching the man, you become aware of the din of traffic passing, and in the midst of its noise there gradually grows the piercing signal of the ambulance. At this your attention is caught by the clothes of the injured man: his suit is like that of your brother, who, you now recall, was due to visit you at two o'clock.

(V. I. Pudovkin, "Asynchronism as a Principle of Sound Film")

. . .

The novel comes into contact with the spontaneity of the inconclusive present; this is what keeps the genre from congealing. The novelist is drawn toward everything that is not yet completed.

(Mikhail Bakhtin, *The Dialogic Imagination*)

. . .

The test of a first-rate intelligence is the ability to hold two opposed ideas in the mind at the same time, and still retain the ability to function.

(F. Scott Fitzgerald, "The Crack-Up")

. . .

[EXT. A Cemetery South of San Francisco (DAY)]

. . .

I . . . am not the visual reality that my eyes encompass, for if I

were, darkness would kill me and nothing would remain in me to desire the spectacle of the world, or even to forget it.
(Jorge Luis Borges, "The Nothingness of Personality")

…

I hated the thought of following my wife. We'd been together seven years. We trusted each other. I pretended to myself that I wasn't following her. I followed her to work, but really I was just running errands early, trying to beat the crowds.

Twice, I saw her on my way home from following her to work. The first time, I saw her in the passenger seat of a car on the other side of the road (she was going in the same direction she had already gone, again). The second time, I saw her through the window of the MAX. Though I told myself over and over that these women could not have been her, I had seen what I had seen. Everything had seemed fine not too long ago, but how could I go on pretending that everything was still fine? I was following her.

In the car, she'd been wearing the jacket she'd stopped wearing after I said she looked beautiful in it. I decided to look through her closet. It wasn't there. When I asked her to wear it to dinner, she told me we couldn't afford to go out, and, besides, she'd donated that jacket to Goodwill. On the MAX, she'd been wearing a dress I had seen her spill red wine on. I looked through her closet. Nothing.

Then she spoke to me, finally, after too long, and it was the worst thing that could have happened. She said she was pregnant. She looked angry. I was on the verge of tears, I think. Even now, I can't be sure what I was feeling. I asked if she was sure. Really, I wanted to stop time, make it so that I didn't have to live this moment. Yes, she was sure. It was a stupid question. We aren't ready, I was thinking. I was thinking: this is the worst possible time for this to happen. What are you thinking? she asked. What she meant was, Should I have an abortion? I'm not

just saying that, now, to make myself feel better about what I said then—that's what she meant. I said that it was going to be her decision. Had she been to the doctor? Was she *really* sure? She looked so disgusted with me. I felt disgusted with me. I thought: When had we even had sex last? It would have been the wrong moment to ask questions about where she was going during the day.

. . .

Such an entity could have been utterly abolished only by the power of nothingness. Only the absolute void could have imposed on him this particular *manner* of vertigo.
(Villiers, *Tomorrow's Eve*)

. . .

It was a severe disappointment, Beyle writes, when some years ago, looking through old papers, he came across an engraving entitled *Prospetto d'Ivrea* and was obliged to concede that his recollected picture of the town in the evening sun was nothing but a copy of that very engraving. This being so, Beyle's advice is not to purchase engravings of fine views and prospects seen on one's travels, since before very long they will displace our memories completely, indeed one might say they destroy them.
(W. G. Sebald, *Vertigo*)

. . .

[Mme. Gherardi], who reappears a number of times on the periphery of Beyle's later work, is a mysterious, not to say unearthly figure. There is reason to suspect that Beyle used her name as a cipher . . . and that Mme. Gherardi, whose life could furnish a whole novel, as Beyle writes at one point, never really existed, despite all the documentary evidence, and was merely a phantom, albeit one to whom Beyle remained true for decades.
(Sebald, *Vertigo*)

...

MADELEINE
WIFE OF
GAVIN ELSTER

...

No mention of Madeleine as anything more than the role she has played. An empty gravestone, if not an empty grave.

...

Did Madeleine's gravestone stay up as long as Carlotta's? It seems unlikely; there are no reports of tourists visiting it. The production took Madeleine's gravestone with them and left Carlotta's.

...

[I see] breakdowns as a philosophical experience that is about the confinement, or even death, of the self.
(Zambreno, *Heroines*)

...

Speaking of the panoramas (huge, often wraparound photographic or painted images, like Atlanta's Cyclorama) popular in the late 19th century, Rebecca Solnit writes, "The passage of a whole day was reduced to fifteen minutes, and those who might not care to watch the changing skies loved to see their imitation, just as they flocked to see the Diorama imitating a nearby church they could have visited in actuality for free. This is one of the great enigmas of modern life: why the representation of a thing can fascinate those who would ignore the original. Perhaps it is the skill, the medium, the

technique, the promise of resolution, or perhaps it is merely that someone has already decided to pay attention to a subject, and the representation invites you to commune with this attention as well as its subject."

...

Schopenhauer wrote that dreams are pages read out of order from the book that records our waking life. We proceed as normal when awake; we read at random while asleep. Does this account for the prophetic properties dreams are said to have? If the vision of the grave is not an invention of his subconscious mind but is instead a prophecy, a page from his own life that Scottie has come upon too soon, what is the rest of the vision? Or which should we regard as "out of order" in *Vertigo*: "Madeleine's" life, or Judy's?

...

The image of real flowers turned to paper flowers [in the dream sequence midway through the movie] suggests the possibility that the whole Madeleine ideal is a fraud is already nightmarishly present.
(Wood, *Hithcock's Films Revisited*)

...

In [Scottie's] dream he achieves identity with Madeleine: first by sinking into her grave . . . then by falling onto the roof. He wants to die in her place, or to join her in death; but looking back we can see his whole attraction to her as a matter of identification— the desire for annihilation.
(Wood, *Hitchcock's Films*)

...

Scottie's spiral in the dream sequence mimics that of the policeman, not that of Madeleine. We—Scottie, you, and I—do not see Madeleine fall from overhead, like we do the policeman. We only see her pass by the window.

. . .

To become the spectator of one's own life . . . is to escape the suffering of life.
(Wilde, *Gray*)

. . .

[There is a hiatus in the MS. at this place.]
(E. T. A. Hoffmann, *The Devil's Elixir*)

Part Two

...

Vertigo Vertigo Vertigo

[INT. Scottie's Bedroom (NIGHT)]

…

There is no dead matter. Lifelessness is only a disguise behind which hide unknown forms of life.
(Bruno Schulz, "Treatise on Tailors' Dummies, or The Second Book of Genesis")

…

Vertigo Vertigo Vertigo
In this book, a man goes through a painful divorce. He believes his wife has cheated on him, and she maintains her innocence. They scream at each other about every little thing. Any time she's late, even by a minute, any time she has to leave the house early or unexpectedly. He starts checking her computer, her cell phone. The whole thing goes on in the only way it can until the two finally decide they can't live with each other anymore. We never learn whether the wife really was cheating on the husband. She takes a job in another city, and the man grieves. He loved his wife, but he couldn't stand the thought of her cheating on him. It is, he thinks, the thought that she didn't love him as much as he did her, that in some way, she had the better end of the deal, because she could just walk away. He gets upset thinking about it. He thinks that this thought is itself a sign of some sort of instability. He starts seeing a therapist.

This man is an instructor at the university. One of his students looks almost exactly like his ex-wife, though he does not see the resemblance. The whole thing is related to us by a third-person narrator, not the man, who tells us that the student looks like the ex-wife, and tells us the man doesn't realize it: The student is a brunette and his wife was a blonde, but in other ways, the two are nearly identical. The student graduates and takes a job in publishing. The man sells his next book, a study of

the film *Vertigo*, to the publishing company she now works for. The two reconnect at a party and begin seeing each other. The man's friends mistake this former student for the man's ex-wife. They comment on how young she looks, how much they like her hair, how good it is to see the two of them together—all these innocuous comments that are just vague enough they don't tip off the man or his student that the man's friends think that she is really his ex-wife. The student has never met the ex-wife, and the man doesn't have any pictures of her—too painful; he has thrown them away—so she has no idea that she looks so much like the ex-wife.

The man and his former student decide to get married. They go to visit the former student's parents. It is an awkward visit. The parents are polite, but it is clear they do not approve—there is the difference in their ages to consider, and the fact that she is his former student. On the last night of the visit, the father asks the man to accompany him on his nightly walk. While they walk, the father tells the man a story.

The former student was adopted; when she was a child, the father says, she was homeless for a year, the year before they adopted her. Her birth mother, who had been raising her on her own, was a schizophrenic. The father had been in construction, and had fallen to his death from the fifth floor of a building he was working on. He died on their anniversary. That morning, after he left for work, the mother had looked around the house for her present. She could be childish like that. There was a box, hidden high up in the closet, with an old dress in it; old, but very beautiful, and very fragile. Thinking it was a present for her, she put it on, called the babysitter, and went to the job site with a picnic lunch. She talked the foreman into giving her a ride up on the construction elevator. When she stepped out of the cage of the lift, she said, her husband backpedalled. It looked like he had seen a ghost, she said. She saw him go over the edge. She saw him hit the ground. She never forgot.

Mostly her schizophrenia had been controllable with

medication before, but now she forgot to take the medication or the doses were not strong enough to compensate for her missed doses. In either case, she began seeing the dead husband. She went into screaming fits, shouting incoherently. She had superhuman strength when she was having one of her fits, and no one could get near her without bruises or blood. Her child, the former student, was neglected, and sometimes, mistaking her for the dead father, the mother would scream at her and strike her. The former student was frightened. She ran away from home. She was safer on the streets.

The former student's adoptive father is telling the man all this because he wants him to know that she—the former student—is predisposed to the disorder, and has shown signs of disorganization in her thinking and even possible hallucinations. He wants the man to be prepared. He asks the man, point blank, whether he would be willing to care for her if it turns out she does have schizophrenia, whether he has that kind of patience. The man tells his future father-in-law that he will stand by her no matter what, but after that he falls silent, remembering the time that she asked him what he was doing at the mall that day, on a day he hadn't gone near the mall. No matter what he said, she would not believe it, until finally she got so angry she walked out. She hadn't answered her phone or her door for days. At the time, he hadn't understood why she was so upset. He is not so sure he *can* care for her, if it turns out she is schizophrenic. He isn't a doctor, or not a medical one, anyway, and, well, he's not sure about his own mental stability.

At this point, the book breaks off the story of the man. We follow a new narrator, a first-person narrator who is obviously a young child. It isn't faux-naïf, but the diction is simple and the words aren't especially complex or erudite. This narrator is running around a house, hiding. The hiding spots are described meticulously, one after the other, each a little better, a little smaller and more out-of-the-way than the one before. We can't be sure whether this is a game or not, but the narrator doesn't

seem frightened. Just when we begin to lose patience with these descriptions of hiding places, the child's father finds the child. Through dialogue, we find out that the child's name is the same as the ex-wife's name from the first story. The child is a girl. At first—because we are still seeing things from the girl's viewpoint—we think that the game is over and the father has won, but then we begin to think that something else is going on, that maybe there is something sinister happening, because of what the father says to the child. He is pretending it is a game, but he is clearly nervous and repeatedly tells the girl to be as quiet as she can possibly be. The two of them haven't left the girl's hiding place, and it is uncomfortable for both of them to be hiding there. The father proposes a new game—let's see who can be quietest while walking to the car. The girl doesn't understand the point of the game, and she doesn't like games like this one—her father has played them with her before—but she goes along with it. When they get to the car, the father leans over and buckles the girl in, putting the car into reverse and backing out of the driveway just as the child's mother comes out of the house, screaming the child's name. Where are you taking her, the woman shouts. Where are you taking my child? The woman bangs on the hood of the car and smashes the rear window with a brick.

Now we return to the first story, but it is before the events that we've already read. The instructor and his wife are still together. They are up late, lying next to each other in bed. They are talking about having kids, about what the rest of their life together will be like. They make a list of things they think they'll need to have before they can have a child: they should each have insurance coverage the other can be on, so that the bills won't be astronomical, they should have a house in a quieter neighborhood, near a good school, she should have a job that will allow her a decent amount of maternity leave, he should have a job that is a little more stable, so on and so on. She tells him these are all good things. He tells her he worries some

of these things may just be a way of putting off having a kid, making it so that things will never be right so that they never end up having a kid. She asks him which things it is he's talking about. Her cell phone buzzes on the nightstand, but she just looks at him. He wonders who would be calling now, almost midnight. He wonders why she wouldn't be curious, too, why she won't answer or at least look at the number.

...

Midway through *Vertigo*, after Madeleine has fallen to her death and her husband, Elster, has left San Francisco, Scottie has a dream. Critic Tania Modleski points out that in that dream, Scottie plays out precisely the hallucination of which he has, in the first half of the film, tried to cure Madeleine. He even dies Madeleine's death. Scottie has become Madeleine, but, because the Madeleine he knows does not exist (it is Judy playing Madeleine), he has thus become someone who never existed—Judy-as-Madeleine. He is committed to an institution. What would it be like to live out the life of something without life?

...

Or does a fiction have a kind of life?

...

In his quest for his lost Madeleine, Scottie becomes like "the mad Carlotta," who accosted strangers in the street in desperation, seeking the child that had been taken from her: after the dream, we see Scottie wandering the city, repeatedly mistaking other women for Madeleine, stopping them in the street only to be bitterly disappointed at his error.
(Modleski, *Women*)

...

Does Elster, too, suffer Carlotta's madness? Had the cameras been rolling prior to the movie's start, might we have seen Elster accosting potential Madeleines in the street, attempting to convince them that he is not mad, that, even though his plan *sounds* reprehensible, he'll make it up to them, until finally he comes upon Judy? "Have you seen my lost child? Have you seen the child of Carlotta?"

. . .

François Truffaut writes, "Alfred Hitchcock achieved a real tour de force in inducing the public to identify with the attractive leading man, whereas Hitchcock himself almost always identified with the supporting role—the man who is cuckolded and disappointed, the killer or a monster, the man rejected by others, the man who has no right to love, the man who looks on without being able to participate." In *Vertigo*, the attractive leading man *is* the man rejected by others, the man who has no right to love, the man who looks on without being able to participate. Or is he? Would Truffaut go against the overwhelming opinion of critics and say that Hitchcock, in *Vertigo*, identifies not with Scottie, but with Elster? Would he be right in doing so?

. . .

But if both Scottie and Judy play out the roles assigned them by Elster, if Madeleine has been dead throughout the movie and Elster's actions have been forced upon him by his murder of Madeleine, then Midge is the only character who truly acts out of her own free will. And she disappears before the second half of the film even really begins.

. . .

It is no exaggeration to say that Masoch [from whom the word

masochism is derived] was the first novelist to make use of suspense as an essential ingredient of romantic fiction. This is partly because the masochistic rites of torture and suffering imply actual physical suspension (the hero is hung up, crucified, or suspended), but also because the woman torturer freezes into postures that identify her with a statue, a painting, or a photograph.
(Gilles Deleuze, *Masochism: An Interpretation of Coldness and Cruelty*)

...

[T]he lover's dream is to identify the beloved object with himself and still preserve for it its own individuality; let the Other become me without ceasing to be the other. To know [the body of the other] is to devour it yet without consuming it.
(Jean Paul Sartre, *Being and Nothingness*, trans. Hazel Barnes)

...

A mimetic relation is one of similarity, not *identity*, and similarity implies difference—the difference between the original object and its reflection, between the real world and the fictional heterocosm.
(Brian McHale, *Postmodernist Fiction*)

...

Jean Corbett, Kim Novak's stunt double for *Vertigo*, died just two weeks after I was born. She appeared in at least 17 films, but her name isn't in the credits of a single one (her name does not appear in the credits of *Vertigo*). Jean had a sister, Joan Corbett, who was in several movies with her sister, always also uncredited. It could be a joke, but it isn't.

...

Hitchock: "The majority of actors are stupid children. Think of Kim Novak. In the second part of *Vertigo*, when she's dark-haired and looks less like Kim Novak, I even managed to get her to act. But the only reason I took her was because Vera Miles was pregnant."

(Oriana Fallaci, *The Egotists: Sixteen Surprising Interviews* (trans. Pamela Swinglehurst))

...

The psychologist Martin Conway believes that what he calls the "reminiscence bump"—the period between the ages of 15 and 25 when the experiences that will become our most vivid memories occur (also when more of our experiences are recorded as memories than at any other time in our lives; as we get older, fewer and fewer events get recorded)—is the thing that makes identity possible. Conway believes the reason memories of this time are so plentiful and so powerful is that this bump is when we create ourselves, and, in order to maintain a more or less consistent self through the rest of our lives, we call upon those memories again and again, as though they were a kind of script, reinforcing and deepening the significance of the experiences they represent. It's a chicken or egg thing, though, isn't it? Maybe we remember the things that happened during the period our memories worked well more frequently because, no matter what else happens, we won't remember it as vividly, or maybe our brains are by nature nostalgic and just naturally return to that period whenever some question about who we are comes up. The surprising thing is that, either way, the memories themselves, our identities, are arbitrary: they are neither more nor less significant on their own than memories made later (or earlier). It is only the age at which they were formed that makes them so important to us.

...

Carlotta commits suicide at 26. Madeleine is murdered at 26. We do not know Judy's age (it would be on that driver's license she shows Scottie; if only we could see, if only we could know), but she might as well be 26 (it's unlikely Elster, so concerned with appearances, would have chosen someone much older or much younger than his wife to play her). These three women, then, are all 26 years of age or nearly so. If Conway's theory is correct, then, they have each only just finished creating an identity. Not one of them has yet had time to inhabit it. Though they are all indisputably themselves, they have not yet had much opportunity to be themselves, to know what that means. Carlotta was driven insane during this all-important period—it is precisely the fact that she has had the identity she thought she had (mistress, mother) taken away from her that drove her insane. Madeleine is supposed to be living Carlotta's creation, her set of memories, though one assumes she didn't actually do so in life—as far as the audience is concerned, Madeleine has no identity; we never see her alive. And Judy is living Elster's creation, which is supposed to be Madeleine's identity, which, in turn, is supposed to have been taken from Carlotta's memories. None of the three has been allowed to live as herself, if living as oneself means to draw upon the memories of the period during which one has decided who one is. The richness of selfhood, the very consistency that is the most important hallmark of identity, is that one can call upon past decisions and act in consonance with them when presented with new problems, that one can have some sort of coherent memory of—and connection to— the past. The real psychic violence committed in *Vertigo* is that neither Elster nor Scottie nor Carlotta's "rich . . . powerful man" have allowed the women they profess to love access to their own memories, their own identities. It would drive anyone mad.

. . .

[INT. Sanitarium Bedroom (DAY)]

173

...

In the breakdown sequence, it is *Carlotta* in Elster's arms, *Carlotta* missing from *Carlotta's* grave. Why does my mind always insist that it is Madeleine? Or rather, Judy?

...

Midge: You don't even know I'm here, do you? I'm here. (01:27:13)

...

In Boileau and Narcejac's novel, *D'Entre les Morts*, there is no Midge. As of 01:29:00, there is no Midge in *Vertigo*, either.

...

For now we see through a glass, darkly; but then face to face: now I know in part; but then shall I know even as also I am known.
(1 Corinthians)

...

Here I come to view a voiceless ghost . . .
Yes, I have re-entered your olden haunts at last;
Through the years, through the dead scenes, I have tracked you.
(Thomas Hardy, "After a Journey")

...

Stranger still, my wife is a woman I have never actually seen.
(Dick, *VALIS*)

...

My girlfriend and I watched a documentary called *The Woman Who Wasn't There*, about Tania Head, a woman who claimed to have been on the 78th floor of the South Tower of the World Trade Center on September 11th. For years, she maintained that she had escaped the tower that day with the help of Welles Crowther and an unidentified fireman. Her husband, a man named "Dave," was, she said, in the North Tower; he did not live.

Head claimed that she had been badly burnt in the attack, and that her right arm had been nearly severed. After a lengthy recovery, she joined a group named World Trade Center Survivors' Network and even acted as its public face for several years, giving speeches about her experience to other support groups and leading tours around Ground Zero. In 2007, however, a reporter for the *New York Times* discovered that Head had not been married to "Dave"—had probably never even met him—had not been injured in the World Trade Center attacks, and had almost certainly been in Barcelona, Spain on September 11th, 2001. Yet she had recounted her gruesome story again and again, in great detail—severed limbs, dead bodies, the stuff of nightmares. She would have been one of only nineteen people on or above the 78th floor that day to have survived had her story been true.

The documentary was directed by Angelo J. Gugliemo, Jr., a member of the World Trade Center Survivors' Network who had known Head for several years. Though I expected talking heads moralizing about the horrible fraud Head had perpetrated, there weren't any. Even among the survivors interviewed, there wasn't much outrage at this woman for taking the spotlight the way she had. This was not a story of someone desperately seeking attention, though it easily could have been. Instead, the way Head's story is told asks a much more interesting question. Not *How could someone do this?* but *Why would someone want to do this?* Why would someone want to put herself in this position, a position that required her to act out and relive memories of terrible suffering over and over? Not only had she chosen to

pretend to have been at the World Trade Center that day and to have barely escaped with her life, having seen and experienced things that scarred her forever, but she had then also chosen to become someone who had lost her husband in those same attacks, someone who had then become someone who was called upon to talk about those experiences again and again and to try to comfort those who had also (really, actually) suffered.

Yes, she was calling attention to herself. The film might have focused on that aspect of the story: the filmmakers could have shown us one of Tania Head's moving speeches about 9/11 and then cut to the reporter who had found out the truth, telling us where she had been (Barcelona) and what she had been doing (she was on vacation from an MBA program). Instead, the only speeches Head gives that are shown in the film have had their audio taken out or overlaid with other audio. Sometimes, we see her about to speak and then cut away just before she begins speaking. Most of her story is told by other survivors, her former friends in the Survivors' Network. When we cut to Spain, it is to hear from Tania's childhood friends, not those who would have known her in 2001. The question "Why would someone do this?" in the mouths of the people interviewed, is less an accusation than it is an honest expression of puzzlement—why? Why would Tania Head—or Alicia Esteve, her real name—why would this woman want to be in my position, they seem to ask. Why would she want to go through something so awful—and then go through it again, and again, and again—if she didn't have to? The acting out of suffering can be—must be—a real suffering; why not spare oneself the pain?

. . .

There's a deeper truth in fiction, because memory is faulty.
(Priest, *The Affirmation*)

. . .

176

Indeed I am convinced that *the most erroneous assumptions are precisely the most indispensable for us*, that without granting the validity of the logical *fiction*, without measuring reality by the invented world of the unconditioned, the self-identical, man could not live; and that a negation of this fiction . . . is equivalent to a negation of life itself.
(Friedrich Nietzsche, *Beyond Good and Evil*)

. . .

What if the whole first half of *Vertigo* is just the fantasy Scottie has while in the sanitarium? Scottie, in pajamas, grieving for the death of the policeman or shocked by his near-death experience, sits in his chair (Midge hovering over him—a cousin? a sister?) daydreaming he'd met a woman named Madeleine and then that woman had died. What if there is no acrophobia, no vertigo, no Madeleine? What if, from hanging from the gutter to waking in the sanitarium, nothing that happens is "real" and everything we see is something Scottie has made up to explain to himself how he has come to be here, in this sanitarium? He feels responsible for the death of a man: the policeman, a colleague, perhaps a friend. It must be a difficult thing to come to terms with. Judy's letter may seem to close off this possibility, but Judy's letter is itself a fantasy. When Scottie meets Judy on the street, she might as well be anyone—any woman can stand in for the woman of a man's fantasy. There would be no coincidence in their meeting, no accident of fate bringing them together, only a madman on the streets and a woman who finds she can't get away from him.

. . .

[INT. Ernie's Restaurant (NIGHT)]

. . .

A partial list of places I saw "myself":

1. In Pioneer Courthouse Square.
2. In Union Square in San Francisco.
3. On Stockton Street in San Francisco.
4. Getting into a taxi at the Hotel Monaco, in Portland.
5. In Irving Park, on the baseball diamond, playing with a dog.
6. At the airport, exiting the gate area just as I was putting my shoes back on after passing through the security checkpoint.
7. From a streetcar window, in San Francisco, on the way to Golden Gate Park, at a stop near a little greenspace, just before the streetcar tracks dipped under an overpass.

. . .

Where, in truth, had I *not* bitter cause to curse him within my heart? From his inscrutable tyranny did I at length flee, panic-stricken, as from a pestilence; and to the very ends of the earth *I fled in vain.*
(Edgar Allan Poe, "William Wilson")

. . .

The changes brought about by technology seemed supernatural at first, and photography was associated with death both in the many, many images of the dead made during the early years of the medium and in the way a photograph seemed to cheat death by making at least appearance permanent.
(Solnit, *River of Shadows*)

. . .

Film, we know, does nothing to time itself, merely to our perception of it—we can speed it up, slow it down, rearrange it, stop it anywhere we choose. Film makes time appear to repeat, but nothing repeats, nothing comes back, nothing returns, except the feeling of what returns.
(Nick Flynn, *The Reenactments*)

…

Madeleine E.

This is a book about a woman who has a terrible accident. She goes into a coma, and it is two months before she comes out of it. Every day, a man comes to visit her in the hospital. He brings her flowers—what flowers do they use in Carlotta's bouquet in *Vertigo*? White roses? He brings her white roses. The story is told in third person. Because the woman is in a coma to begin with, we don't know anything about her, and the man only says, "I love you, Madeleine." We know that she is blonde. We know that she is beautiful.

The book repeats itself: The man comes to visit, the man leaves. The man comes to visit, the man leaves. A month passes.

The middle third of the book is a very long scene of Madeleine coming out of her coma. She wants to know what she's doing in the hospital. She remembers being at work, and then . . . The nurse calls the doctor. The doctor's daughter is downstairs, in another room, very ill. He is understandably distracted, but he has fallen in love with the woman a little bit, despite himself, and he feels responsible for her. He does a few quick tests. She seems to be functioning normally. He sends the nurse to fetch the man. The man is having something to eat in the cafeteria, but he's left instructions that he be paged if she wakes up. He has told everyone he is her fiancé. At the exact moment the nurse leaves the room, the doctor is paged and, worried there is something the matter downstairs, runs off without telling the woman what has happened to her. She is alone and confused. There are white roses in bouquets all around the room, many of them dead and now dried, others wilting, the perfume of them all nearly overwhelming. We stay with this woman for a few pages, as she looks at these bouquets and wonders about them. Each bouquet is described. Then the nurse knocks and the man enters. He is so happy and so surprised, he doesn't know what to say. He can't speak. He runs

over to the bed and collapses onto the woman. He is crying. She immediately recognizes him, calls him by his name, Scottie, and asks what happened to her, why she is here.

He tells her what happened, or what he knows. He doesn't know everything, he says, and he doesn't know exactly why what happened happened, but he will try his best to explain and maybe she'll remember the rest. She was found on the sidewalk outside a chapel in the Mission, an old church that's being renovated. They'd been to a party near there a week before the accident; otherwise, it wasn't a neighborhood they went to all that often. The police said they thought she had climbed up the scaffolding and then fallen. No one knows why she would have climbed the scaffolding, but her injuries were consistent with a fall, and there would have been no other way up. It was a miracle she hadn't died. The last time he'd seen her, he tells her, was the night before, when they'd gone to their favorite restaurant together. They'd had an argument and she'd left on her own. She asks what the argument was about, but he says it isn't important, that she should just forget about it. She reminds him that he's just told her it will be good for her to try to remember things. He says that he's forgotten what it was about, but it's obvious that he's not telling the truth. The woman becomes suspicious. Not about the argument, about the man—it occurs to her that she doesn't even know him, that he *looks* like the man she remembers seeing, but he definitely isn't that man. She calls for the nurse and makes a scene, telling the nurse she doesn't want this stranger in her room. The nurse tells her this man has been to see her every day, spent almost as much time at the hospital as she, the nurse, has, if not more. He must care for the woman a lot. It doesn't matter, the woman says, get him out of here. The man is surprised and clearly hurt, but he leaves. He doesn't want things to get any worse. Other nurses are arriving because of the shouting. Security is on its way.

The woman is stuck in her hospital room, under observation, and she has plenty of time to think about things.

She can't remember what happened, but she's sure this man had something to do with it. Why wouldn't he tell her what the argument was about? Why was he trying to come off like someone she knew, when he was so clearly a stranger? She calls the police to try to get a better idea of what happened. She speaks to an officer, Detective Ferguson, who tells her he'll come by to get her statement, and maybe, with the right questions, he can help her remember the rest.

Detective Ferguson is helpful. They talk about the night of her accident. She remembers that she broke up with Scottie that night. That's why they left the restaurant separately. She still can't remember where she went afterward or why, but she feels relieved to have remembered *something* from that night on her own, and thinks maybe the rest will come back, too. The detective asks about the bouquets. Why so many? Funny he should mention that, she says. One of the reasons she had broken up with Scottie was that he was controlling, overwhelming. The roses are exactly his style. She wants them gone, but she feels bad about asking the nurses to do so much work for her. She asks the detective to come back the following day. She is tired. Maybe she will remember more, what happened after she left the restaurant. Already, she remembers a car. Was there a car at the accident? No, says the detective, no car.

Though a detective does come by the next day, she's sure it isn't the one who was there the day before. Are there two detectives who look the same, or is this man even a detective? What kind of a trick is he playing on her? Where's the one she talked to yesterday? There is another scene and the detective leaves, confused and a little heartbroken. He'd put on his best suit, gotten a haircut, was freshly shaved. He wanted to impress her. Instead, he seems to have frightened her. He always comes on too strong, he thinks.

The doctor's daughter has stabilized and his ex-wife has told him he is not needed anymore. They do not get along, the doctor and his ex-wife. He returns to his rounds. He has several

patients his colleagues have been helping out with, but none he is more excited to see than the woman who has just come out of her coma. Who is she? What happened? He wants to know more about her. Even though he isn't on rounds until the next morning, he visits, tells her what to expect. She listens carefully. She does not recognize the doctor from two days before, and then she does. There is something strange about him. She keeps this to herself. So far, he hasn't asked any questions, other than the obligatory *How are you feeling*? She is beginning to worry that there is something very wrong with this hospital. Where has she woken up? The nurses, the doctors, even the visitors: there is something off about all of them. She wants to get out and to get out, she'll have to show them that she's okay. Thinking she's tired, the doctor leaves her, goes home.

Once the doctor has gone, her ex-boyfriend, Scottie, enters the room. He has brought even more flowers. She tells him to take them away, to take them all away. Then, something about him jogs a memory—this is the man in the car, the man with whom she left the restaurant that night! Not her ex-boyfriend, but someone who looks a lot like him, a man who'd wanted her to pretend to be his girlfriend to make some other woman jealous, or so he'd said. They were in the car because they were on their way to a club in the Mission that night. He was going to pay her a thousand dollars to pretend to be his girlfriend. She was a sales associate at Nordstrom, but, ever since her roommate had moved out, she couldn't pay rent on what she made. She couldn't turn down a thousand dollars. It was creepy, but the guy reminded her of her boyfriend, and he seemed harmless enough, so, she figured, what the hell. It *is* weird that he looks so much like her ex-boyfriend, though, she thinks. She can't remember where she met this guy. How does she know him? And why is he here, now? Did *he* push her off the scaffolding? She can't remember, but she pushes the call button. She doesn't say anything to the man, even when he asks her questions. When the nurse gets there, she tells the nurse she doesn't want this

man there, doesn't want him admitted anymore. And could she please do something about the flowers?

The man looks inconsolable. He tells the nurse that she doesn't need to worry about the flowers, and she doesn't need to worry about him bothering them anymore. He won't be back. He starts picking up bouquets. He is on the verge of tears. The nurse has seen how devoted this man was to the woman, how he stayed by her those two month, how he brought flowers every time he came, how he talked to her. She is angry at her patient, as angry as she has ever been at a patient, but she has been a nurse long enough, has seen enough of people, that she is able to hide it. She helps the man gather up all the flowers. They put the flowers on one of the flat-carts the attendants use to bring meals to the ward on. The nurse says that, if the man doesn't mind, she'll take the more recent ones around to the nurses' stations. He says that it's a great idea. They throw the older ones away. She asks him if he wants to help her. He does help her, though it's obvious he's struggling with his emotions. Though she doesn't really know why she does it, the nurse takes the man home after her shift, and the two of them make love.

It takes a few chapters, but the man falls in love with the nurse, and the woman gets out of the hospital. The doctor finds out that she has suffered head trauma that seems to have caused Capgras delusion, a rare syndrome in which the person affected recognizes faces but believes the people she recognizes are impostors. This explains, to the doctor, her odd behavior. He goes to her room to tell her, but she has discharged herself. The detective is there, with a bunch of white roses. He asks the doctor about the man who used to bring this kind of flowers, whether he ever said anything to the doctor, and what it was that he said. He asks about the woman, about the odd way she acted. He knows the doctor can't say anything, because of doctor-patient privilege, but maybe he could give the detective a hint? He only wants the woman to be happy, happy and healthy. The doctor says no, sorry. She fell, went into a coma, came out of it.

She is well enough to go home. These are things the detective knows already. As for the man who visited and brought roses, the doctor barely said a word to him. The doctor says, You probably know much more about him than I do. The detective doesn't know what this means, or why the doctor is looking at him so strangely.

The woman, not knowing what has happened but not wishing to have to deal with the police again, declines to bring charges against anyone. There is no reason for the detective to have anything further to do with her, but one day, he shows up at Nordstrom. He finds out she quit soon after her return to work. She had been acting strange, everyone agreed. She had been evicted from her apartment while she was in the hospital, and the woman she was staying with afterward says she thinks the woman has gone back home, somewhere in Kansas. She says it was very difficult to live with the woman. She really was acting very strange. The detective leaves, a little more heartbroken.

The nurse's relationship with the man is getting serious. He has moved some things into her apartment: just little things, but things. She is a brunette, has been most of her adult life (she was a blonde when she was a child, her hair is almost white in pictures), but one day, she decides to get her hair dyed. She thinks it will be a fun new thing to try. She has it dyed, platinum blonde. It looks good on her. She decides to really splurge. She goes to Nordstrom, picks out a new outfit and new shoes. She gets a lot of very odd looks, and one sales associate comes over and says, Hey, welcome back, but she doesn't think much of it, just thinks it's a new sales tactic. She puts on her new outfit before the man comes over. They are going out to dinner, to a restaurant she's never been to. He assures her it's good.

A few months later, the nurse runs into the detective on the street. Neither recognizes the other—they met only for a few minutes, in the hospital, some time ago—but there is some odd attraction between them. The detective thinks she looks like . . . but it can't be. He invites her out to dinner. She feels a certain

amount of power, a feeling that has been developing ever since she dyed her hair and started dressing differently. She's been asked out by a number of people, men and women, in the last few months. She's tired of the man she's been seeing—he's very romantic but also very possessive and clingy. She's planning to break up with him that night, at dinner. She tells the detective no, thank you, I'm flattered. The detective persists. She thinks for a minute. The old her would have played it safe, broken up with her boyfriend and then gone home. Maybe she should think different. She tells him she's having dinner with an old friend, but if he doesn't mind picking her up at the restaurant, and if he doesn't mind that it's fairly quick, she will join him for a drink after. He readily agrees. As he's walking away, she thinks, *You know, he kind of looks like . . .*

. . .

Cinema . . . was and is a breach in the wall between the past and the present, one that lets the dead return, albeit as images of flickering light rather than phantoms in the dark or armies marching across the land. Anyone who watches old movies watches the dead.
(Solnit, *River of Shadows*)

. . .

There is nothing more in being born twice than once. Every thing in this world is the effect of resurrection.
(Voltaire, *Princess of Babylon*)

. . .

I think what a person normally goes to the cinema for is time, whether for time wasted, time lost, or time that is yet to be gained.

(Andrei Tarkovsky, *Sculpting in Time*)

...

Ingrid Bergman: "To irritate us, he would say, 'Well, all my fun is over now that you actors are here.' Because all his fun had been in the preparation, the writing, the camera setups, the fantasy of his mind, he regarded us as intruders to his fantasy. But he was always very controlled. He never lost his temper or screamed at anyone. And yet he always got what he wanted."

...

Hitchcock: "There is a great confusion between the words 'mystery' and 'suspense.' The two things are absolutely miles apart. Mystery is an intellectual process, like in a 'whodunit.' But suspense is essentially an emotional process. You can only get the suspense element going by giving the audience information. I daresay you have seen many films which have mysterious goings-on. You don't know what is going on, why the man is doing this or that. You are about a third of the way through the film before you realize what it is all about. To me that is absolutely wasted footage, because there is no emotion to it. . . . There is no emotion from the audience. . . . The mystery form has no particular appeal to me, because it is merely a fact of mystifying an audience, which I don't think is enough."

...

[INT. Palace of the Legion of Honor (DAY)]

...

I am . . . I . . . a sea of . . . alone.
 Being Hitchcock's last words to Suzanne Gauthier.

…

A book, even a fragmentary one, has a center which attracts it. This center is not fixed, but is displaced by the pressure of the book and circumstances of its composition. Yet it is also a fixed center which, if it is genuine, displaces itself, while remaining the same and becoming always more central, more hidden, more uncertain and imperious. He who writes the book writes it out of desire for this center and out of ignorance. The feeling of having touched it can very well be only the illusion of having reached it.
(Maurice Blanchot, *The Space of Literature*)

…

"What we all dread most," said the priest in a low voice, "is a maze with no centre."
(G. K. Chesterton, "The Head of Caesar")

…

My agent wanted the book done. In order to finish it, I needed to go to San Francisco. Hitchcock had seen San Francisco and thought, "I must make a movie here." He rejected Maxwell Anderson's script because it would not have accommodated many of the images Hitchcock had conceived on that first visit. Even though the majority of the filming had taken place on a soundstage in Los Angeles, there was something about the city that was vital to the production. Now, there was something about it that was vital to my book.

My girlfriend objected that I had lived in San Francisco for years. Did I really need to go back now, less than a week after we had moved in together? She had just found out she was pregnant. We needed to save money, be careful. I invited her to come with me. I told her it would be good. I needed a subject,

a foreground for my research; without her there, I would not be able to see the scenes I was writing as I needed to see them. Alone, the city was the city, an environment to be navigated; with her there, it would become a *setting*, a place where things happened. She wasn't convinced. I told her to imagine a canvas without any paint on it, or paint without a canvas. This is what I remember saying, those words, though the analogy is obviously flawed. She was not my subject, *Vertigo* was. Thinking about it now, I realize what I was saying was I needed a medium to work in. This is another way of saying that I would be lying if I said I didn't know where things began to go wrong. I needed her there. It wouldn't work otherwise.

...

The characteristic subject of [Hitchcock's] art, often taken to be suspense, is more accurately anxiety.
(Taylor, *Hitch*)

...

One does not create by adding, but by taking away. To develop is another matter. (Not to spread out.)
(Bresson, *Notes*)

...

How much time passes between "Madeleine's" faked death (Madeleine's real death) and Judy's unmasking? It takes minutes onscreen, but we're meant to believe that . . . months have gone by? Later, we're told it has been a year since San Juan Bautista, long enough for Midge to give up hope in Scottie, and for Scottie to begin to recover some equilibrium. How long does that take? For some people, it can take years. For some people, there is no healing some wounds.

...

We are in fact by this time [immediately following Madeleine's supposed suicide] so thoroughly identified with Scottie that we share his shock, and the resulting sense of bewildered desolation, in the most direct way, just as we share his sense of helplessness, even of responsibility. We are stunned, the bottom is knocked out of the world, we cannot at all see where the film is going, what possible sequel this event can have: all is chaos.
(Wood, *Hitchcock's Films*)

...

The body is imaginary, and we bow to the tyranny of a phantom. Love is a privileged perception, the most total and lucid not only of the unreality of the world but of our own unreality: not only do we traverse a realm of shadows; we ourselves are shadows.
(Octavio Paz, *Alternating Current*)

...

[EXT. Podesta Baldocchi (LATE AFTERNOON)]

...

"SOMEWHERE . . . SOMEHOW he'd loved her and let her slip through his fingers. *He had seen her die.* And now here she was looking into his eyes again . . ."
Tagline for *Vertigo* ad

...

When a fantasy object, something imagined, an object from inner space, enters our ordinary reality, the texture of reality is twisted, distorted. This is how desire inscribes itself into reality,

by distorting it.
(Zizek, *The Pervert's Guide to Cinema*)

...

Two persons, looking each other in the eye, see not their eyes but their looks.
(Bresson, *Notes*)

...

There are multiple doppelgangers for Judy: not only Madeleine (played by Novak's stunt double), but also the woman Scottie mistakes for Madeleine (a third actress), the assistant at Ransohoff's (platinum blonde, and apparently the same size), and the actress that plays Carlotta in the dream sequence. Do any of these women get a screen credit?

...

Judy, walking with her friends or coworkers, stops outside of Podesta Baldocchi. Where were they going? To Podesta Baldocchi? She doesn't live above it. She doesn't go in to buy flowers. None of her friends do, either. She comes to a stop just in front of Scottie, standing in front of an assortment of arrangements they've both seen multiple times, in "Portrait of Carlotta." It's meant to look like an accident, but how can it be?

...

Once set down on paper, each fragment of memory ... becomes, in fact, inaccessible to me. This probably doesn't mean that the record of memory, located under my skull, in the neurons, has disappeared, but everything happens as if a transference had occurred, something in the nature of a translation, with the

result that ever since, the words composing the black lines of my transcription interpose themselves between the record of memory and myself, and in the long run completely supplant it.

Simultaneously, my recollections grow dull. To conceptualize this fact, I use the image of evaporation, of ink drying; or else water on a pebble from the sea, the sun leaving behind its dulling mark, the salt film. The recollection's emotion has disappeared. Occasionally, if what I have written in explanation satisfies me (later, on rereading), a second induced emotion, whose origin is the lines themselves in their minute, black succession, their visible thinness, procures for me a semblance of a simulacrum of the original emotion, now grown remote, unapproachable. But this emotion does not recur, even in lesser form.
(Jacques Roubaud, *The Great Fire of London*)

. . .

He who defines personal identity as the private possession of some depository of memories is mistaken. . . . Memory is no more than the noun by which we imply that among the innumerable possible states of consciousness, many occur again in an imprecise way.
(Borges, "The Nothingness of Personality")

. . .

When I type an open quotation mark (") into the search bar at the top right of my computer's web browser, the browser, anticipating what I will type next, immediately suggests "judy barton," followed by "gabriel blackwell." Though this is the result of my own (past) actions, I can't help but be struck by it.

. . .

It would all be much too complicated and unproductive to go

into, since all we really care about on the outside is our hero on the run, not where he is running from and what, if anything, he is running to. . . . The chase itself is the point.
(Taylor, *Hitch*)

...

In life someone may just go mad . . . suddenly giving way under a strain. But will that be acceptable in a dramatization of these same facts?
(Taylor, *Hitch*)

...

Hitch's letter to Maxwell Anderson, Dec. 4:

You have to realize one very important fact. Here is a woman who has been an accessory to a murder, she has let herself revert back physically to her original color and style. And yet, she allows a man to recreate her in the image of the dead woman. Here, as you will see, she is taking a terrible risk. After all, she is a woman virtually in hiding. When she renews her association with the ex-detective she would love to pursue their old relationship in her current physical appearance, but naturally, he will have none of this. It is only as Madeleine he wants her. So, you see, Max, the woman must be desperately in love with him to allow him to do this. And this she tells him at the end of the story.

You can see what a chance she is taking because as Renee [the Judy character's name at this point in the screenwriting process, the name given that character in Boileau and Narcejac's novel], she is safe both within her identification and being able to stand up to any probe into her background. Because remember that she was Renee before she was turned into a blonde, and was dressed as nearly as possible like Gavin's wife. So again, Max, you see the woman falling in love with him is of the utmost

importance to justify her behavior in section two.

…

Out of this narrative will emerge a chalk outline. It is the body
of a woman.
(Zambreno, *Heroines*)

…

It is Scottie's idea to go to San Juan Bautista. It is prompted
(as was certainly planned) by Judy/Madeleine's dream, but the
timing (noon) and the date (the next day) are left up to Scottie.
If he had not thought of San Juan Bautista? If he had planned
the trip for the following week? Gavin Elster, in the tower,
waiting with a dead woman, his wife, Madeleine, for hours,
perhaps days. How, for that matter, did Elster get Madeleine's
body into and up the tower? Does Judy scream because this has
not, after all, been the plan? Are we so sure that she knows she
is impersonating a dead woman so that that woman's murder
can be covered up? When she is confronted with this gruesome
scene (the sun is shining, it is California—the corpse, many days
old, cannot be in very good shape), does she scream not because
she has been told to but because she is truly frightened? Why
doesn't anyone go up the tower once the body is discovered on
the tiles below? How do Elster and Judy make their escape?
 Elster pays Judy off, buys her silence. It seems we are
meant to believe this is what has happened, their partnership
ended with a transaction. But isn't it much more likely that
Judy, having come upon this man waiting patiently in the tower
with the rotting corpse of his murdered wife for an eventuality
whose timing, even the likelihood of its occurrence, could not
realistically have been planned so exactly, is disgusted with
Elster—and with herself—and tells him she never wants to see
him again? Any money that changes hands does so by way of an

indulgence, a pardon.

…

When did Elster kill his wife? Wouldn't it have to be before he approaches Scottie, before he goes to Ernie's with Judy, dressed up as Madeleine? If she's alive, there is always the possibility that Scottie will see the real Madeleine. If she's dead, there is no such worry for Elster.

…

It almost seemed as if she had some presentiment of what would happen. She resisted the trip so strongly. Eventually, though, we got on the plane, we took the BART to the hotel, we checked in. She was tired. She went to the room, undressed, and fell asleep on the bed. I walked up to Union Square—we were staying on the edge of the Tenderloin—and then over to the Argonaut and the other nearby locations. As I had thought, it was no good without her there.

…

Earlier in my notes, I had wondered about how Elster could have gotten down and out of the tower unseen. I had wondered how Scottie, stricken by acrophobia such that he could not accompany Madeleine up the tower or move from the step when he saw her go past, could have gotten down. Nowhere did I wonder how *Judy* could have gotten down, but hers is the most unlikely escape of the three. Judy has been made up and dressed to look like the dead woman just discovered; she cannot be other than dead, must now act out that part, remain confined to the tower, unable to call out or move as though in a grave. If Elster is spotted, he might go unnoticed or unrecognized (no one knows how he is dressed, only Scottie knows what he

looks like), invent some excuse or give a believable reason for his presence ("My answering service rang to tell me the police were looking for me") but if Judy is spotted, all is lost. There can be no such coincidence or explanation for Judy, no blind spot in the crowd below—she looks like the dead woman and is costumed as her, and both of those facts are immediately apparent and infinitely suspicious. Though I want to liberate Judy from Scottie's stranglehold, the only way to make sense out of her escape from the tower is to once again give the narrative over to him: he has never left the tower. He sits on the steps or clings to the gutter, terrified of falling, dreaming of Judy on the street, Judy in her room, Judy in his arms, Judy in the tower.

…

E. T. A. Hoffmann's story "The Sandman" is about a young man named Nathanael who is in love with Klara, the sister of his best friend Lothar. Nathanael leaves Klara to go to school in another town, where he is accosted by an eyeglass salesman who bears an uncanny resemblance to a man who Nathanael feels was responsible for his father's death. Thus distracted, he buys a telescope from the salesman to get rid of him. Looking through the telescope, he sees into his neighbor's rooms, where a beautiful girl sits alone at a table, night after night. Nathanael becomes fascinated by this girl, named Olympia and said to be the neighbor's daughter, even falls in love with her after attending her piano recital and then dancing with her all night long. Perhaps it is the suddenness (and the thoroughness) of Nathanael's change in affections, but something about the story makes me think there must be some resemblance between Klara and Olympia: Though we learn about Klara—even hear from her, via her letter to Nathanael—before we learn about Olympia, Olympia's introduction comes soon after the beginning of the tale, and she immediately eclipses Klara. One substitutes for the other, both in the story and in Nathanael's affections.

Noting the young man's obvious interest in his daughter, Olympia's father, a professor, invites Nathanael to come over and spend time with Olympia whenever he likes. Nathanael passes hours on end with Olympia, reading poems to her and telling her his thoughts and feelings, and all the while Olympia simply stares into his eyes and sighs. She is perfectly attentive and quiet, just what Nathanael has apparently always wanted (Klara, in her letter and in Nathanael's memory, has been for him the shrill voice of reason, calling his fear of the eyeglass salesman a fantasy and denigrating his poetry as silly), never saying a word except when Nathanael finally takes his leave, whereupon she says, "Goodnight, my dearest." But it turns out that Olympia's perfect attentiveness is the result of the limits of her mechanism, for she is not human at all but an automaton created by her "father," the professor. Nathanael discovers this when the eyeglass salesman quarrels with the professor and takes the lifeless (and, in an odd detail, eyeless) Olympia away with him, slung over his shoulder. Nathanael is driven mad by the revelation that he has so exhausted his affections on an automaton, a thing, a mere conception. He was in love with Olympia, but Olympia was not real. What does that make him? He attacks the professor, screaming, "Whirl round, circle of fire! Merrily, merrily! Aha, lovely wooden doll, whirl round!" He nearly strangles the man, but is apprehended at the last moment and taken away to a sanitarium.

When he has recovered, he is sent back home, where he finds Klara is still in love with him, and, through her constancy, he rediscovers his own love for her. The two make plans to marry. But, on the point of leaving for their new home, they decide to climb the town hall's tower one last time, to "look at the distant mountains." Once at the top of the tower, Nathanael pulls out the telescope he bought from the eyeglass salesman and accidentally looks at Klara (standing beside him) through it, recalling memories of Olympia and driving him mad once more. He grabs Klara, and, screaming "Whirl wooden doll!

Whirl wooden doll!" he tries to throw her from the tower. Her brother, who has remained on the ground, hears all of this and rushes up the stairs. He saves Klara, but Nathanael, believing he sees the eyeglass salesman in the crowd below, throws himself from the tower before he can be restrained.

At the very least, the conclusion of "The Sandman" calls to mind Hitchcock's *Vertigo*. There is the mysterious climbing of the tower, the man driven mad by the vision of a woman (who is not what she seems), the other man climbing to the top to save her. But even before that there is the sanitarium, the woman as mirage or projection, the madness of the man when confronted by the rational woman, the fixation of the protagonist. Nathanael watches out of his window as the eyeglass salesman, who he believes to be the Sandman, a creature that plucks out the eyes of children who won't fall asleep at bedtime, descends the stairs with the woman (not, as it turns out, a real woman) he loves, and is driven mad by the sight of it. Scottie watches out of the window of the tower as Madeleine (not, as it turns out, a real woman) apparently throws herself to the roof below, and is driven mad by the sight of it.

But where Boileau and Narcejac or Hitchcock and his screenwriters might have borrowed certain images, atmosphere, even plot points from Hoffmann, the deformities they introduce into that same narrative present us with some interesting questions: as the protagonist of "The Sandman," it seems natural to align Nathanael with Scottie, the protagonist of *Vertigo*. And Scottie is there with Judy in the tower; whether he intends to destroy Judy or not—psychologically, physically—he *does* destroy her. Nathanael, though innocently, we would say, out of madness, definitely intends to destroy Klara, but she is saved. It is as though *Vertigo* is a mirror image of "The Sandman" in this, most important scene. The differences in these scenes make me think that in "The Sandman," we have really only half of the story of *Vertigo*—the first half. Can it be that Elster, though seeming perfectly sane in the scene in his office and the scene

197

at the inquest, has in fact—before the movie has even begun—been driven insane by the love for a woman who has not turned out to be, in some sense, real? Can it be that Nathanael is Elster rather than Scottie, and Scottie, in *Vertigo*, is only repeating what Elster has already gone through? Who else but a madman could contrive the atavistic story of Carlotta Valdes and Madeleine Elster? Who else but a madman would waylay a salesgirl and force her to play his wife playing a dead woman? Who else but a madman would ruin another man's life by tricking him into playing witness to a death that isn't a death, just to cover up a murder that no one has yet suspected has occurred, and which no one seems to care much about after it has been discovered? Who else but a madman could lie in wait in a church tower with the stinking corpse of his wife next to him, waiting for a woman he has hired to play this dead woman to come up through the trapdoor and scream at the grisly sight before tossing his wife's corpse carelessly from the tower, having apparently given no thought to whether someone might then come up to the top of the tower to see if there is someone there, someone who might have pushed the woman over the edge? Scottie is the madman who succeeds in destroying the object of his love; he cannot be Nathanael. Nathanael succeeds only in destroying himself; he watches another man destroy his love. Elster, it would seem, murders his wife, but she is not after all his love. (Is she? How could he have any affection for a corpse?) Up in the tower at San Juan Bautista, he destroys his past life.

In *D'Entre les Morts*, the parallels are clearer. After the tower, the Elster character is broken. The Scottie character refuses to act as a witness, and Gévigne (Elster) is haunted by charges that he has murdered his wife (which, of course, he has). He loses his fortune and is killed in the war. This, we would say, is nothing more than what he has deserved. Indeed, it is difficult to understand why, especially under the Hays Code, Hitchcock and his screenwriters would have let Elster off so completely. He suffers no repercussions from the murder of his wife, none at

all. If the inquest is the last word on these matters, he inherits her fortune and goes off to live in a foreign country, unbothered by allegations or suspicions, perhaps out of the way of extradition even. He has committed the perfect murder, gotten away with it. But does anyone ever truly "get away with it"? Can there really be someone out there so completely without conscience, for whom the killing, the erasing, of another human being has *no* effect? Psychopaths can become more psychopathic, can't they?; if we don't completely understand their psychology, that doesn't mean they don't have one.

…

In his book *Invisible Cities*, Italo Calvino describes the city of Zobeide: "the white city, well exposed to the moon, with streets wound about themselves as in a skein." Zobeide, he tells us, was founded by men who had shared a dream of a woman, naked, running through the moonlight in the streets of an inscrutable city. When these men came together, it was decided that the city of the dream should be built. It is unclear to me whether they believed that building the city would draw this mysterious woman from their dreams like baking soda draws the poison from an insect's sting or if they believed that they were simply creating a situation in which the possibility of their dream coming true was somewhat less improbable (or, for that matter, whether they felt they were carrying out some dream directive or if they were all similarly mad). Whatever their reasons for building it, each arranged for this city's streets to dead-end where they had lost sight of this woman in their dream. When new men arrived, having also suffered this dream, they changed the city's plan to accord more closely with their own dreams' endings, where each had lost sight of the woman. What Calvino doesn't tell us is that, in doing so, numerous pockets of the city, inaccessible to anyone but those who found themselves there while the new citizens were executing their own dream engineering, were then

closed off, creating tiny pockets of city in which one might find that the only passage out had suddenly been blocked, creating, at a stroke, completely private courtyards, so private as to not allow entrance or exit—prison cells, in other words. Inevitably, awaiting the dream-woman's arrival, the founders of Zobeide laid in wait in these pockets of city, ahead of their dream-selves, waiting for the woman to be driven toward them. When other seekers came along, the founders found only themselves trapped, stuck behind walls too high and too smooth to scale, in front of doors opening into buildings now without egress, their lives even more circumscribed than the ones they had planned for their dream-woman.

…

A single woman contains, for the man who loves her, the souls of all other women.
(Villiers, *Tomorrow's Eve*)

…

She first saw him on our way to lunch. I thought she would say something, but she just looked surprised, surprised and angry. She stopped in the middle of crossing the street, still in the crosswalk. This was how I knew she had seen him—in that instant she turned to face me, slowly, cautiously, as though the man were a poisonous snake and the moment she took her eyes off him he would strike. When the light changed and the cab in front of us honked, we had no choice but to continue crossing the street to where he was still standing. But when we reached the sidewalk, my wife slowed until she was well behind me and gave me a look meant to pierce my obliviousness, a look of displeasure that would have taken real effort to ignore. Why did we have to keep going around in circles, looking for this place where I had said we should get lunch? Why couldn't we

stop wandering and just eat somewhere? She didn't care where we ate, she didn't care about the historical significance or the restaurant's Yelp scores or what it served or how well it served it, she just wanted to stop. She just wanted to sit down and to eat. She was going to go into this place (it was an Indian place with a huge buffet) and I could come with her or I could go on without her.

I was worried she would spring onto the curb and attack him. Instead, she glared at me and then went into the restaurant without saying anything. Inside, we picked at food we didn't really want and made a point of not speaking to each other. She had chosen a table far away from the window. I really can't remember what I ate or whether it was good.

…

Thinking back now, my memory puts her where she hadn't been. She was asleep, in the hotel room, blocks away, but I can also see her there, with me, on the street. Which memory was the unreliable one?

…

[INT. Judy's Hotel Room (NIGHT)]

…

Judy lives in the Empire Hotel, next to a restaurant (?) named—what else?—"Twelfth Knight," *Twelfth Night* being Shakespeare's farce of identity, in which men fall in love with men who are not men and women fall in love with women who are not women.

…

In many countries, the traditional Twelfth Night celebration

201

ends the winter festival that begins with Halloween. There is drinking and feasting. Children run through the streets knocking on doors and ringing bells to drive out evil spirits. The order of things is reversed: the king is treated as a peasant, and, from among the peasants the Lord of Misrule, who presides over the festivities, is chosen. In other countries, Twelfth Night begins Carnival, which involves the same reversal and many of the same traditions.

...

Judy: "I've been on blind dates before. Matter of fact, I've been picked up before." By Elster? An allusion to (before) the beginning?

...

Better well hanged than ill wed.
(Soren Kierkegaard, *Philosophical Fragments*, via Shakespeare, *Twelfth Night*)

...

I've been understanding since I was seventeen.
(01:44:15)

...

Judy writes her note to Scottie left-handed, as though (for nine out of ten people) seen in a mirror.

...

While we are, I think, meant to assume that Judy is taking down all that she says in her voiceover, when she holds her letter up to

tear it in half, we can see that she has only written two lines. It's possible, I suppose, that there is more writing on the other side of the paper, but it isn't visible to us, and it really doesn't seem likely, given the wide margin of blank space we can see. What did she really write?

…

Scottie sees the same woman, a woman who is not Madeleine or Judy, at Ernie's at 01:43:00 (gray suit) as at 01:31:00 (blue dress/ brooch).

…

Green (as Edith Head, who designed two green outfits for Kim Novak, flatly observed) is the colour of death.
(Krohn, *Hitchcock at Work*)

…

Green is also the color of rebirth.

…

We met up with my wife's friends on Market Street, barely two hours after we'd touched down. This trip was supposed to be a reconciliation, an apology—she held it all against me. I held it all against me, too. She chose San Francisco as a poke in my eye, I thought, but I felt I deserved a poke in the eye. I couldn't be sure it was my fault, of course, but I thought it was probably my fault. And I was still afraid of this other man. I wanted to order in, stay in our hotel room, make up or at least talk. She made plans on the plane, before we'd even touched down, without telling me what they were. We'll be late, she said. I didn't know we were going out, I said. I was not in a position to refuse.

The two women who screamed when they saw my wife and I coming down the sidewalk were less friends than they were former co-workers. My wife's happiness at seeing them was clearly forced. When she went in to give them a hug she looked directly at me, into my eyes. It was clear that the two women were there to help my wife make me feel worse about myself. I tried to make myself as invisible as I could for the rest of the afternoon, but then I was worried about this other man. It was awkward to be out clothes shopping with these three women who did not want to have anything to do with me, but I couldn't risk just standing outside of the shops on the street. I had to stay close.

My wife explained to the two women that I had been working on a book about *Vertigo*. She called it "his little book." The two women knew nothing about the movie. I've never seen it, they said, is it good? They pretended to be interested, but the moment I said anything about it, they ignored me and started talking to each other. We walked up towards Nob Hill, along Sutter. As we passed under the awning of the Hotel Vertigo, one of the women said, Isn't that that movie you were just talking about? I didn't have a chance to answer. She explained to my wife she couldn't wear shorts like *that*, but she kind of wanted a pair anyway. I knew she wasn't listening, so I didn't tell her that the building that prompted her question had played an important role in the film. I didn't tell her it had appeared there under a different name, its old name, the Empire. I didn't tell her I had read that Hitchcock had begun planning the shooting of a movie in San Francisco during his first visit to the city, during that visit's first hours, long before there was a story or a script to be shot there. He'd hardly needed a location scout during *Vertigo*'s pre-production, I didn't say. I didn't tell the woman how strange it was that Hitchcock, so in love with San Francisco, set the two most important scenes in the movie he shot there ninety miles outside of it—really, nowhere near it, at San Juan Bautista. He might as well have filmed them in Sacramento, I

didn't say. Though I guess, I didn't go on, that seemed a little less surprising when one considered that Hitchcock had a home— far and away his favorite home—in Scotts Valley, not far from San Juan Bautista. He spent more of his time in his home in Los Angeles, of course, I didn't say. I didn't mention that the other two important, bookended scenes in *Vertigo* took place at Ernie's, one of Hitchcock's favorite restaurants in San Francisco. It didn't really matter. Ernie's was no longer there and we were many blocks away from where it had been.

…

"Is this some kind of Gallup poll?" Judy, even as Judy Barton, must act a part, even after she has given up the part of Madeleine. She has, in accepting the part of Madeleine, agreed to play a part for the rest of her life, the part of Judy-who-was-never-also-Madeleine. Can there ever again be a "real" Judy?

…

Scottie is in every scene of *Vertigo*, with just two exceptions: when we cut to Midge in her car outside of his apartment, and in Judy's hotel room, after he has left. But, in the case of the scene of Midge in her car, we know that Scottie *is* there, it's just that he's not visible because of where the camera is set up. Move just a couple of steps down the sidewalk and suddenly there he is, in the lighted window. In the Empire Hotel scene, however, not only has he left the shot, he has left the hotel, too. (Hasn't he? Is he standing behind the door?) We have momentarily lost track of him, the first and only time in the film. Both Wood and Modleski tell us the movie is meant to be seen as subjective, as though from Scottie's point of view, but, if that's so, we have to wonder whose point of view this scene in Judy's room represents. The effect of his absence, his altogether exceptional absence, is to turn this scene into a fantasy. One has to believe

it's *his* fantasy since he's not in the frame, but it doesn't matter whose fantasy it is if it *is* a fantasy—the scene is ultimately more about exposition than psychology. The letter, we may conclude, cannot be real.

…

A letter always arrives at its destination.
(Jacques Lacan, *Seminar on* The Purloined Letter)

…

Hitchcock wanted the letter in the film, at this particular moment in the film, even though many people close to him advised against it. Critics said it was a clunky way of explaining what was going on and asked why the audience would keep watching if they found out what had happened forty minutes before the movie actually ended. But holding something so large over the audience's head was not suspense: that was mystery, and Hitchcock did not deal in mystery.

There is no such letter in Boileau and Narcejac's novel, though it would be much more natural there—although the narrator of the novel is close to Flavierès (Scottie in the film), it *isn't* Flavierès, it is a third person narrator not bound to what Flavierès knows; it can tell us what Flavierès can only suspect. In fact, Flavierès's certainty is the only thing the reader has to go on in believing that Renée (Judy in the film) is Madeleine—she will not admit it until the end of the novel, and by that point we can't be sure her confession isn't made out of exasperation with Flavierès's insistence that she is Madeleine, out of a kind of fatalistic resignation or *folie à deux*. Indeed, because it is a book and the story is told in words only—Boileau and Narcejac do not have the luxury of having the same actress play both parts—it seems much less likely that Renée is Madeleine than that Judy is Madeleine. We cannot see to believe. We must trust in Flavierès's words, and we know him to be unreliable. By the

end, he will have strangled this woman, whoever she is, to death; how can we possibly trust him?

. . .

In Scottie's fantasy of Judy's memory, Elster has to cover Judy's mouth to keep her from screaming.

. . .

I believe in my conscience I intercept many a thought which heaven intended for another man.
(Laurence Sterne, *The Life and Opinions of Tristram Shandy, Gentleman*)

. . .

And at the base of Coit Tower, while my wife and her friends stopped in the shade to discuss their plans for the night, while I looked at my phone to try to figure out which way to go to get back to our hotel, I looked up and the man was simply standing there, looking not at me but through me, into the tower, where my wife and her friends were standing, and I reached out as though to push him away, and he brushed past me. He had been no heavier than the fog that had come in that morning and then dissipated. I felt almost as though, if I had kept my arm extended, it would have passed right through him.

. . .

Anyone would distrust a person who said, "My companions and I are illusions; we are a new kind of photograph."
(Bioy Casares, *Morel*)

. . .

The more you disguise yourself, the more you look like you. (Saramago, *The Double*)

. . .

It seems, at first, simple: Judy writes the letter to explain everything to Scottie. This letter, then, far from *being* a mystery, is trying to dissolve one. But it is not as simple as it seems, because why write a letter? Judy has promised to meet Scottie again; she could just as easily explain everything at that meeting. Though it would be difficult and hurtful, still, to share this secret might well, with time, bring them closer together—how much more intimate to *say* it (as she does to us, the audience) than to write it. And so the letter, the fact that Judy writes these words she ought to speak, seems to indicate a distance Judy wants to maintain.

A letter must be *delivered*; unlike speech, which depends upon time, a letter transcends time but must move through space to do so. When two people cannot be together in the same place to speak to one another, they write, and an intermediary (the post office, typically) delivers their words. What then is the nature of a letter hand-delivered by the person who has written it? Such a letter typically contains words that cannot be spoken aloud, words that cannot bear the pressures of being heard. Such a letter declares unrequited love; such a letter breaks off a relationship; such a letter announces the death of a loved one or the reasons for a suicide. Which of these is it for Judy? All are equally possible once we have accepted that she loves Scottie but he loves only Madeleine, and that to break off her relationship with this man who, now that he has found her, will never leave her alone, means to leave San Francisco, and that to leave San Francisco and this man means also to leave Judy Barton, to become yet another person, to live yet another life. She tears up this letter because she decides she cannot bear to once again look in the mirror and not see herself; because she has decided she cannot bear to repeat some strange name

over and over again until she responds to it as she would her own, until she can give that name on command; because she has decided that, though it will mean being Madeleine again, through being Madeleine again, she might finally be able to be Judy. She might be able to be only Judy.

…

And yet if one calls the New York Medical Examiner's Office to learn its own estimate of how many people might have jumped [on 9/11], one does not get an answer but an admonition: "We don't like to say they jumped. They didn't jump. Nobody jumped. They were forced out, or blown out." And if one Googles the words "how many jumped on 9/11," one falls into some blogger's trap, slugged "Go Away, No Jumpers Here," where the bait is one's own need to know.
(Tom Junod, "The Falling Man")

…

All of the stories of doubles and doppelgangers I've read involve a confrontation between the two doubles, and they all end with the death of one of those doubles. Edgar Allan Poe's "William Wilson" and its echo, H. H. Ewers's "The Student of Prague," both end with that confrontation and what may be interpreted as either the murder of the double or a suicide, as did their progenitor, E. T. A. Hoffmann's "The Doubles." The confrontation in José Saramago's novel *The Double* does not lead to murder or suicide, but precipitates an accident that ends one double's life. Hoffmann's long novel *The Devil's Elixir* features many murders of the story's double, all apparently botched. Fyodor Dostoevsky's *The Double: A Petersburg Poem*, too, features many confrontations, and a death. I mention this because this story, the one I seem to be telling, is not one of those stories.

I had a feeling this wasn't the last time I was going to see this

man, but I decided it would be the last time I took any notice of him. It seemed as though, when he had passed through my arms like so much mist, he had also passed through my consciousness. He had lost his hold on me. He was just one of many people in San Francisco at that moment, a stranger to me, as were all of the others. He was nothing more to me than they were. He was living a life that had, briefly, coincided with mine, at least in space, but in that respect he was no more exceptional than millions of other people. I felt freed of something.

And that was when he grabbed my wife's arm and went into the tower. It sounds melodramatic, or silly, but it happened. I did not imagine it. When I woke my wife the next morning with breakfast I had brought up from the restaurant of the hotel across the street (our hotel's restaurant was only open for dinner), and which I accompanied with a small bunch of pink roses I bought from a vendor I saw down the block, I had already decided I wouldn't ask what had happened, where she had been. I had written her a love note that was also an apology for my behavior of the last few months. She refused to read it—why couldn't I just tell her what it said?—but eventually she saw I was sincere and she put the note away, still unread, in her bag. She kissed me. I told her I had decided to give up the book I was writing. She looked relieved. I told her I was going to look for a job when we got back to Portland, first thing, that our life was going to return to normal. I think I meant it. But how could I not wonder what had happened? How could I not ask? The rest of my life, I would have this thing hanging over me.

…

[INT. Ransohoff's (DAY)]

…

Edith Head: "He explained . . . that the simple gray suit and plain

hairstyle were very important, and represented the character's view of herself in the first half of the film. The character would go through a psychological change in the second half of the film, and would then wear more colorful clothes to reflect the change. Even in a brief conversation, Hitch could communicate complex ideas. He was telling me that women have more than one tendency, a multiplicity of tastes, which can be clouded by the way they view themselves at any particular moment."

…

Believe me, there lies in such outward things, more consequence than is usually ascribed to them. Surely you will not misunderstand, or suspect me of levity, when I remind you of the effect produced by dress on an actor. On assuming the costume of any character, he experiences in himself a corresponding change of feelings.
(Hoffmann, *The Devil's Elixir*)

…

The quickness of the hand deceives the eye: speed, says Hitch, is preoccupation, and . . . the rapidity of the transitions keeps the audience so preoccupied that they are always cheerfully, breathlessly, one step behind.
(Taylor, *Hitch*)

…

Drama, Hitch has said, is life with the dull bits left out.
(Taylor, *Hitch*)

…

My wife arranged for me to interview with a firm specializing in patent law, whose clients, she told me, were some of the biggest

tech companies in Oregon. One of her oldest friends had just become a junior lawyer there, and had told her the firm was looking for a courier. If they hired me, they would pay part of my tuition to the local community college's paralegal certificate program and allow me to work around my school schedule. I would be employed, and I would have no time to write. I saw the ploy for what it was, but I couldn't say anything; conversations were still tense. I was too aware I had inflicted some hurt I couldn't cancel. The interview was set for a week later.

We discovered that the blue pinstriped suit I had bought many years before no longer fit, so it went to Goodwill and my wife bought me a new suit and paid to have it tailored. I had not worked in three months; there was no question I would do this on my own, and my wife, it seemed, wanted the job more than I did. The interview turned out to be mostly pro forma. My wife's friend's recommendation was, apparently, enough. The HR specialist handed over a binder filled with glossy papers covered in information about health plans and retirement packages. She told me I should talk it all over with my wife before making a decision.

…

Do Scottie and Judy kiss before 01:56:00, i.e., *after* her costuming as Madeleine? I don't think they do.

…

Sometimes when a person does something wrong, she finds it easier to continue in a wrong way; for if having done a wrong thing, she proceeds to do a right thing, the wrong thing may appear to others all the more plain.
(Sara Levine, *Treasure Island!!!*)

…

In *Vertigo*, the whole emotional situation is invested with a nightmarish intensity because its true nature is unacknowledged and its natural cause diverted. The hero's passion for the girl in the second half of the film is perverse not because he continues hopelessly to love someone he believes dead—bereavement is not such an unnatural situation—but because he is incapable of reacting to a real, living woman until he has dominated her completely and transformed her, completely against her will, into the image of his lost love. In other words, he has chosen the fantasy over reality, and tried to transform reality into fantasy by the sheer force of his obsession.
(Taylor, *Hitch*)

…

Specular space is on-screen space; it is everything we see on the screen. Off-screen space, blind space, is everything that moves (or wriggles) outside or under the surface of things, like the shark in *Jaws*. If such films "work," it is because we are more or less held in the sway of these two spaces. If the shark were always on screen it would quickly become a domesticated animal. What is frightening is that it is not there! The point of horror resides in the blind space.
(Pascal Bonitzer, "Partial Vision: Film and the Labyrinth")

…

In *Vertigo*, Hitchcock deftly softens the sobering abuse of his female protagonist, Kim Novak's Judy, by focusing on the passion and torment of her lover, Scottie (and casting James Stewart in his role) Consider the scenario, though, from Judy's perspective: She's picked up by one significantly older man, Gavin Elster (Tom Helmore's character), who gives her a new persona (Madeleine) and then involves her in the original Madeleine's murder. He promises her a deeper attachment, only

213

to dump her unceremoniously after the deed is done. Then she finds the process repeated with Scottie—yet, despite his earnestness, his behavior is doubly humiliating, as it carries an implicit rejection of Judy's own self in favor of the fantasy of Madeleine. In *Vertigo*, the figure of the woman pursued . . . found its paradoxical culmination.
(Auiler, *Vertigo*)

. . .

The Marilyn Monroe explosion of the fifties had given studio heads the notion that they could take any woman with the right dimensions and create a sensation, and so [Harry] Cohn [head of Columbia Pictures] began grooming [Kim] Novak to replace Rita Hayworth as Columbia's leading lady.
(Auiler, *Vertigo*)

. . .

Novak, after all, had had plenty of experience being told how to dress and act by an older man.
(Auiler, *Vertigo*)

. . .

But Judy isn't told how to *act*.

. . .

Judy's reaction to Scottie's "Let me take care of you"—another clue to Elster's proposal?

. . .

Elster's settlement is only enough to keep Judy out of sight

for a year (Scottie says, "It's been a year since the death of Madeleine," and we assume he's been in the hospital for most of that year), maybe less—maybe much less—but surely he would have been concerned about Scottie finding Judy? One would think he would tell her to move away. What about the police? They're Scottie's friends, aren't they? One would think, at the very least, Elster would give Judy enough money that she doesn't have to go back to working at Magnin's less than a year later. Why doesn't he kill her? Why be squeamish about something like that when he's already murdered his wife twice over? (She was already dead when he brought her up the tower.) How can he have failed to anticipate Scottie's discovery of Judy? How can it be he hasn't heard Scottie is out of the hospital? He can't be bothered to check up even a year later? He isn't worried? There is no statute of limitations on murder.

…

The gentleman seems to know what he wants.
(01:47:17)

…

Flesh, being never the same, exists almost exclusively in the imagination.
(Villiers, *Tomorrow's Eve*)

…

Kim Novak said, of her role as Judy Barton, "I related to the resentment of being made over and to the need for approval and the desire to be loved. I really identified with the story because to me it was saying, Please, see who I am. Fall in love with me, not a fantasy." But there is an inconsistency in what she says. Judy objects to being dressed as Madeleine (by Scottie

but apparently not by Elster), but she doesn't seem to want or need Scottie to "see who [she is]." If anything, in turning him away after their first meeting, she seems to want Scottie *not* to see who she is, not to fall in love with *her*, Judy Barton. She seems—indirectly perhaps, but perhaps not—to want to leave undisturbed his fantasy of her as Madeleine.

...

[INT. Elizabeth Arden Salon (DAY)]

...

Novak played Madge Owens of Salina, Kansas in 1955's *Picnic*, a role for which she had her hair dyed auburn. Four years later, she played Judy Barton of Salina, Kansas, hair dyed a shade browner than that earlier red. *Picnic*'s director, Joshua Logan, had wanted a "mouse brown." Harry Cohn, head of Columbia Pictures (the studio behind *Picnic*) refused and tried to get Logan to take Novak as she was, a platinum blonde. They settled on the reddish color. Judy wanted a natural color, a color her own. Scottie refused, had her dye her hair a platinum blonde, Novak's "natural" color.

...

Kim Novak: "I had to have long red hair for the role [of Madge Owens in *Picnic*], so I wore a wig, and my own hair was dyed to match it. I felt very, very different as a redhead. After the picture, I kept my red hair for a while, but I didn't feel quite the same . . . not like myself."

...

When Judy comes out of the bathroom at 01:55:00 (the scene

216

in which she is once again fully costumed as Madeleine), the
fog filter/green light mimics that of the HOTEL EMPIRE sign
outside the window, over Scottie's shoulder. But this is not that
light—the light in the room, as we've already seen, is untinted.

…

Pygmalion saw so much to blame in women that he came at
last to abhor the sex, and resolved to live unmarried. He was a
sculptor, and had made with wonderful skill a statue of ivory,
so beautiful that no living woman came anywhere near it. It was
indeed the perfect semblance of a maiden that seemed to be
alive and only prevented from moving by modesty. His art was
so perfect that it concealed itself and its product looked like
the workmanship of nature. Pygmalion admired his own work,
and at last fell in love with the counterfeit creation. Oftentimes
he laid his hand upon it as if to assure himself whether it were
living or not, and could not even then believe that it was only
ivory. He caressed it, and gave it presents such as young girls
love,—bright shells and amber. He put raiment on its limbs and
jewels on its fingers, and a necklace about its neck. To the ears
he hung earrings, and strings of pearls upon the breast. Her
dress became her, and she looked not less charming than when
unattired. He laid her on a couch spread with cloths of Tyrian
dye, and called her his wife, and put her head upon a pillow of
the softest feathers, as if she could enjoy their softness.

The festival of Venus was at hand—a festival celebrated with
great pomp at Cyrus. Victims were offered, the altars smoked,
and the odour of incense filled the air. When Pygmalion had
performed his part in the solemnities, he stood before the altar
and timidly said, "Ye gods, who can do all things, give me, I pray
you, for my wife"—he dared not say "my ivory virgin," but said
instead—"one like my ivory virgin." Venus, who was present
at the festival, heard him and knew the thought he would have
uttered; and as an omen of her favour, caused the flame on

the altar to shoot up thrice in a fiery point into the air. When he returned home, he went to see his statue, and leaning over the couch, gave a kiss to the mouth. It seemed to be warm. He pressed its lips again, he laid his hand upon the limbs; the ivory felt soft to his touch and yielded to his fingers like the wax of Hymettus. While he stands astonished and glad, though doubting, and fears he may be mistaken, again and again with a lover's ardour he touches the object of his hopes. It was indeed alive! The veins when pressed yielded to the finger and again resumed their roundness. Then at last the votary of Venus found words to thank the Goddess and pressed his lips upon lips as real as his own. The virgin felt the kisses and blushed, and opening her timid eyes to the light, fixed them at the same moment on her lover. Venus blessed the nuptials she had formed, and from this union Paphos was born, from whom the city, sacred to Venus, received its name.

(Bulfinch's *Mythology*)

...

Scottie is not really fascinated by her, but by the entire scene, the staging. He's looking around, checking up: are the phantasmatic ordinates really here? At that point, when the reality fully fits fantasy, Scottie is finally able to realize the long-postponed sexual intercourse. So, the result of this violence is a perfect coordination between fantasy and reality.

(Zizek, *The Pervert's Guide to Cinema*)

...

What exactly was the nature of Pygmalion's offering?

...

This was the moment at which we would have to decide. To wait

would mean enduring a more involved procedure—eventually, to wait would mean not to decide, to have our decision made for us. We decided to talk about it, but we did not talk about it, we only set a date or a time to talk about it. When it came up—because it had to come up—my girlfriend lost patience with me. Maybe she had lost patience with herself. I couldn't imagine what it was like for her, and I didn't try.

A week before, we had been in San Francisco. I was showing her where I'd lived. I wanted her to have a good time. I was not thinking about it as a last gasp, a new parent's equivalent of the bachelor party, but the long walk's mood was on us both. We went out with her friends. We had lunch in Chinatown, took the boat to Alcatraz, shopped in the Mission, even went up Coit Tower. When we kissed at the top of the tower, she laughed and told me I was being cheesy. I had said something about how she was my damsel in distress. When we got back on the ground, she became serious, a different person almost. She was short-tempered with her friends, more so with me. I was not stupid. I knew what had happened. She had thought about it on the way down, thought about what she had to think about. Now, back in Portland, there were none of those things to distract us. We worked. We came home from work and talked about what we would have to do if it was x, what we would have to do if it was y. Still we could not address the question of whether it would be x or y.

...

That done, he falls in love with his own work.
The image seems, in truth, to be a girl;
one could have thought she was alive and keen
to stir, to move her limbs, had she not been
too timid: with his art, he's hidden art.
He is enchanted and, within his heart,
the likeness of a body now ignites

219

a flame. He often lifts his hand to try
his work, to see if it indeed is flesh. . .
(Ovid, *Metamorphoses*)

. . .

The ivory had lost / its hardness; now his fingers probe; grown
soft, / the statue yields beneath the sculptor's touch, / just as
Hymettian wax beneath the sun / grows soft and, molded by the
thumb, takes on / so many varied shapes—in fact / becomes
more pliant as one plies it.
(Ovid, *Metamorphoses*)

. . .

To become more pliant the more one is plied.

John Berger writes, "The original Pygmalion creates a statue
with whom he falls in love. He prays that she may become alive
so that she may be released from the ivory in which he has
carved her, so that she may become independent, so that he can
meet her as an equal rather than as her creator." Could the same be
said for Scottie?

. . .

On the one hand the hypocrisy, the guilt, which tends to make
strong sexual desire—even if it can be nominally satisfied—
febrile and phantasmagoric; on the other hand the fear of
women escaping (as property) and the constant need to control
them.
(John Berger, *About Looking*)

. . .

In *Vertigo*, we have little doubt that Scottie would rather have a

dead Judy than a live one, if she isn't (or can't be transformed into) Madeleine.
(Wood, *Hitchcock's Films*)

...

Neither beautify nor uglify. Do not denature.
(Bresson, *Notes*)

...

Men dream of women. Women dream of themselves being dreamt of. Men look at women. Women watch themselves being looked at.
(Berger, *Ways of Seeing*)

...

Because it was late in the year, and because I would have to wait another year to enroll if I put it off, I decided to enroll at the junior college while I was still undergoing the law firm's background checks and waiting for their offer to be formalized. As one might expect with a law firm, this process took longer than seemed normal, but the admissions process also took a few days and I was glad not to be starting a new job on top of it. I would be reimbursed for much of the cost once I had been officially hired, and I was assured that I would be hired. The only possible snag was my record, but there was nothing on it that would cause my future employers to reconsider. So I thought.

I was not already a student and had never taken any classes at the junior college, so I had to meet with the head of the certificate program before I could be admitted. This, too, was a formality, I was told, especially given my teaching experience and my master's degree, but, with her first question, the woman, a lawyer, gave me pause. I stumbled through my reasons for

pursuing the certificate. Really, I had no passion for the work at all, had no idea what it entailed, and this must have been clear because she warned me that the work would be repetitive and boring at times, that the challenge was in keeping oneself mentally agile, not allowing oneself to fall into set patterns of thought, to approach each day as though one were starting all over again. I nodded and smiled politely. I would not get in, I thought. After thirty minutes of warning me about what I was getting into, however, she had somehow talked herself around her own objections to my candidacy by emphasizing how new it would all be to me, how I would be a perfect candidate precisely because I had no preconceived notions of the law. I had barely said a word, just let her talk about me. I wondered if my presence had even been necessary, really. I could have been anyone, with any background.

…

A woman is always accompanied, except when quite alone, and perhaps even then, by her own image of herself. While she is walking across a room or weeping at the death of her father, she cannot avoid envisaging herself walking, or weeping. From earliest childhood she is taught and persuaded to survey herself continually. She has to survey everything she is and everything she does because how she appears to others and particularly how she appears to men is of crucial importance for what is normally thought of as the success of her life.
(Berger, *Ways*)

…

Dürer, who believed in the ideal nude, thought that this ideal could be constructed by taking the shoulders of one body, the hands of another, the breasts of another, and so on. Was this Humanist idealism? Or was it the result of an indifference to

who any one person really was? Do these paintings celebrate, as we're normally taught, the women within them, or the male voyeur? Is there sexuality within the frame, or in front of it? (Berger, *Ways*)

…

[INT. Judy's Bedroom, Hotel (DAY)]

…

Speaking of the filming of the scene in which Judy comes out of the bathroom remade as Madeleine, Kim Novak said, "It was so real to me, the coming out and wanting approval in that scene. It was like, is this what you want? Is this what you want from me? My whole body was trembling. I mean I had chills inside and goosebumps all over just because it was the ultimate defining moment of anybody when they're going to someone they love and they just want to be perfect for them. And that's what I think makes it contemporary. It's about that thing that goes wrong in love, when you're attracted to someone and then suddenly you need to change them."

…

If Scottie's fantasy of the letter is real—if Judy really was Madeleine—Madeleine dies at the end of the movie and Judy dies at 01:57:00.

…

I turned her into the brittle, prickly thing she became. I had pretended to be one kind of man and revealed myself to be quite another.
(Gillian Flynn, *Gone Girl*)

...

Because of the nature of the firm's clients, my job—hand-delivering important documents to courthouses and other law offices—involved monthly trips to Seattle and Olympia, San Francisco and Sacramento. Even the rental car counter in Sacramento was a bright spot in the mindless routine of it. Though I was making less than I had as a professor, I no longer had to worry about what I would do in six months, a year, two years. As long as I did my job, I had a job. My wife picked up more work to make up for what I could no longer pay for. She took me out to eat. She decided when we would go to the movies, where we would go on vacation. She bought me what she called "school clothes." She took me to get my hair cut.

...

She decided. It was her decision, ultimately. I hadn't wanted to say it, as often as I thought it, but it was her decision, not mine.

...

Madeleine E.
This book is about a screenwriter. When the book opens, the screenwriter is still just a struggling writer, hardly a writer at all. He's never had anything published, he doesn't have an agent, nobody's heard of him, and he doesn't live in New York or Los Angeles. He lives in Portland, and he works as a barista. He gets up early every morning to write, then he goes to work. He has to be at work by 6 AM, so he has to get up very early, but he does it. At work, no one knows he's a writer. He doesn't ever talk about it. He writes spec scripts and short stories, and he starts a novel he knows he won't finish because he's never finished one yet. He wants each thing he writes to be something special, something new, but none of them are. None of them look like he thought

they would. He is frustrated, but he keeps writing.

One day, one of the screenwriter's coworkers tells him that someone at the coffee shop has a crush on him. He can't imagine who it is. He doesn't want to ask this coworker because he thinks he will look desperate if he does, but eventually he decides that looking desperate is better than being desperate, and he asks. He hasn't been on a date in over a year, and his last relationship ended when the girl he was seeing just disappeared—her phone was turned off, and her roommates told him she had moved out; he never saw her again—which, he thinks, partly explains why it's been so long, but does nothing to make his situation better. It turns out it's a customer, someone he never really thought too much about. He knows who she is, but he can't even call a clear image of her into mind. She doesn't come in very often, and she's kind of awkward and giggly when she does come in. He can't believe he didn't figure it out sooner. He asks her out, and on their first date the two of them are nervous around each other, a good sign. She moves in with him and his three roommates less than a month later. The two of them move out to get a place of their own.

All along, the screenwriter has been writing. He still doesn't have anything published, still doesn't have an agent, no one knows anything about him, and he's still in Portland, but, maybe because of the love he feels for his girlfriend, he thinks that things will work out somehow. With the support of his girlfriend, he quits his job at the café to write full-time. Even though he doesn't sell a script, he does have a few near-misses. He tells her about them over dinner. She keeps working; in fact, because he isn't working, she starts working more so that they will have enough money to pay rent and eat and so on. At first, the screenwriter was able to pay his share of things out of his savings, but after a while, he'd spent all his savings and she was paying for everything. But still things are good between them, they're still in love, and she believes in him, or at least wants him to be happy.

Because she is gone more often, and maybe because the script he's working on is about a betrayal, the screenwriter suspects that his girlfriend is cheating on him. He starts following her around when he should be at home, writing. She's at work, working to support the two of them, but he can't believe it. Tensions rise. She doesn't know he's been following her, she just knows that he's possessive and always wants to know where she's been, even when she's only a few minutes late.

Then, it's three or four years later. The screenwriter, a casting director, and a producer are casting a movie the screenwriter has written and is set to direct. We learn that each of the three has his or her favorite—the producer wants a star who the screenwriter thinks can't act (and the producer knows the production can't afford), the casting director likes another actress, a "rising talent" she's tried to get into several roles, and the screenwriter wants an unknown actress who he decides he likes best before she's said a single line. She is a nobody but he gets her in on the call based on her headshot, and now that she's here, in the flesh, walking and talking, he's certain she's perfect. He can't stop thinking about her, and he's so persistent that the producer relents (secretly, the producer's thinking he can get the screenwriter yanked before they go into production, especially if he keeps throwing tantrums like this one), and the casting director comes around to his way of seeing things, too. The casting director makes a suggestion about the leading man, and the screenwriter, seeing he's being offered a trade, agrees, even though he liked another actor better. The screenwriter tells the actress she has the job. She's excited but a little afraid, too, because she thinks the screenwriter—who will be her director, the director of her very first film role—is coming on to her. Still, it's a big role, and she needs the work.

In contrast to the first part of the book, which, by the end, was taking place almost entirely at home, this second part doesn't even mention where the screenwriter lives. It takes place on the set. We move ahead a few months, into production. The

screenwriter is talking to the costume designer about the actress's wardrobe. We learn there have already been many fights on set, between the screenwriter and the actress, the screenwriter and the crew, the actress and the crew. He wants her dressed and made up one way; she wants things another way. She is implacable, but he won't get rid of her. The producer is working to get them both thrown off the movie, but, for whatever reason, this isn't happening, or is happening too slowly. The screenwriter wants her hair done a certain way, dyed a certain color; she hates that color, doesn't want to cut her hair because—she says—the woman she's playing wouldn't cut her hair that way, wouldn't dye it. Really, she thinks it will make it harder to find other work, later, but she knows she doesn't have the clout to make that argument. Already, several crewmembers have quit.

The screenwriter has an idea. If the actress's argument is that her character wouldn't dress the way he wants her to dress, he will change the script so that she has to dress that way . . . as part of the story. Before, it was a simple story about a girl and a boy—they fall in love, the girl gets pregnant, the boy leaves because he is frightened and cowardly. They both have jobs, at least at the start of the movie (later in the script, he quits his job, a source of tension between them), but the jobs aren't particularly important and the movie doesn't really pay much attention to them. Now, however, the screenwriter writes the girl's character as an amateur actress. She acts in commercials. More of the movie takes place at her work. He, the screenwriter, will play the part of a tyrannical commercial director who insists that the girl change her appearance to suit the commercial she's in. This happens after she has discovered she is pregnant but before she's told the boy she's pregnant. She knows she won't be able to get work once she starts showing, so she can't turn it down, but the director is playing out some sick fantasy of a girl he's obsessed with, and she's afraid he could turn on her. This anxiety in part explains the frustration she has with her boyfriend's lack of a job—she feels trapped in this situation.

The director begins to call the actress by her character's name, and, because it's a commercial for laundry soap, the name and even the character is completely made up. She suspects the "character" the director has made up is really a former girlfriend. He writes lines for her that make no sense in the context of a commercial for laundry detergent. He explains her motivation: she's pregnant; she's thinking about leaving her boyfriend for another man who she thinks may be the father of the child she's carrying; her boyfriend is acting possessive and weird towards her, but she feels like she can't say anything because she is, after all, cheating on him; she hides the evidence of her assignations by taking a shower as soon as she comes in; she throws her clothes in the washer, too, so he won't smell the other man on them. That's how good this laundry detergent is, the director tells her. It's so good, no one will suspect your infidelity. The actress is scared.

The actress—not the one in the movie, but the one who plays the one in the movie—is increasingly afraid of the screenwriter. She wants to leave the production, but she's worried she might not get another break like this again. She thinks, surely the editor, the producer, the studio won't leave these scenes in, these scenes of the commercial. Surely, she thinks, they'll see the screenwriter has gone off the deep end and will pull him off the picture. I might as well play along with it, she thinks. She gets her hair dyed. She puts on the clothes he's picked out for her. She even acts out the scenes with the screenwriter. He's a terrible actor. She feels even more confident that the scenes won't make the cut, that someone will step in.

She can tell something else isn't right, though—something more than she'd suspected. Though the screenwriter hasn't come on to her, at least not directly, the producer has (this is part of the reason things have deteriorated between the screenwriter and the producer—they are both jealous of each other), so she's not comfortable going to him with her concerns, but she doesn't think she has a choice anymore, the screenwriter's so unbalanced,

so she sets up a meeting with him, the producer. The producer figures nothing will be as damaging as the truth, so he tells the actress the screenwriter hasn't changed the script or the movie at all, not really. The footage they've been shooting was never intended to be used. It was all a sham. The screenwriter put in lines that would work in other parts of the film, filmed a few of the key scenes with the boyfriend between those new, fake scenes, all so that, even if the actress leaves the production or refuses to go on in costume, he, the screenwriter, can edit her back into the film the way he wants her to appear. There is just enough coverage to make her unnecessary. He took you, babe, the producer says.

…

Robin Wood writes: "The pretense was that Carlotta was taking possession of Madeleine; in reality, Madeleine has taken possession of Judy. . . . Judy, we feel (the Judy of the last third of the film), is not a girl who would ever allow herself to become explicit about, perhaps even conscious of, such fears: she hasn't the intelligence, the self-awareness, or (despite her evident capacity for suffering) the depth. The fears can only be released in her through her being Madeleine: in a sense, it is Madeleine who is the more 'real' of the two, since in Madeleine all kinds of potentialities completely hidden in Judy find expression." But this is Scottie's theory of Judy, perhaps Hitchcock's (perhaps not); it should not be the critic's. Wood seems to be making/remaking Judy into Madeleine. Judy doesn't have the "depth" to be frustrated to find herself in love with a man in love with a "pretense"? Or to despair at it? On the contrary—she shows all the grace and depth Wood could want merely by not grabbing Scottie by the shoulders and shaking him violently back to consciousness.

…

Hitchcock to Novak: "You have got a lot of expression in your face. Don't want any of it. I only want on your face what you want to tell to the audience—what you are thinking. Let me explain to you. . . . If you put in a lot of redundant expressions on your face, it's like taking a sheet of paper and scribbling all over it—full of scribble, the whole piece of paper. You want to write a sentence for somebody to read. If they can't read it—too much scribble. Much easier to read if the piece of paper is blank. That's what your face ought to be when we need the expression."

. . .

Novak wasn't liberated. She felt imprisoned. Her character even had to walk in a certain way, trapped and clinched into clothing she had disdained. . . . Hitchcock molded the look and behavior of Novak, the way Scottie molds Judy—he trapped her with his attitude. Madeleine/Judy also feels trapped, and most critics believe that the director drew out Novak's greatest performance for *Vertigo*, helping her transcend her limitations.
(McGilligan, *Alfred Hitchcock*)

. . .

Thus even the critics would seem to have trapped Novak/Madeleine/Judy.

. . .

Throughout postproduction, Hitchcock [refined] his vision of a film as he never had before, reediting, stripping away the elements that made the story explicit, allowing for longer stretches for Herrmann's music, and in the process completing the transformation of *Vertigo* from an everyday murder mystery into a haunting emotional allegory.
(McGilligan, *Alfred Hitchcock*)

…

Hitchcock: "I leave holes in my films deliberately."

…

It's easy to agree with Hitchcock; his films are not mysteries. There are mysteries in them, but those mysteries are not the point. A Hitchcockian mystery is solved and then tossed aside. It is frequently outlandish, even sometimes improbable, but, because it is not why the film exists, we are not disappointed by it. Judy's letter doesn't ruin the film; it makes us anxious about what comes after. When will the axe fall? But *Vertigo* is profoundly a mystery, as are all tales of murder. We may learn who committed the murder, we may even learn their ideas about why they committed the murder, but we will never understand why someone has been killed, just like we will never understand why we exist. Murder is such an abomination to us we simply have no understanding of it. Why did Elster murder Madeleine? Perhaps there were motives, but do they really explain why one day she was alive and the next she wasn't? And why did Elster involve Scottie and Judy? Why did Judy go along with Elster? Why did Scottie spurn Judy in favor of Madeleine, even after he knew there was no Madeleine? How can one claim that *Vertigo* isn't a mystery when there are so many things we will never understand in it?

…

The things we bring off by chance—what power they have! (Bresson, *Notes*)

…

In all of my time on the street, going in and out of buildings and up and down blocks or driving to and from offices and circling

231

until I found a space, I never once saw my wife. When she went to work now she went to work and she stayed at work. And if I ever saw the man, I did not later remember that I had seen him, just as I did not later remember seeing any of the other people I saw on the street but whom I did not know. The city was no longer strange to me.

I sometimes missed the long mornings at home, writing, but as time went on, I found I missed them less and less. My friends from work took me out. We watched basketball and football (I quickly found I still did not enjoy soccer, or baseball) and sometimes went to Blazers games when the partners weren't using their box. We met my wife's friends for brunch on weekends, and I started a garden. I started cooking again. My wife and I talked about having a baby; when I had found a job as a paralegal, of course, but this was not so far off, as things go. In less than nine months, if all went as planned, I would have my certificate and a promotion at work, or, if the promotion didn't come through, I could begin looking for jobs elsewhere. What really had all of that writing been for, I wondered? I had not been paid so much as a cent for my book. Few people had bought it and even fewer had read it. I had long ago deleted my social media accounts, and I found I had stopped feeling the petty jealousies that had made this writing thing seem so crucial, so pressing. I felt, for the first time in a very long time, that I was doing absolutely as much as I needed to do, and that it was enough. I could no longer remember why I would ever have put myself through what I had put myself through. I worked out. I lost weight. I went to the doctor. I slept well.

…

I had sought to understand Gracia through Seri, whereas in reality she was my own complement. She fulfilled what *I* lacked, became the embodiment of that. I thought she explained Gracia, but in reality she only defined me to myself. . . . A creation of

my manuscript, she was intended to explain Gracia to me. But the events and the places described in the manuscript were imaginative expressions of myself, and so were the characters. I had thought they stood for other people, but now I realized they were all different manifestations of myself.
(Priest, *The Affirmation*)

...

Where remarriage to a wrongly cast-off wife is a rebirth after an apparent death, remarriage to another woman is a second death for the first wife. And indeed, remarriage to the first wife after such a long time, long enough for her to have become another woman, is also a kind of death for the woman she used to be.
(Doniger, *The Woman*)

...

Judy clings to Judy's purple dress because it is Judy's, not Madeleine's. We see her smothering it just after she's ripped her letter to Scottie in half, and she wears it at least twice in the montage of scenes after their affair has begun.

...

I wish you'd leave me alone. I want to go away.
(01:49:27)

...

Scottie, no matter how obsessed with transforming Judy into Madeleine he gets, never forgets Judy's name, never once calls her Madeleine by accident.

...

To create is not to deform or invent persons and things. It is to tie new relationships between persons and things which are, and *as they are*.
(Bresson, *Notes*)

...

There might actually occur a case where we should say "This man *believes* he is pretending."
(Ludwig Wittgenstein, *Philosophical Investigations*)

...

[Stories of reincarnation] suggest that each of us, in our present lives, may at any moment be awakened to the memory of another, lost life, that we all constantly reinvent ourselves out of the scraps of the past, so that, in a sense, we are always imitating our past selves. . . . All of us, too, helplessly spin out of our desires the lives we have inherited from our former selves. And so in each new life, we pretend, once again, to be who we are, repeating lines from an earlier script even when we think that we are improvising or that we are not performing at all.
(Doniger, *The Woman*)

...

In movies, in fictions, the woman always falls for the man. Though his behavior may seem frightening or violent or disturbing to us, still, she cannot help herself: The intensity of the man's attraction to her is attractive. In Brian DePalma's *Obsession*, at the end of their first date, after almost a full day of listening to Michael Courtland talk about his dead wife, about how much she looks like this dead wife, Sandra Portinari allows herself to be led in an imitation of the dead wife's walk. "Don't sashay," he tells her, his hand on her hip. It is a stolen

intimacy, an invasion. We would not believe the attraction was mutual if she didn't believe it was, if she didn't believe that love guides Michael, not obsession. That Judy goes along with Scottie is equally unbelievable to us. In both cases, we find there is some history between the two people—Sandra is Michael's daughter, seeking revenge for her mother's death, and Judy feels some guilt about her part in Scottie's incapacitation—we can understand each woman feigning an attraction (Sandra's ulterior motive, Judy's real attraction). But both films really only serve to illustrate the truth of the matter: The man, the seducer, fails to realize that his behavior shouldn't be attractive to the woman, that the only possibility is that he is being fooled by the seduced. I don't mean that "love is blind"—to say that would be to lead us back to where we started: The woman cannot see the horrible things the man is doing because she is in love with him. No, that gets us nowhere. I mean that in order for the seducer to convince himself that he is seducing the seduced, he must first seduce himself.

...

When [Scottie] meets [Judy], after the murder, we see her as masquerading as herself—that is, with her hair dyed brown (presumably its true color, as in the photograph with her mother), in order to become not-Madeleine; it is brown over blonde over brown. . . . Scottie then forces her to add yet another layer: blonde over brown over blonde over brown, or Judy (in Kansas)-as Madeleine (when Gavin had made her over)-as Judy (when Scottie met her again after the murder)-as Madeleine (after Scottie had made her over). This woman is still not just like Madeleine . . . she has not enough of Carlotta, whose ghost further complicates the already layered roles of Judy and Madeleine.
(Doniger, *The Woman*)

235

...

The best candidates for America's sweetheart were classic neurotics out of sync with their own times. They found Hollywood and became all-American. Marilyn (Kim) Novak was the exception to this rule. She was a shy, suburban daddy's girl who found Hollywood and *became* a neurotic.
(Brown, *Novak*)

...

Kim Novak: "I hadn't asked to become an actress, but once I was thrust into a movie career, I decided to give it my best."

...

Kim Novak: "He gave me the most important gift—faith and confidence in myself as a woman. So why am I drifting away from him and pouring more and more of myself into this career? This was all an accident in the first place."

...

Impostures succeed because, not in spite, of their fictitiousness. They take wing with congenial cultural fantasies. Impostors persevere because any fear they may have of being discovered is overshadowed by their dread of being alone. Their perpetual reincarnations of second bodies arise out of a *horror vacui*, terror of empty spaces within and without. Manic, they are always beside themselves.
(Schwartz, *Culture*)

...

I realized that in those two years, in order to preserve

something—an inner hush maybe, maybe not—I had weaned myself from all the things I used to love—that every act of life from the morning toothbrush to the friend at dinner had become an effort. . . . I saw that even my love for those closest to me had become only an attempt to love, that my casual relations—with an editor, a tobacco-seller, the child of a friend, were only what I remembered I *should* do, from other days.
(Fitzgerald, "The Crack-Up")

…

One begins writing a book about something because one is interested in that subject; one finishes writing a book in order to lose interest in that subject: the book itself is a record of this transition.
(Dyer, *Rage*)

…

[EXT. San Juan Bautista (NIGHT)]

…

Any tradition is better than any reconstruction. A tradition may be a ruin, broken unrecognizably, or shabbily built over in a jungle of accretions, yet it always retains some nucleus of antiquity; whereas a reconstruction, say a new Life of Jesus, is something fundamentally arbitrary, created by personal fancy, and modern from top to bottom. Such a substitution is no mere mistake; it is a voluntary delusion which romantic egoism positively craves: to rebuild the truth nearer heart's desire.
(George Santayana, "Spengler")

…

Despite the rhetoric of uniqueness and once-in-a-lifetime experiences, our culture . . . mocks that romanticism which seeks out the irreproducible as the source of Truth. . . . If constant repetition renders some events surreal . . . singularity now surrenders events to apparition, evanescence, insignificance. . . . [E]vents must take place twice to take place at all.
(Schwartz, *Culture*)

. . .

A thing that has failed can, if you change its place, be a thing that has come off.
(Bresson, *Notes*)

. . .

To observe a recurrence is to divine a mechanism.
(Santayana, *The Life of Reason*)

. . .

Everything which causes repetition to vary seems to us to cover or hide it at the same time.
(Deleuze, *Difference and Repetition*)

. . .

Déjà vu is no mere gambit. Its intensity and sense of inevitability are consequent upon living, as all humans do, an integrally double life present *and* past, actual *and* virtual. Déjà vu is *un souvenir de présent*, a memory of the on-going, a slight catch in the flow of time, an intersection between our two inherently oscillating points of view.
(Schwartz, *Culture*)

…

The two women at the center of Paul Verhoeven's *Basic Instinct* are also its most obvious parallels to *Vertigo*—that is, apart from a number of shots echoing or even recreating shots from *Vertigo*; for instance, the view down Michael Douglas's apartment stairs, which is a near-perfect recreation of the view down the bell tower at San Juan Bautista. Sharon Stone plays Madeleine to Jeanne Trippelhorn's Judy, blonde (Stone as Catherine Tramell/ Kim Novak as Madeleine) and brunette (Trippelhorn as Beth Garner/Kim Novak as Judy Barton), illusion and truth. Tramell, like Madeleine, has at least two alter egos: one, a pseudonym— she is a writer, writing under the name "Catherine Woolf," and the other, her double, frequently confused for her in the film, her lover, Roxy. But Trippelhorn's Beth Garner also has an alter ego, having begun her life under a different name, Lisa Hoberman, a fact uncovered in the course of the film. She also has a past with Tramell, it turns out, back when she was known as Lisa Hoberman—both women accuse the other of imitating them in dress, hairstyle, and mannerisms. We never learn who imitated who, but the question hardly seems important to the inciting mystery of the movie: who murdered Johnny Boz? That mystery is never fully solved, though the last shot of the film strongly implies that Tramell is the murderer.

If we treat *Basic Instinct*, with its many allusions to *Vertigo*, not as an homage or an imitation but as a piece of criticism, then we can see that Verhoeven and his screenwriter, Joe Eszterhas, are implicating Judy Barton in her own murder, and in the murder of Madeleine Elster. If Tramell (who not only does her hair as Judy-as-Madeleine did, but also dresses very like Judy-as-Madeleine did—white coat over turtleneck, gray suit, etc.) is guilty, then the implication is the woman she is modeled on is guilty, too. If Tramell is the murderer, she is a serial murderer, a calculating, plotting, remorseless criminal. Is Madeleine? Or, rather, is Judy? What would that mean?

The final shot of *Basic Instinct* implies that Tramell will murder Michael Douglas's Nick Curran. Has Judy affected Scottie in some analogous way? Has she done more than simply change his life—has she ended it? It doesn't seem fair to say such a thing, but the accusation does serve to focus us on Judy's complicity in Elster's plot, her coldness in carrying it out—to the end—long after she later leads us to believe she has fallen in love with Scottie. If she were truly in love with Scottie, if she really cared for him, could she have gone through with it, pretending to die in front of him in just such a way? The best outcome is that Scottie feels he has failed to save the woman he loves from death. The worst outcome, the actual outcome, is that Scottie feels he has caused the death of the woman he loves, by bringing her to San Juan Bautista in the first place. Isn't Scottie's treatment of Judy, here most of all, a kind of revenge rather than simple obsession? Revenge on Judy for her treatment of him earlier in the film, revenge on her for his psychic break and the long, possibly endless trauma of having her "die" in front of him? When he looks out at the end of the film, in a way he couldn't have when "Madeleine" died, isn't this a kind of triumph, as one experiences at the summit of a mountain? When he looks down, what does he see? Is he even looking at Judy's body, or is he looking elsewhere?

…

We are what we pretend to be, so we must be careful about what we pretend to be.
(Kurt Vonnegut, *Mother Night*)

…

The more we attempt to tell things apart, the more we end up defending our skills at replication. The more intrepid our assertions of individual presence, the more makeshift seem our

identities, the less retrievable our origins.
(Schwartz, *Culture*)

…

All identities are only simulated, produced as an optical 'effect'
by the more profound game of difference and repetition.
(Deleuze, *Difference and Repetition*)

…

The staircase up the belltower is, if you take away the walls, a
spiral not unlike a corkscrew. The difference being either that its
ends have been reversed, with the sharp, piercing end at the top
rather than the bottom, or else that it has no top, no bottom,
no orientation. Both ends are sharp points. There is no handle.

The other peculiarity in this spiral is that Scottie does not
complete it until the very end of the movie. When, in the dream
sequence at the middle of the movie, the spiral of Scottie's
descent into the grave appears, it doesn't echo any literal
movements he has made up to that point—instead, it prefigures
those he will make at the end of the movie. It isn't uncanny—he
doesn't, can't, recognize it—it is oracular. When he reaches the
top, either in horror or in triumph, he experiences a moment of
déjà vu; he has been here before, even though he hasn't been here
before. What is the experience of déjà vu? It is the experience
of touching a parallel reality we have always suspected but never
(or only seldom) witnessed. It is as profoundly disturbing as
would be catching sight of yourself waiting for the bus from
the window of that bus. It is the experience of looking through
space but seeing a difference in time.

…

If you or I ever really accepted the moral responsibility for what

we've done in our lifetime—we'd drop dead or go mad. Living creatures weren't made to understand what they do.
(Philip K. Dick, *Now Wait for Last Year*)

. . .

And I come face-to-face with what I have learned: our lives are a spiral and, though we circle and circle, we never quite come back to where we began.
(Kitchen, *Distance and Direction*)

. . .

I was once asked to do voice-over work for a short film because of a reading I gave with the director's cousin. I thought she'd said it all took place in an elevator in a skyscraper, but I couldn't be sure because I hadn't been paying much attention. At the time, I'd thought it was a prank.

A year and a half after the reading, long after I'd forgotten I'd even given this person my email address, I got an email from the director, wanting to know if I was still interested and asking to meet me sometime that week if so. She proposed a coffee shop around the corner from where my wife and I lived; this made me nervous, I remember, but I said yes, at least, after I remembered the reading. Because I barely remembered even that, I didn't think I would recognize her, but she stood up as I entered the shop—she had recognized me—and I was shocked to find that, in this different light, she looked nothing like what I remembered. Which is to say that, because I could not remember what she looked like, she looked incredibly familiar to me, but not in an expected way. She looked like my wife had when we met—not that my wife looked so different now, but I had become accustomed to the changes in her looks. Now, when I look at photos of that time, I can't believe how young she looks. And this was how this woman looked.

I couldn't make sense out of what she handed me, but I didn't need to—I was assured it would be, at most, a few hours' work, and would all be done on the same day, whatever day I had free that week: I would say my lines (already highlighted for me on the script), they would be run against a master of the film, and we would do any rerecording we needed to do on the spot. That would be that. I could use my speaking voice, which was perfect, she said—it was the reason she had asked me to do it. I wouldn't need to memorize anything, and I wouldn't even need to act—I could just read from the script. "All you really need to do," she told me, "is show up on Thursday," Thursday being the day we had just agreed on. I looked over at her, this woman who looked startlingly like my wife, and had to resist the impulse to look into her eyes as I had done with my wife, whose eyes were perhaps her best feature.

In order to avoid doing something I knew would be inappropriate, I decided to focus on the task at hand. I looked over the script. As I read the lines in my head, I kept hearing the graveled voice of the narrator of seemingly every trailer I had ever seen, and then imagining my own voice saying those same words. My speaking voice, even at its lowest, was nothing like that impressive bass. When recorded and played back to me, it always sounded weaker and thinner and higher-pitched than I imagined it as it came out of my mouth. I avoided listening to my own voice or allowing it to be recorded whenever possible, just as I had avoided being photographed for as long as I could remember, and kept no photographs of myself, which drove my wife crazy. The photographs in our apartment were of her alone or of her with other men. I thanked this woman for the opportunity, confirmed the address she had given me, and told her I would see her on Thursday.

The recording studio, as it turned out, was a small room in a building that had been designed to be used as either a self-storage place or a very low-rent office space, depending, I guessed, on the imagination of the person leasing the unit. The

only way to get into the building was the elevator, which stood open on the parking lot. The doors didn't close when I got on. I had been told to key in a three-digit number on the intercom's keypad, which I did. A dialtone droned for a moment, and then someone picked up on the other end, not the woman I'd dealt with but a man I didn't know. I told this man my name and the line went dead. A few moments later, the doors closed and the elevator took me up to the third floor. Only some of the doors in the hallway the elevator let me off into had numbers, and the numbers there seemed to have been distributed at random. I went around the entire floor once without seeing the unit I was looking for, and was a little panicked by the time I found it.

Inside, the room was empty except for a microphone, a music stand, and a man seated on a low cabinet, typing very quietly on a laptop. He gestured to the microphone and asked if I was ready. The woman I had met with a few days before was not there, but I decided not to mention this. The man positioned the music stand and adjusted its height, explaining that I should spread out the pages in front of me, as many as would fit, so that the microphone wouldn't pick up the sound of me moving them around. He said that, when I was ready, I should read the first page of lines once, stop, read it all again, and then go ahead with the rest in the same way, pausing between each line for at least three seconds. "Think 'One Mississippi, two Mississippi,'" he said. He went out of the door I had just come in through. I was now more convinced than before that this was some sort of joke. Why pick on me, I thought. As I read that first page, my throat betrayed my distrust by closing around certain words. I choked and tears came to my eyes. The line was "One shouldn't live alone," which sounded familiar to me, though I couldn't place it at the time. Later, now, writing this, I realized it was a line from *Vertigo*, that in fact all of my lines were lines from the movie, though often paraphrased or scrambled or sometimes slightly rewritten. "I was a made-to-order witness," I said. "I let you change me because I love you." "What happened to you?"

At the time, I wished I had thought to bring a bottle of water with me. I traced the microphone cable up to the flocked ceiling, but I couldn't see what it could possibly be attached to. I read through the lines I had been given, then went over to the low cabinet the man had been sitting on and sat down to wait. I wasn't sure if this was what I was supposed to do. I guessed the man was probably right outside the door or in another office, but, I thought, if he had somehow been listening, he would know to come in, wouldn't he? Was it all a prank? I pictured the woman, and I wondered if I would ever see her again.

…

I wonder if the male genius identifying with the female heroine is really a form of masquerade, like Marcel Duchamp in drag as his alter-ego Rrose Sélavy. An exaggerated performance of feminine stereotypes as opposed to really trying to enter and understand a character.
(Zambreno, *Heroines*)

…

You were the copy. You were the counterfeit.
(02:04:16)

…

To become so possessed by a character you begin to play the part.
(Zambreno, *Heroines*)

…

He made you over just like I made you over, only better.
(02:04:43)

...

The word "jealous" comes from the ML *zelosus*, or "zealous," Gr *zelotes*, "an emulous person." "Zealous," in turn, is derived from *zel*, or zeal, "fervor, spirit of emulation," and shares that root with *zemia*, "punishment," also "to strive."
(Partridge, *Origins*)

...

Was I Hitchcock? Or Elster? Or was I Scottie? Was I Judy? Or Madeleine?

...

Is the perspective from which we see Madeleine's body on the tiles the same from which we see the policeman's body in the alley? If so, what might that mean to us? We almost don't notice déjà vu at first, but we feel something is off. Would we feel, perhaps without really knowing why, that the film has begun again, halfway through? Do we wonder whether we will have to go through it all again, on our way to the same conclusion? I guess what I'm asking is: does this shot put us in an empathetic position, with regard to Scottie?

It seems to me that, if the perspective is the same, the coincidence is too great. Wood's theory about the point of suspension and Scottie's dream, the bulk of the film, is—must be—correct. But that theory still makes more difficulties than it solves. As in a dream, the images produced would be the result of real stimuli—in this case, the body in the alley becomes the body on the roof. The guilt Scottie feels over the death of the policeman becomes the more personal and even erotically charged guilt of Madeleine's death. Worse, following the train of thought to its end, Scottie is then ascribing the policeman's death to a conspiracy of some kind rather than simple accident—and,

given that Madeleine's death at San Juan Bautista is the result of a conspiracy to deceive him into feeling guilty, it would be a double(d) guilt. Why? Does he feel some attraction to or more-than-professional concern for the policeman? The film seems suddenly to revolve around Scottie's feelings for the policeman rather than Madeleine/Judy's feelings for him.

The policeman, a *uniformed* patrolman as Scottie is a *plainclothes* detective, is an archetypal figure, placed opposite Scottie by Scottie. He represents an image—The Law—that Scottie fears he can no longer project to others. In the film, the reason given for this fear is the rooftop accident, but if the film is itself a kind of dream or projection of Scottie's then, even before the accident, Scottie has already accused himself of failing to live up to this image: he is unable to help the policeman, and, as a result, the policeman falls to his death. Not only that, but the policeman is, by virtue of being archetypal, Scottie's almost-double, a kind of golem for the film. For instance, he is not given a name; in the same way as the criminal he and Scottie are chasing, his face is seen but can never be stamped on the viewer's consciousness because he is never made into a character. Is he even seen in a close-up? He is not quite human, lacking features and identity, but given life and set free on Scottie's conscience, he is explicitly tied to the most human character in the film, Judy Barton.

...

Perhaps one never seems so much at one's ease as when one has to play a part.
(Wilde, *Gray*)

...

Someone dead.
(00:13:37)

...

One final thing I have to do. And then I'll be free of the past.
(02:00:04)

...

There are always two deaths, the real one and the one people
know about.
(Jean Rhys, *Wide Sargasso Sea*)

...

"I heard voices." Is it Madeleine that Judy sees at the moment
she falls or jumps? What was Judy's relationship with Madeleine
before her death, if any? The nun speaks with Kim Novak's voice
(it was Kim Novak who provided the audio), with Madeleine's
voice, with Judy Barton's voice, with the voice of the actress
playing the part.

...

Aristotle, in his *Poetics*, never promised catharsis for the makers
of art, only for the audience.
(Flynn, *Reenactments*)

...

In one of my last classes, my students and I got into a discussion
about "theme" and "symbols." I told them that when we see
something seemingly everywhere, it doesn't mean that the thing
that we think we are seeing again and again has multiplied
somehow or that the world is a code or a conspiracy, but that, in
finally taking notice of that thing, we are creating for ourselves
a new way of seeing, one that has always been available to us,

but one which we might otherwise never have put to use. For instance, I told them, say we decide to buy a particular model of car. Instantly, we would see that car parked in every other driveway we passed. But history would not have changed, and our neighbors wouldn't suddenly decide to buy a certain car simply because we had decided to. Those cars would have been there for weeks, months, perhaps years, and if we were shown security-camera footage of our every movement for the days preceding our decision to buy that model of car, we would, with our new attention, notice them parked in those driveways (and perhaps many other places besides), even as our recorded selves would be going about their business, totally oblivious to them. We have to tell our brains to notice a thing before our brains will notice that thing. Of course I was thinking about the man, but I did not tell my students that.

I also did not tell my students that what is most disturbing about this is that it makes the thinness of our perception clear to us. We really and truly notice almost nothing of the world. We live only a small fraction of our lives. All around us are systems and connections of which we are completely ignorant. We go around thinking these things we don't notice don't exist, but of course they do. The overwhelming majority of people and things in the world are, to us, not even ghosts or phantoms but absolutely nonexistent. But ghosts exist, and they are not waiting for our attention.

. . .

In a short section on *Vertigo* in Nick Flynn's *The Reenactments*, a memoir about the process of turning his earlier memoir, *Another Bullshit Night in Suck City*, into a movie, *Being Flynn*, Flynn writes: "The real appearing unreal, the unreal appearing real—this is the definition of the uncanny." His definition is not definitive, though: the uncanny comes to us from Freud's *unheimlich*, "unhomely," meaning, "that which ought to have

stayed at home, but hasn't," and this meaning, ultimately, is the more complete, the more complex, the more accurate definition. Freud's "homely," *heimlich*, the German homely, doesn't mean "plain or banal"; it refers instead to family secrets and the memories we leave behind when we leave home (i.e., "grow up"). The uncanny, then, the unhomely, is that which dredges up these old secrets, secrets that are sometimes not even known to us—the uncanny is not a species of déja vu, in other words, not something we recognize as something we've seen before, but something which we haven't seen but is yet familiar to us or else something we have seen before but which seems unfamiliar to us. The classic example is that of a traveler in a strange house, waking in the middle of the night and catching his reflection in a mirror, believing it to be someone else. Flynn, perhaps without realizing it, describes the reverse example elsewhere in *The Reenactments*, sitting on a couch on the set that is to stand in for the house he grew up in: "After all, whose childhood home doesn't feel like a prop, until you leave it, then it is the dream you enter, night after night."

Describing a "treatment strategy" prescribed by a hypnotherapist, Flynn is reminded of Buster Keaton's *Sherlock, Jr.*, in which Keaton plays a projectionist who falls asleep while showing a movie, finds that the actors in the movie are people he knows, and, ultimately, joins them onscreen. The hypnotherapist's treatment asks the client to imagine himself in a movie theater, in front of a movie of his own traumatic experience, in control (as projectionist) of the speed and direction of that movie. This, Flynn is told, allows the client to separate the associations that have built up, to remove or at least divide the traumatic memory from the words that describe it. Flynn is not so sure: "Even if you rewrite the trauma . . . in the end she will still be dead." But the purpose of the treatment is not to alter the past—that would be impossible—it is to make the present bearable, to make the past past, to allow it to pass.

...

Under normal circumstances, your memories of daily events are consolidated . . . by an area of the brain called the hippocampus. But during frightening situations—such as a car accident or a robbery—another area, the amygdala, also lays down memories along an independent, secondary memory track. Amygdala memories have a different quality to them: they are difficult to erase and they can pop back up in "flashbulb" fashion—as commonly described by rape victims and war veterans. . . . We're not talking about a memory of different events, but multiple memories of the *same* event—as though two journalists with different personalities were jotting down notes about a single unfolding story.
(David Eagleman, *Incognito: The Secret Lives of the Brain*)

...

History decomposes into images, not into stories.
(Walter Benjamin, *The Arcades Project*)

...

Our desires have found and will find no real echo in the world. "The people we love do not love us, or not in the way we hope," Sandor Marai says.

...

If we view ourselves from a great height it is frightening to realize how little we know about our species, our purpose, and our end.
(W. G. Sebald, *The Rings of Saturn*)

...

Our sense of time—how much time passed and what happened when—is constructed by our brains. And this sense is easily manipulated, just like our vision can be.
(Eagleman, *Incognito*)

…

Towards the end of my certificate program, I had to go to San Francisco on consecutive weekends, for the firm. I didn't like these trips. They made me nervous. I would fly down on Thursday night or Friday morning, and then I would have to wait until Monday to finish my business. I usually stayed in the hotel all weekend and watched tv. I brought books with me and read them in restaurants and on the street, walking to the restaurant. Anything to keep from seeing him on every corner, her next to him. Thousands of hims. Thousands of hers. My wife invited herself down for the second of the two weekends. The hotel was going to be taken care of by the firm anyway, she said, and why would anyone care? Besides, I wouldn't be working Saturday or Sunday. I told her it wasn't allowed. While I was in class, she talked to her friend, and when I got home the first thing she said was, Guess who's going to San Francisco?

I went on my own the first weekend and stayed in the firm's shared apartment, in Nob Hill. No one was staying there, and hotel rooms were scarce that weekend because of the Folsom Street Fair. The apartment was beautiful, with two bedrooms each with their own bathroom, hardwood and marble everywhere, and even a fancy coffee-maker nicer than the one in the office. The picture windows faced up the slope, with Coit Tower in the center. I pulled the blinds shut and kept them shut all weekend, but I couldn't help myself and I looked up the tower on the internet. I could see a picture of a few people frozen at the base on Google Maps. Wikipedia told me it had been built by Lillian Hitchcock Coit, no relation. Apparently, Ms. Coit had an affection for firemen, and designed the Tower

to resemble a firemen's hose.

On Sunday morning, my wife called to tell me there had been a huge fire across the street from our apartment building, in a new building that had only just been completed. Though the building was only four stories high, the flames had apparently reached fifteen stories, and the entire building was reduced to debris. All of the streets in our neighborhood were blocked off, and fire engines and cranes with water extensions had been spraying the site all night and all morning. She said that when she had passed by that afternoon while walking the dog, she could still feel the heat coming off it.

When we returned to San Francisco the following weekend, the apartment I had used the week before was taken by someone more important than me. The firm put us up in the usual hotel, south of Market, but I begged my wife to get out of the city. We decided to rent a car and drive south along the coast, though actually I cannot recall deciding this. I only said, *We've already seen everything in the city. Maybe we should stay in, or leave the city altogether.* This drive was either my wife's idea or the concierge's, and I think I must have objected, perhaps even refused, but, either way, I found myself behind the wheel of the rental car, having passed over the Bay Bridge into Oakland and down through San Jose, cutting across the mountains to Santa Cruz, where we would meet up with Highway 1.

...

Man is equally incapable of seeing the nothingness from which he emerges and the infinity in which he is engulfed.
(Blaise Pascal, *Pensees*)

...

In October of 1979, a woman named Jane or Janie Wilmot climbed over the railing of the Golden Gate Bridge onto the

253

metalwork below. Just past her toes there was nothing at all for 245 feet or four seconds, all the way down to the water. A man climbing over next to her—did he say anything to her?—tripped over something and let go of the railing. He fell over backwards, out into the air. Up on the bridge, it would have been impossible to hear the splash four seconds later. A second man, wearing a top hat and a tailcoat, toasted Wilmot with a flute of champagne. She jumped, and in that moment, Wilmot became the first female bungee jumper. A camera crew on the bridge captured several jumps, then, with the police on their way, got on their bicycles and rode south, towards the city. They stopped at Fort Point to film the cords hanging from the bridge, standing in the spot where Madeleine and Scottie had stood twenty years earlier. By the time the crew got to Fort Point, though, Wilmot had already entered the water and been rescued by boat.

…

Garrett Soden, author of the book *Falling: How Our Greatest Fear Became Our Greatest Thrill*, likens a long fall to a three-act tragedy: "the leap, the fall, the impact." He writes, "The second act functions as it does in any tragedy: it reveals that the victim's moral failure will lead to a horrible end—and that nothing can be done to stop it." Is the fear of heights then ultimately a fear of being discovered (by oneself), of having one's moral failings put on display (to oneself)? Is Scottie's acrophobia just a symptom of his guilty conscience? And guilty of what? Why?

…

During the construction of his famous Tower, Gustave Eiffel wrote, "Whether a man fell from forty meters or three hundred meters, the result was the same—certain death." So, for those of us afraid of heights, afraid of falling, it is not the result that worries us; it is the length of the fall leading up to it. Perhaps we

fear what will go through our minds in those moments. We fear the fear of death more than we fear death itself. Our minds, it would seem, turn in upon themselves naturally.

…

Above a phone on the Golden Gate, the words: "THE CONSEQUENCES OF JUMPING FROM THIS BRIDGE ARE FATAL AND TRAGIC."

…

A child's desire for a doll to come to life may become, in adulthood, a fear.
(Gaby Wood, *Edison's Eve*)

…

The more images I gathered from the past
the more unlikely it seemed that the past had actually happened
in this way or that, but rather one had pulled back from the edge
and for that moment it all came rushing in.
(Ronk, *Vertigo*)

…

If I see the body I was looking for it is almost always mine.
(Ronk, *Vertigo*)

…

It was thus without planning it or even willing it that my wife and I came to be at San Juan Bautista on a day that was sunny but not particularly warm, looking at each other as though something neither one of us could name had stirred up an old enmity that

had arisen from yet another mystery. She pulled me along as though I was resisting, but I was not resisting, or else I felt I was not resisting. I had no reason to, although I was conscious of not wanting to reopen old wounds. But that had never been within my power, had it? Perhaps it was that that I was afraid of—that I had no control over what I could see coming.

…

In Villiers de l'Isle Adam's novel, *Tomorrow's Eve*, Lord Celian Ewald, distraught at finding himself in love with Miss Alicia Clary, a woman he despises (Villiers's characters are, it needs to be said, extraordinarily misogynistic), tells his friend, the American inventor Thomas Edison, that he is going to commit suicide. Edison, to save his friend's life, proposes to replace his friend's lover with an android named Hadaly, an android that will have all of Lord Ewald's lover's physical qualities as well as "a sublime spiritual presence" (as opposed to the coarse "spiritual presence" Lord Ewald describes as belonging to his lover). Edison proceeds to show off to Lord Ewald his invention, going so far as to perform an "autopsy" on it in his friend's presence—"If you're already familiar with the charm of the Android when she's fully completed," Edison explains, "no explanation can keep you from feeling that charm—any more than seeing the flayed skin of your living beauty would prevent you from loving her still, if afterwards she appeared before your eyes *as she is today*."

Hadaly's movements and her finer gestures are made possible through a mechanism Edison describes as "the exact analogy of those so-called barrel organs, on the cylinders of which are encrusted, as there are on this, a thousand little metallic points. Each of these points," Edison tells Lord Ewald, "plucks a particular tone at a particular time and thus the cylinder plays exactly all the notes of a dozen different dance airs or operative operas. So here; the cylinder, operating on a complex of electrical

contacts leading to the central inductors of the Android, *plays
. . . all the gestures, the bearing, the facial expressions, and the attitudes of
the woman that one incarnates in the Android.*" The android's palate is
thus limited in its scope, as are its exclamations: Hadaly's speech,
Edison explains, is phonographically recorded sound.

Lord Ewald objects. "To hear exactly the same words for
ever and ever? To see them always accompanied by the same
expression, even though it's an admirable one?" To which
Edison rebuts, "The man who loves, doesn't he repeat at every
instant to his beloved the three little words, so exquisite and so
holy, that he has already said a thousand times over? And what
does he ask for, if not the repetition of those three words, or
some moment of grave and joyous silence? . . . It's apparent that
the best thing is to *re-hear* the only words that can raise us to
ecstasy, precisely because they have raised us to ecstasy before.
. . . When one of these absolutely perfect moments brushes us
with its wind, we are so constructed *that we want no others*, and we
will spend the rest of our lives trying, in vain, to call this one
back—as if the prey of the Past could ever be snatched from
its jaws."

. . .

But just think how many little *nothings* like this, added one to the
other, produce sometimes an irresistible impression! Think of
all the *nothings* on which Love itself depends!
(Villiers, *Tomorrow's Eve*)

. . .

At the moment that Hadaly, in her new guise as Miss Alicia
Clary, is revealed to Lord Ewald, Villiers writes, "He had just
experienced, all of a sudden, the sensation that comes over a
traveler when he is lost on a mountain pathway, hears his guide
say in an undertone, 'Don't look to your left,' then carelessly

257

does so—and suddenly sees, right beside his foot, one of those perpendicular drops so deep and steep that its bottom is hidden from him in the mists, but which, as it returns his horrified look, seems to be inviting him over the precipice."

...

Without this stupefying machine for manufacturing the Ideal, he might never have known such joy. The words proffered by Hadaly had been spoken by the real actress, who never experienced them, never understood them. She had thought she was "playing a part," and here now the character had taken her place within the invisible scene, had not only "assumed" but *become* the role. The false Alicia thus seemed far more *natural* than the true one.
(Villiers, *Tomorrow's Eve*)

...

It seems so unlikely to me that the tower would be open to the public, even a year later, after Madeleine Elster had "committed suicide" there. Why wouldn't the mission close it off, at least to visitors? Is this just a doubt I have because of the times I live in, a symptom of the security-obsessed (really, indemnification-obsessed) culture of America in the early 21st century? Or is it as unlikely as I think it is? And this is the same man who has already been questioned about Madeleine's death, who was present at that "suicide" a year prior. How could he go unnoticed at the Mission?

...

Then again, authorities have resisted putting up barriers on the Golden Gate Bridge for decades, because to do so would be to mar the bridge's beauty.

...

Madeleine E.

This is a book about a man writing a book about *Vertigo*. In his book, he thinks, he will trace his thoughts about the film as they relate to the guilt he has about how he has lived his life, about the lives he hasn't led, and about the lives of others he believes he has ruined. "The past is the only inaccessible part of our present, the one thing we can't change about how we are now," he writes. This is the first line of the book.

He writes every day. He writes quickly and confidently. He writes about his troubled relationship with a woman, how they met, how quickly things moved in the relationship, how she became pregnant and how he fears he may have manipulated her into getting an abortion. He writes about *Vertigo* and the things he finds most interesting about it. He intends to draw parallels between his actions and those of Scottie, but he realizes he can't quite understand Scottie as a character or as a person. He can't enter into that mindset. Still, he tries. As he is writing the scene at Planned Parenthood, he realizes he feels more at home with Elster. This, for him, is a disturbing realization.

Now, he has a great deal of trouble writing. He has never had trouble before, but now he cannot write—not the book, not anything. We understand it is a difficult process for him, not only the process of producing a work of art, but the process of reckoning, of understanding what he has done as others understand it. He struggles with the best way of writing his story—should it be plain or baroque? fractured or carefully constructed?—but then he thinks, *Aren't I trivializing things by wondering about the best way to represent them? Isn't there something evil about struggling with aesthetics in the face of one's past bad actions?* In a weak moment, he wonders whether the two things—the expression of one's past actions and those actions—can truly be separated.

And so he erases it, the entire book, piece by piece. He

worries writing about this woman is exploitative. He worries that taking on so much responsibility for what happened is itself disrespectful to her. First, he erases everything having to do with her. Then, worried he has only made things worse, he erases everything having to do with himself. All that is left are his thoughts on the film, and these are nothing special, he thinks. He erases them, too, one at a time, until he is left with nothing. He has brought himself back to a time before he began writing this book, but he wants to go back even further, to a time when he was still innocent.

If I can make her life better somehow, he thinks, *maybe I can make up for all that I've done. But I'm a writer*, he thinks, *which means I'm incompetent to do most things. The only thing I can do*, he thinks, *is write.* So he writes, but now he doesn't concern himself with "art" and instead writes a thriller as dumb and hackneyed as he can make it. The characters are cardboard and the sentences are wooden. His new book is about a killer who preys on young women. We leave the story of this man to follow the story he is writing.

In the man's book, we follow a woman. She goes to work, goes to the gym, goes to a coworker's birthday party, goes on vacation with her boyfriend, etc. When we least expect it, almost eighty pages in, our protagonist is murdered. This—this cycle of being introduced to a character, following her, and then learning she has been murdered—repeats itself, happens three times, with each subsequent murder happening at a random interval so that it will come as a surprise to us. Indeed, one of the writer's obvious strengths is in convincing us that each woman will make it out alive, that each will defy the pattern being established. The murders are not described; at the end of each of these sections, we see the police arrest a man, an excellent suspect, almost always with motive and opportunity and a history of violence against women. Each time, some piece of evidence turns up exonerating him. It is always a different man the police arrest, but we get the idea that the murderer has been the same in every case.

We leave this book to return to the story of the man writing it. We are told the book has sold to a publisher and has become an overnight sensation. The rights are sold to a Hollywood producer, and now the writer has money to burn. This has been his plan all along: to make money writing so that he can make the woman's life better. He is shocked that he has been successful in his plan, that things could be so easy, but now his fortunes change. He doesn't know how to get in touch with the woman anymore. He goes to her friends, asks them where she is, but he can't get anything out of them, and he can't find her family—to whom he was never introduced, he realizes. He asks everyone where he can find her, what happened to her, and always the answer is I don't know, I haven't seen her, I can't help you.

He can't spend the money, and he can't just give it away, either, he thinks—at least half of it is rightfully hers. She was the inspiration for the book, the reason he wrote it. He says as much in interviews, though he never says how she inspired the book or what her name is, still worried the story isn't his to tell. She doesn't come forward, so finally, he hires a private detective. After many, many months, the detective finds the woman, living under an alias. The detective tells the woman the situation, or at least as much as he knows about it: There is a man, a writer, who wants to know where she is and is willing to spend quite a bit of money to find her. She is scared when the detective first approaches her—as it turns out, she is wanted for a crime under a different alias, a fact not even the detective knows, but with which she lives in abject guilt. We are not told what the crime is, only that it is serious. She cannot afford to be in the spotlight, she thinks, and if she comes forward, the story will be everywhere. She'll be caught. She pleads with the detective not to tell anyone where she is or what name she is now going under. She doesn't tell the detective about her crime; instead, she tells him the writer abused her, mentally. The detective listens to her story. He seems genuinely sympathetic. He tells her he won't say anything, her secret is safe with him.

This detective, however, is unscrupulous, or rather, has been made unscrupulous through his financial woes. His wife, a model who works car shows and conventions around Las Vegas, has gambling debts in six figures; to make matters worse, he is still paying child support to his ex-wife. He wonders how much money he can get out of this woman. He can keep the writer dangling for a while longer before he, the writer, goes to another detective, he thinks, especially if he can show a little progress has been made. And while that's going on, the detective can threaten to give up the woman's whereabouts to the writer and get money from *her*.

The woman could pay the detective off if she had the writer's money, but she doesn't want to see the writer and can't face being exposed, so she can't pay what the detective wants. If the writer knew the position he had put her in, he would feel worse than he already does and would buy the detective off, but he doesn't know anything, only that the detective is making very slow progress, which is still better than nothing. And the detective's situation gets worse by the day—the people his wife owes money to have made threats against her before, but now they are incredibly specific threats, threats of ruining her career by first breaking her nose so that it cannot be re-set, then, by breaking her cheekbones. If the debts still aren't paid off, they will remove her teeth, and then they will scar her face with acid. The detective feels he has no choice: he asks for even more money from the woman to keep her secret. The woman feels trapped. She thinks constantly of the crime she has committed: Is this her punishment? She feels like there is no way out.

In the last scene, we have jumped forward in time. The detective is emailing the writer a link to the obituary of the woman's alias. He tells the writer, this is the woman you wanted me to find. She's dead. I'm sorry. We do not learn how the writer takes the news, because we stay with the detective in his office. He initiates a public documents search for a name we recognize from the writer's novel, the thriller, the one that made so much

money.

The end.

…

Failed suicides and people who have suicidal tendencies frequently report imagining the circumstances of their (future) suicide in great detail. Whereas our daydreams about the future are typically vague and lacking in detail, these suicidal fantasies are exact: a particular bend in the road where one will fail to turn; a specific razor, where one will get it from, and just the right temperature of the water; the spot on the bridge where one will climb over the railing. These fantasies are so exact, in fact, that if the person is prevented from visiting the place described or otherwise barred from realizing the exact circumstance they have envisioned, an overwhelming majority of them will simply give up on killing themselves.

When Madeleine tells Scottie about her dream and he insists they visit the place she has described, he is, we would then say, driving her to her death. He is doing just that, in a nearly literal way, except it isn't Madeleine whom he is driving but Judy— Madeleine is already dead. But later, perhaps, he will drive Judy to her suicide. Having witnessed Madeleine's body being thrown out of the tower while pretending to be Madeleine, Judy is seeing her "self" die. In being later forced to recreate that day without the aid of Madeleine's body to stand in for her, Judy must then act out Madeleine's part. All along, Scottie has been forcing her to recall the events that led up to this death—taking her to Ernie's, dressing her as Madeleine, taking her to have her hair done as Madeleine did hers, taking her to his apartment, and so on. If Judy's death is a suicide, it is a suicide that has been caused by the actions of another, a kind of induced suicide.

Are all attempts to relive the past incitements to suicide?

Another way of saying this: for Judy, Madeleine's faked death is a kind of suicidal fantasy—Judy "being" Madeleine at

the time. She is able to forget it because she cannot revisit the scene of the crime. But Scottie forces Judy to think as she did at the time she pretended to be Madeleine, even going so far as to take her, costumed in the way she had been at the time, back to San Juan Bautista and the tower where she saw herself thrown from the tower by a man who was pretending that she was the woman he was throwing from the tower. Now, in the tower with another man pretending that she is not who she is, she is helpless not to act out the fantasy that is really history—she must throw herself from the tower. What else can she possibly do?

. . .

The only serious philosophical question is what Eurydice saw when Orpheus looked back. What Eurydice saw when Orpheus looked back determines the worth of his song.
(Peter Dimock, *George Anderson*)

. . .

Casanova considered the limits of human reason. He established that, while it might be rare for a man to be driven insane, little was required to tip the balance. All that was needed was a slight shift, and nothing would be as it formerly was. Casanova likened a lucid mind to a glass, which does not break of its own accord. Yet how easily it is shattered. One wrong move is all that it takes.
(Sebald, *Vertigo*)

. . .

Scottie says, "It's too late. There's no bringing her [meaning Madeleine] back." To Judy. Just before she falls.

. . .

It is a fundamentally insane notion, he continues, that one is able to influence the course of events by a turn of the helm, by will-power alone, whereas in fact all is determined by the most complex interdependencies.
(Sebald, *Vertigo*)

…

In Boileau and Narcejac's *D'Entre les Morts*, Flavières (Scottie) strangles Renée (Judy). Though Madeleine's death earlier in the narrative has been faked in the same way—a fall from a church bell-tower—it is not repeated again in the novel as it is in *Vertigo*. Of course *Vertigo*'s ending has been changed; I cannot imagine any studio in 1950s Hollywood greenlighting a script that has the protagonist strangling the heroine at the end. Nor can I imagine an actor willing to play such a part. Jimmy Stewart was already playing wildly against type in *Vertigo*, as a man who cruelly transforms a woman against her will into the woman he is obsessed with, a man who then—though the ending of the film leads us to believe that Judy's death is an accident— drives this same woman to suicide. And yet Flavières, who is unequivocally Renée's murderer, seems so plainly out of control that his actions seem somehow more excusable than those of Scottie, who is completely in control in taking Madeleine down to San Juan Bautista again and seems to thus be acting all the more cruelly toward her. Perhaps it is that Renée will not admit to being Madeleine, even though Flavières is so certain that she is (and finds evidence of it in the necklace)—the reader can easily believe that she is cruel, too, taunting the obviously disturbed Flavières—whereas Judy seems innocent, having undeceived us at the very beginning of her story by coming clean in her letter to Scottie. She seems to sincerely regret her actions in the first part of the narrative; the same cannot be said about Renée, who maintains her stonefaced denial even in the face of the evidence of the necklace, maintains it so long and so adamantly

that it is possible to read the book as the story of the murder of an innocent woman by a mentally-disturbed man and nothing more. No plot against Flavières, no perfect murder on the part of Gevigne, no echoes of the past in Madeleine, no doubling or trebling in Renée, just a man completely undone by fate and the woman he tortures and then murders.

...

Far from becoming clearer, things now appeared to me more incomprehensible than ever. The more images I gathered from the past, I said, the more unlikely it seemed to me that the past had actually happened in this or that way.
(Sebald, *Vertigo*)

...

Thanatos can assume any form it wishes; it can kill *eros*, the life drive, and then simulate it. Once *thanatos* does this to you, you are in big trouble; you suppose you are driven by *eros* but it is *thanatos* wearing a mask.
(Dick, *VALIS*)

...

Isn't Judy's death precisely what Scottie wants out of his visit to San Juan Bautista? Though he is, one supposes, trying to correct his previous mistake, he certainly never explicitly says so; what he says is "There's just one thing I've got to do, then I'll be free." It almost isn't necessary to say this statement can be read several different ways, and only one is positive—Judy knows it. The one thing that is absolutely clear is that Scottie is trying to recreate exactly the previous visit. Though this time he can climb to the top and look out, everything else must be as it was. If that is so, mustn't it end with "Madeleine's" death? There is

no other possible ending that would satisfy him, it seems. He may or may not believe he is going to rectify the past—he does, as far as he is concerned, by overcoming his acrophobia—but what we discover is that he can only rectify *his* past, not Judy's, not Madeleine's, as though once a witness to her death, he will always remain just a witness, as though all of the events that follow take place behind glass. Just as he was powerless to help the woman he believed to be Madeleine then, he will not be able to help the woman he believes to be Madeleine now (here, in this final scene, is the only time he will call Judy Madeleine). If he were out to rectify the past, he would not bring Judy to San Juan Bautista. If he were out to rectify the past, he would not bring Judy to the top of the tower. If he were out to rectify the past, he would leave well enough alone. It always seems possible to love someone for who they are, even while it is impossible to love them for anything but what one believes them to be.

…

Of course, nothing so bad happened or even could have happened at San Juan Bautista, because there is no tower there. There was once a steeple, but it burned in a fire. Hitchcock's tower is a special effect, a combination of matte painting, scale models, and trick photography. The tower is an illusion, Hitchcock's fiction. My girlfriend and I looked up into the blue of the sky. A wispy cloud passed. She told me she was cold. We got back in the car, started on our way back to San Francisco. Across the lawn, another couple was fighting with each other. Their voices were not loud, but they were intense, meant not to carry but definitely meant to be heard. Because of the way the man held the woman, it was impossible to tell who was pulling who, but they were stumbling towards the church, almost as if by accident. My girlfriend called to me from the car.

…

267

Every effort to understand destroys the object studied in favor of another object of a different nature; this second object requires from us a new effort which destroys it in favor of a third, and so on and so forth until we reach the one lasting presence, the point at which the distinction between meaning and the absence of meaning disappears: the same point from which we began. (Claude Levi-Strauss, *Tristes Tropiques*)

. . .

Another inquest, surely. Even if there is no corresponding breakdown, there must be another inquest. And can it go any differently than did the first? "The law has little to say on the subject of things left undone." *Vertigo* itself is such a thing, it seems to me, for here we are, on the brink of beginning things again, and yet here the narrative ends. One might object that, with Judy dead, there can be no repetition, but that supposes Judy's letter is real, something I cannot believe in myself.

. . .

Judy screams when Elster tosses Madeleine's body off the tower. Madeleine, dead, makes no sound at all. The policeman screams. Judy screams, but she may only scream at the sight of the nun, not on her way down (the camera angle prevents us from knowing). Whatever is going through their minds as they fall, they have no words for it.

. . .

Not a look of triumph, but not one of remorse, either. Awe.

. . .

When a man falls over a cliff, he almost certainly smiles before

he hits the ground, because that's what his own demon tells him
to do.
(Ossip Zadkine)

WORKS CITED

Auiler, Dan. *Vertigo: The Making of a Hitchcock Classic*. New York: St. Martin's Press, 1998.

Bakhtin, Mikhail. *The Dialogic Imagination*. Austin: University of Texas Press, 1982.

Baudrillard, Jean. *Simulacra and Simulation*. Ann Arbor: University of Michigan Press, 1995.

Benjamin, Walter. *The Arcades Project*. Boston: Belknap, 2002.

Berger, John. *About Looking*. New York: Vintage, 1992.

Berger, John. *Keeping a Rendezvous*. New York: Pantheon, 1991.

Berger, John. *Ways of Seeing*. New York: Penguin, 1990.

Binet, Laurent. *HHhH*. New York: FSG, 2012.

Bioy Casares, Adolfo. *The Invention of Morel*. New York: New York Review Books, 2003.

Blanchot, Maurice. *The Space of Literature*. Lincoln, NE: University of Nebraska Press, 1989.

Boileau, Pierre and Thomas Narcejac. *Vertigo*. London: Bloomsbury Publishing, 1997.

Bonitzer, Pascal. "Partial Vision: Film and the Labyrinth." *Wide Angle 4*, no. 4 (1981): 58.

Borges, Jorge Luis. *Selected Non-fictions*. New York: Penguin, 2000.

Bresson, Robert. *Notes on the Cinematographer*. Copenhagen & Los Angeles: Green Integer Books, 1997.

Brown, Peter Harry. *Kim Novak: Reluctant Goddess*. New York: St. Martin's Press, 1986.

Calvino, Italo. *Invisible Cities*. New York: Houghton Mifflin Harcourt, 1978.

Carson, Anne. *Short Talks*. Toronto: Brick Books, 1992.

Deleuze, Gilles. *Difference & Repetition*. New York: Columbia University Press, 1994.

Deleuze, Gilles. *Masochism: An Interpretation of Coldness and Cruelty*. New York: Zone Books, 1991.

Dick, Philip K. *A Scanner Darkly*. New York: Library of America, 2008.

Dick, Philip K. *Dr. Bloodmoney*. New York: Library of America, 2008.

Dick, Philip K. *Now Wait for Last Year*. New York: Library of America, 2008.

Dick, Philip K. *VALIS*. New York: Library of America, 2009.

Dimock, Peter. *George Anderson: Notes for a Love Song in Imperial Time*. Champaign, IL: Dalkey Archive Press, 2012.

Doniger, Wendy. *The Woman Who Pretended To Be Who She Was: Myths of Self-Imitation*. New York: Oxford University Press, 2005.

Dyer, Geoff. *Out of Sheer Rage*. New York: Picador, 2009.

Dyer, Geoff. *Zona*. New York: Vintage, 2012.

Eagleman, David. *Incognito: The Secret Lives of the Brain*. New York: Pantheon Books, 2011.

Eco, Umberto. *Confessions of a Young Novelist*. Cambridge, MA: Harvard University Press, 2011.

Faulkner, William. *Mosquitoes*. New York: Library of America, 2006.

Fitzgerald, F. Scott. *The Crack-Up*. New York: New Directions, 1993.

Flynn, Nick. *The Reenactments*. New York: W. W. Norton, 2013.

Flynn, Gillian. *Gone Girl*. New York: Crown, 2012.

Freud, Sigmund. *The Uncanny*. New York: Penguin, 2003.

Highsmith, Patricia. *Ripley Under Ground*. New York: Random House, 1999.

Highsmith, Patricia. *Strangers on a Train*. New York: W. W. Norton, 2001.

Hofstadter, Doug. *Godel, Escher, Bach*. New York: Vintage, 1980.

Jabr, Ferris. "The Reading Brain in the Digital Age." *Scientific American*. April, 2013.

Jung, Carl. *Psychology and Alchemy*. Princeton, NJ: Princeton University Press, 1980.

Junod, Tom. "The Falling Man." *Esquire.* September, 2003. http://classics.esquire.com/the-falling-man

Kitchen, Judith. *Distance and Direction.* Minneapolis: Coffee House Press, 2001.

Kitchen, Judith. *Only the Dance.* Columbia, SC: The University of South Carolina Press, 1994.

Kjaerstad, Jan. *The Seducer.* New York: The Overlook Press, 2006.

Krohn, Bill. *Hitchcock at Work.* London, Phaidon, 2003.

Kundera, Milan. *The Unbearable Lightness of Being.* New York: Harper Perennial, 2009.

Levé, Edouard. *Autoportrait.* Normal, IL: Dalkey Archive Press, 2012.

Levé, Edouard. *Suicide.* Normal, IL: Dalkey Archive Press, 2014.

Levine, Sara. *Treasure Island!!!* New York: Europa Editions, 2011.

Levi-Strauss, Claude. *Tristes Tropiques.* New York: Penguin, 2012.

Markson, David. *This Is Not a Novel.* San Francisco: Counterpoint, 2001.

Markson, David. *The Last Novel.* San Francisco: Counterpoint, 2007.

Martone, Michael. *Four for a Quarter.* Tuscaloosa, AL: The University of Alabama Press, 2011.

McGilligan, Patrick. *Alfred Hitchcock: A Life in Darkness and Light.* New York: Regan Books, 2003.

McHale, Brian. *Postmodernist Fiction.* New York: Routledge, 2004.

Modleski, Tania. *The Women Who Knew Too Much: Hitchcock and Feminist Theory.* New York: Methuen, 1988.

Nelson, Maggie. *The Art of Cruelty.* New York: W. W. Norton, 2012.

Neruda, Pablo. *Twenty Love Poems and a Song of Despair.* New York: Penguin, 1993.

Nietzsche, Friedrich. *Beyond Good and Evil.* New York: Oxford University Press, 1999.

Ovid. *The Metamorphoses.* New York: Harcourt Brace, 1995.

Paz, Octavio. *Alternating Current.* New York: Arcade, 1990.

Poe, Edgar Allan. *Poetry and Tales.* New York: Library of America, 1984.

Rhees, Rush (ed.). *Recollections of Wittgenstein.* New York: Oxford University Press, 1984.

Pessoa, Fernando. *The Book of Disquiet.* New York: Penguin, 2002.

Pethybridge, Jeffrey. *Striven, the Bright Treatise.* Mesilla Park, NM: Noemi Press, 2013.

Priest, Christopher. *The Affirmation.* New York: Scribner, 1981.

Pudovkin, V. I. *Film Technique and Film Acting.* London: Vision Press, 1954.

Ronk, Martha. *Vertigo*. Minneapolis: Coffee House Press, 2007.

Rose, Mark. *Shakespearean Design*. Boston: Belknap, 1972.

Ross, Adam. *Mr. Peanut*. New York: Vintage, 2011.

Roubaud, Jacques. *The Great Fire of London*. Normal, IL: Dalkey Archive Press, 2006.

Santayana, George. *The Life of Reason*. New York: Prometheus Books, 1998.

Santayana, George. "Spengler." *The New Adelphi*. II, 1929.

Saramago, Jose. *The Double*. New York: Houghton Mifflin Harcourt, 2004.

Sartre, Jean Paul. *Being and Nothingness*. New York: Philosophical Library, 1956.

Schwartz, Hillel. *The Culture of the Copy*. New York: Zone Books, 1996.

Schulz, Bruno. *The Street of Crocodiles*. New York: Penguin, 1992.

Sebald, W. G. *The Rings of Saturn*. New York: New Directions, 1999.

Sebald, W. G. *Vertigo*. New York: New Directions, 2000.

Soden, Garrett. *Falling: How Our Greatest Fear Became Our Greatest Thrill*. New York: W. W. Norton & Company, 2003.

Solnit, Rebecca. *River of Shadows*. New York: Penguin, 2004.

Spoto, Donald, *The Dark Side of Genius: The Life of Alfred Hitchcock*. New York: Ballantine Books, 1984.

Spoto, Donald. *Spellbound by Beauty: Alfred Hitchcock and His Leading Ladies*. New York: Harmony Books, 2008.

Stein, Gertrude. *The Autobiography of Alice B. Toklas*. New York: Vintage, 1990.

Tarkovsky, Andrei. *Sculpting in Time*. New York: Alfred A. Knopf, 1986.

Taylor, John Russell. *Hitch: The Life and Work of Alfred Hitchcock*. New York: Pantheon Books, 1978.

Truffaut, François. *Hitchcock/Truffaut*. New York: Touchstone, 1985.

Villiers de l'Isle Adam. *Tomorrow's Eve*. Chicago: University of Chicago Press, 1982.

Vonnegut, Kurt. *Mother Night*. New York: Dial Press, 2009.

Wittgenstein, Ludwig. *Philosophical Investigations*. Upper Saddle River, NJ: Pearson, 1973.

Waldrep, G. C. "D. W. Griffith at Gettysburg." *The Threepenny Review*. Issue 119, 2009.

Wilde, Oscar. *The Picture of Dorian Gray*. London: Dover, 1993.

Wood, Gaby. *Edison's Eve*. New York: Knopf, 2002.

Wood, Robin. *Hitchcock's Films Revisited*. New York: Columbia University Press, 1989.

Zambreno, Kate. *Heroines*. Los Angeles: Semiotext(e), 2012.

Acknowledgments

Scenes from this book have appeared, often in very different form, in *The Collapsar*, *3:AM*, *The Portland Review*, and *The Fanzine*. Thanks to editors James Brubaker, Nathan Knapp, Greg Gerke, Brian Tibbetts, Sophia Pfaff-Shalmiev, and Janice Lee.

About the author

Gabriel Blackwell is the author of *The Natural Dissolution of Fleeting-Improvised-Men*, *Critique of Pure Reason*, and *Shadow Man*. He is co-editor of *The Collagist*.

CPSIA information can be obtained
at www.ICGtesting.com
Printed in the USA
LVOW11s1757090317

526680LV00003B/634/P